FROM THE FRONT

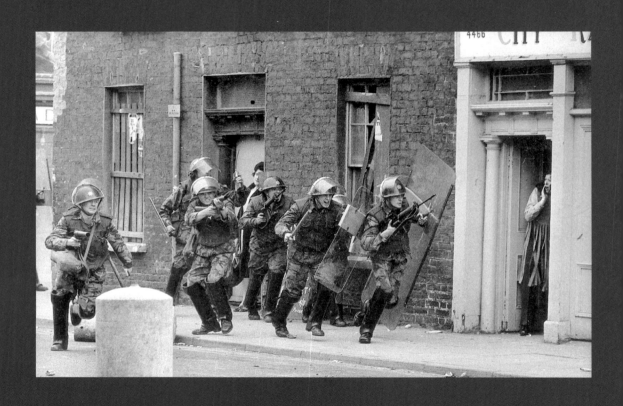

FROM THE FRONT: The Story of War
by Michael S. Sweeney

Featuring Correspondents' Chronicles

NATIONAL GEOGRAPHIC
WASHINGTON, D.C.

*A signpost, left, at a crossroads in Tacloban, on Leyte,
the Philippines, indicates the soldiers' sense of humor and
their yearning for home. Preceding page: Troops storm
residential streets in Londonderry, Northern Ireland, in 1970.*

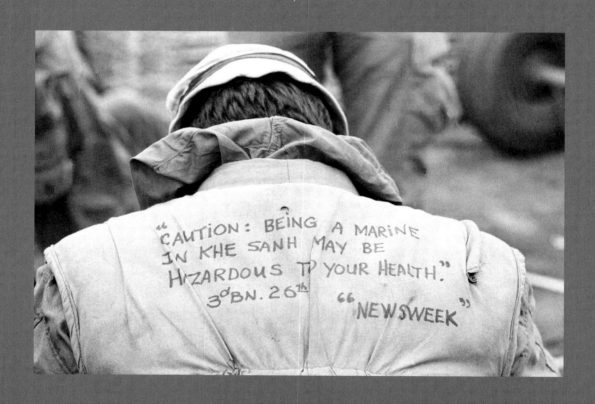

INTRODUCTION

by Michael S. Sweeney

JACK LONDON thought it would be fun to cover a war. America's most popular writer, he leaped at the opportunity when the powerful publisher William Randolph Hearst hired him to chronicle the clash of tsarist Russia and Imperial Japan. London arrived in Japan in January 1904. Russia and Japan had not declared war, but Russian troops had invaded northern China. Russia looked to expand eastward, and Japan looked to do the same toward the west. Their interests crossed in Korea and Manchuria.

London boarded a steamer for Korea. With notebook, camera, and interpreter, he linked up with the Japanese First Army in Pyongyang. He had reported only one skirmish when Tokyo bureaucrats ordered that he play "the game," as London called it. "We saw what we were permitted to see, and the chief duty of the officers looking after us was to keep us from seeing anything," London noted. Only one reporter visited headquarters daily, then shared any information gained—although the battlefield censor, a relatively new invention, rarely said more than "All is going according to plan." Soon after Japanese and Russian troops fought at the Yalu River in May 1904, London headed home, realizing that war correspondent adventures were more fiction than fact.

For two centuries, journalists have gone to war, believing that the public has a right to know the news.

A United States Marine, left, shares a message on his flak jacket at the Khe Sanh base on February 21, 1968. The North Vietnamese bombarded the camp with artillery shells, rockets, and mortars continually for three months.

In the fog of war, dispatches can be distorted, erroneous, or incomplete, but when correspondents get it right, they can shake the world. A vigorous press often runs afoul of the government and the military. Its focus on strategy and tactics can provoke accusations of helping the enemy. Britain's Duke of Wellington, battling France's Napoleon, would not tolerate correspondents in his camp. He said some papers had revealed too much when they "accurately stated not only the regiments occupying a position, but the number of men fit for duty of which each regiment was composed."

In Wellington's day, the early 19th century, war combat stories came from soldiers, command reports, and civilian letters. The first journalist hired to write war news was Henry Crabb Robinson. In 1807 the *Times* of London commissioned him to go to Altona and write about Napoleon's army. Robinson did not dash into combat, though. He made arrangements with a German editor to translate stories from continental papers. Small wonder that Robinson's reports contained little that modern readers would recognize as hard news.

The difference between a soldier's and a journalist's battle account showed up clearly with the first true war correspondents. The journalist, beholden to neither king nor army, could speak plainly. For the sake of his livelihood, though, he could not be dull. Serious reports from the front followed upon major changes in technology, financing, and content— and upon the emergence of more war fronts.

The world continues to be all too accommodating to those who thrill to the sound of war.

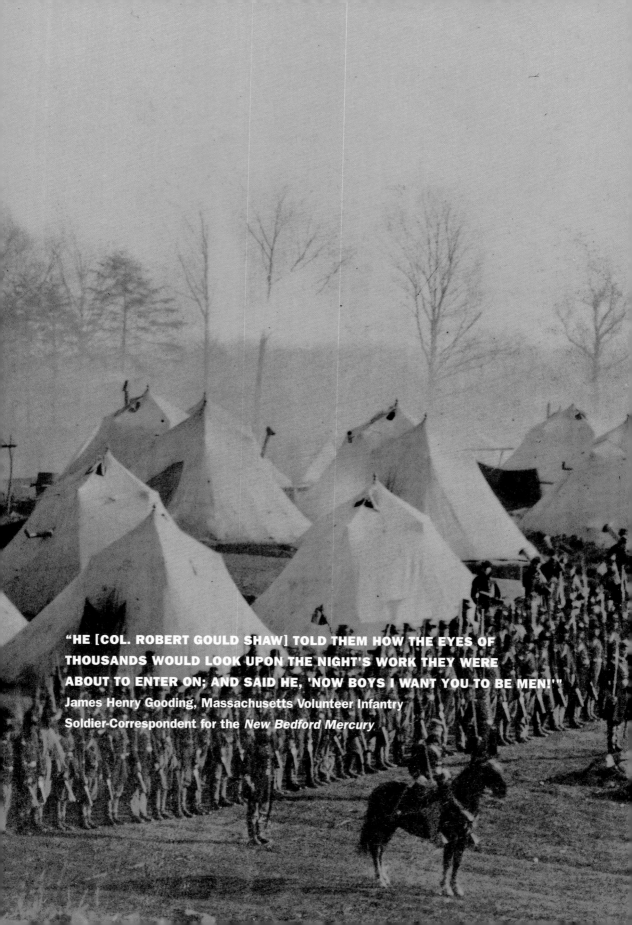

"HE [COL. ROBERT GOULD SHAW] TOLD THEM HOW THE EYES OF
THOUSANDS WOULD LOOK UPON THE NIGHT'S WORK THEY WERE
ABOUT TO ENTER ON; AND SAID HE, 'NOW BOYS I WANT YOU TO BE MEN!'"
James Henry Gooding, Massachusetts Volunteer Infantry
Soldier-Correspondent for the *New Bedford Mercury*

CHAPTER ONE WAR IS NEWS

THE ILLUSTRATED LONDON NEWS.

No. 1197.—VOL. XLII.　　　　SATURDAY, APRIL 4, 1863.　　　　Two Sheets, Fivepence.

CONGRESS TO ENFORCE THE RIGHTS OF POLAND.

A FEW hours before Parliament adjourned for the Easter holidays, Lord Palmerston, in reply to an inquiry put to him by Mr. Hennessy, announced in somewhat general terms that England and France had agreed upon a course of diplomatic action in reference to the affairs of Poland, and that he believed the papers which he hoped to lay before both Houses soon after Easter would satisfy the country as to the steps which the Government had taken on behalf of that unhappy nation. We suppose there can be but little room to doubt the authenticity of the information given to the British public in the *Times* of the same date, to the effect that, "both as members of the community of nations, the civilisation of which has been outraged by the tyranny of the Russian Government, and as parties to the Treaty of Vienna, the chief States of Europe have felt themselves compelled to consider their relations with Poland, and to take counsel as to the best means of removing a great scandal and a danger to the peace of the world." The noble Premier, it is true, did not, in words, corroborate this announcement, but neither did he deny its accuracy; so that, piecing together the authoritative language of the *Times* on Friday morning and the more reticent phrase of Lord Palmerston on Friday night, we are tolerably safe in concluding that England and France are unitedly seeking a congress of those European Powers whose representatives signed the Treaty of 1815, to which Russia will be invited that she may at once explain her own case, and accept or reject the decision of Europe.

We can well understand why the leading Governments of Europe should entertain objections to the assembling of a general congress, and should discourage a resort to the moral coercion which this kind of international machinery may bring to bear upon States supposed to be chargeable with the offence of misruling their own subjects. Each is desirous, as a matter of course, of preserving intact its own sovereign rights, and is therefore cautious of trespassing upon those of others. But the relations of Russia and Poland are so peculiar, the title of the other Powers of Europe to deal with them is a matter of such express treaty stipulation, and the peace of the world would be so endangered by a continued refusal to act upon that title, that general objections are overborne by the pressure of the particular case, and it has become safer to employ an irresistible diplomatic action for the protection of the Poles than to be governed in this instance by the modern and generally-accepted principle of non-intervention. The truth is, that Poland has never yet surrendered her rightful claim to be considered an independent nation. The partition of the old kingdom of Poland in 1772 by Russia, Austria, and Prussia was a crime which the conscience of Europe has never condoned; and the earliest provisions of the Treaty of Vienna in 1815 prove that all the parties to that great international instrument, Russia included, formally recognised the right of the Poles, under whatever sovereignty, to retain inviolate the nationality of their kingdom.

We accept Lord Palmerston's interpretation of the treaty as the true one. It is a public engagement in which the several subscribing Powers pledge themselves to each other in relation to the distribution amongst them of political authority, an engagement which gives a European sanction to all the stipulations it contains, which entitles each Power to use the whole force at its command, should it be so advised, to enforce upon any of the other Powers an observance of its provisions, but which does not bind any of them to draw upon its own resources, or to risk its own well-being in the attempt to give effect to the common agreement. We are under no treaty obligation to preserve to Poland the rights which that instrument solemnly recognised as hers; we are not even morally bound to go to war in her

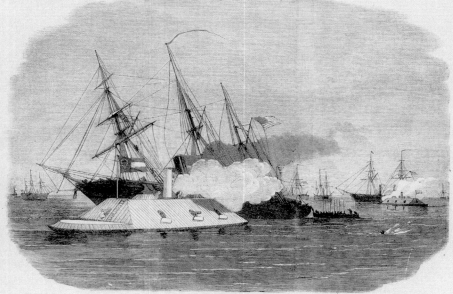

THE WAR IN AMERICA: ATTACK ON THE BLOCKADING SQUADRON OFF CHARLESTON BY IRON-CLAD GUN-BOATS.—FROM A SKETCH BY OUR SPECIAL ARTIST.—SEE PAGE 372.

CHAPTER ONE

GEORGE WILKINS KENDALL knew the value of speed. Speed gave one newspaper a scoop. Speed spread that scoop to a large audience while the news was still fresh. Speed made reputations and fortunes.

Kendall was one of about ten full-time reporters and dozens of soldier-correspondents who rode with the United States Army into Mexico in 1846-47. Born in New Hampshire in 1809, the same year as Abraham Lincoln, he had tried his hand at New York journalism before moving to New Orleans in 1832. Five years later, he and a friend founded the *New Orleans Picayune*. A "picayune" was a coin similar to a penny; likewise, the newspaper was cheap fare for the masses. New Orleans was the closest major American city to Mexico when the United States Congress declared war in May 1846, so Kendall sped to the camp of Gen. Zachary Taylor to cover the conflict. Never before or since had journalists had such opportunities. They were under no restrictions.

Preceding pages: At the start of the American Civil War, in 1861, the Vermont Brigade encamps near Washington, D.C. At left, the world's first illustrated periodical, the Illustrated London News, *combined dispatches with engravings of news events, such as the Civil War clash of ironclads off Charleston, South Carolina, in 1863.*

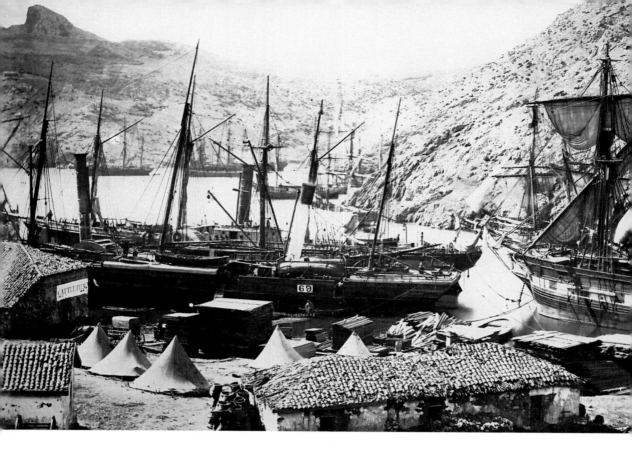

The Mexican-American War had been brewing for more than a decade. In 1835, Americans who had settled in Mexico's Texas province rebelled against the government of Gen. Antonio Lopez de Santa Anna. They gained independence in 1836, and Texas remained a republic until annexed to the United States in 1845. Expansionist sentiment, guided by Manifest Destiny—the American "right" to spread over the entire continent—contributed to a border clash. In March 1846, U.S. troops under Taylor advanced to the Rio Grande, occupying territory claimed by Mexico. On May 13, 1846, the United States declared war. In February 1847 Taylor defeated Santa Anna, clearing the way for Gen. Winfield Scott to advance toward the capital, Mexico City. On September 13 Scott captured fortified heights outside the city. American soldiers stormed up the rocky slopes and climbed the fort walls, desperately defended by a band of about 100 cadets from the Mexican Military College. On September 14 Americans prepared to bombard the city and the Mexican troops surrendered.

Throughout the war Kendall was both journalist and fighter. He captured a cavalry flag, suffered a bullet wound in his knee, and was called "Major" by war's end. Another reporter—Jane McManus Storms, writing as Cora Montgomery in the *New York Sun,* the only woman to cover the conflict—went behind Mexican lines. The reporters were under no censorship. Their dispatches held news of Generals Taylor, Scott, and Franklin Pierce, and promising young officers Jefferson Davis, Robert E. Lee, Ulysses S. Grant, Thomas J. Jackson, and George McClellan. Details of their victories in the Halls of Montezuma went straight to the United States's reading public. Not fast, though. Most of the dispatches moved only as fast as horses or steam engines. Samuel Morse had made the telegraph practical in 1844, but messages traveled only where wires did—in the major cities of the eastern seaboard.

Some eastern papers had correspondents in Mexico and their own horse, rail, and steam transportation to speed the news. But the *Picayune's*

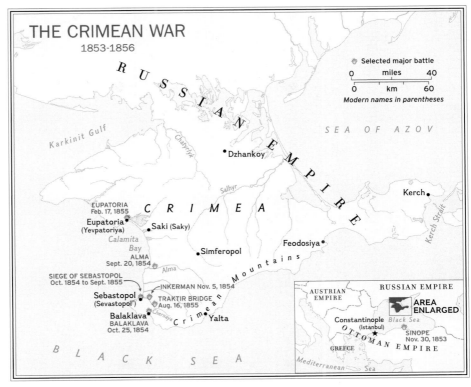

THE CRIMEAN WAR
1853-1856

Selected major battle

0 miles 40

0 km 60

Modern names in parentheses

RUSSIAN EMPIRE

SEA OF AZOV

Karkinit Gulf

Dzhankoy

Kerch

EUPATORIA
Feb. 17, 1855

CRIMEA

Eupatoria
(Yevpatoriya)

Saki (Saky)

Calamita
Bay

Simferopol

Feodosiya

ALMA
Sept. 20, 1854

Alma

Mountains

SIEGE OF SEBASTOPOL
Oct. 1854 to Sept. 1855

INKERMAN Nov. 5, 1854

Sebastopol
(Sevastopol')

TRAKTIR BRIDGE
Aug. 16, 1855

Balaklava
BALAKLAVA
Oct. 25, 1854

Chernaya

Crimean

Yalta

BLACK SEA

AUSTRIAN
EMPIRE

RUSSIAN EMPIRE

AREA
ENLARGED

Black Sea

Constantinople
(Istanbul)

SINOPE
Nov. 30, 1853

GREECE

OTTOMAN EMPIRE

Mediterranean Sea

system was the best. Kendall arranged for his own riders to take *Picayune* articles and Army dispatches through guerrilla country to the port of Veracruz. Several riders were killed or captured, but "Mr. Kendall's Express" proved reliable. The messages were placed aboard fast ships bound for New Orleans, then intercepted near the Mississippi Delta by boats outfitted with typesetting equipment, so while they steamed to port, compositors set up the stories for the presses. Thus Kendall's paper was the first with the war news. The *New York Herald* had its own journalists in the field but also printed the *Picayune's* news, as did the *Baltimore Sun*.

Those reports seem puffy and passive today. "At early daylight this morning a heavy cannonade was opened upon the stronghold of Chapultepec, which was increased during the day as additional siege guns were placed in position," Kendall wrote of the final assault in September 1847. Two days later he reported the "glorious" capture of the Mexican capital and the flight of General Santa Anna,

"wandering with the remnant of his army no one knows whither."

Getting such news to the States was expensive. One time, Kendall reportedly chartered a special steamship for $5,000. He chartered a steamer faster than the government's ship to take a copy of the Treaty of Guadalupe Hidalgo to New Orleans. The paper printed an "extra" edition, which steamships and pony express riders carried to Baltimore and on to Washington. The *Sun* reached government officials before any official Army dispatch. Time and space were under attack.

Before the 1830s, newspaper production had not advanced far from Gutenberg's 15th-century workshop. A printer put one sheet of paper onto a bed of inked type, then lowered a plate and applied pressure. He had to dry a sheet before printing the other side. The sheet was folded and cut to produce a four-page newspaper. A skilled printer could make 100 impressions an hour, but by the mid-19th century, one steam-powered rotary press could make 20,000 in the

13

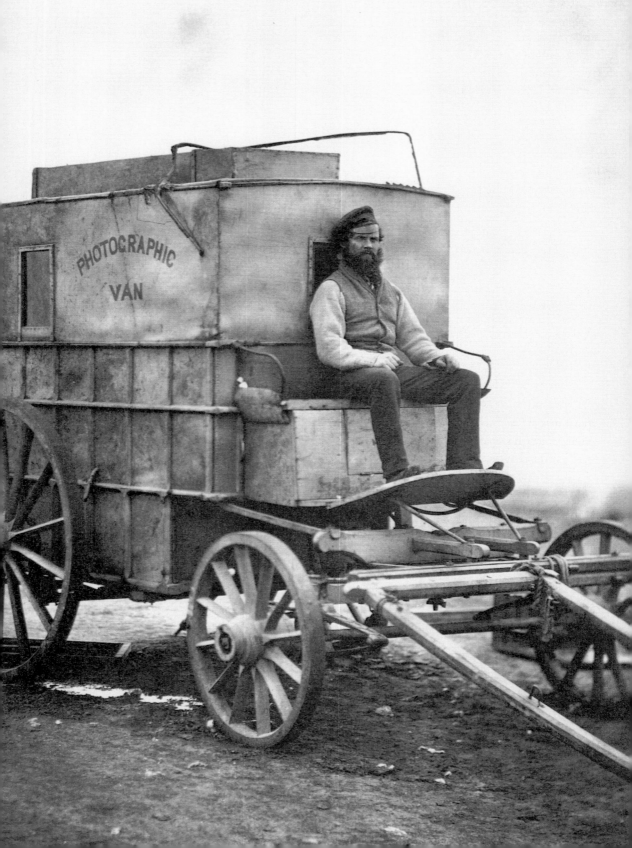

same time. By 1861, Horace Greeley's *New York
Tribune* was using papier-mâché molds for the lead
printing plates that fit onto the revolving cylinders.
This "stereotyping" process allowed the printer to use
more presses and produce hundreds of thousands of
copies an hour. Railroads and an improved postal
system distributed these mountains of newsprint to
a large circulation area, creating some of the first
national papers, including the weekly edition of the
Tribune. Reader numbers swelled with the growth of
literacy, thanks to the spread of public education.

"It Shines for All" read the motto of the *New York
Sun,* first issued on September 3, 1833. *Sun* pub-
lisher Benjamin Day had a plan for making money.
At the time, newspapers cost about 6 cents when the
average daily wage was only 75 cents. They were
filled with news and advertising for the upper crust.
Their publishers turned a profit by selling a small
number of expensive copies. Day figured he could
make money by selling a large number of cheap
copies. He priced the *Sun* at a penny and filled it with
crime news, poetry, anecdotes, and human interest
stories. Day's circulation reached 34,000 in five
years, nearly eight times larger than the biggest
New York paper before the dawn of the *Sun.*
Imitators in the "penny press" sprang up, including
the *New York Herald*. Cheap American papers
appeared everywhere, quadrupling in number from
1825 to 1860. British presses also moved toward a
paper for the masses.

For illustrations, these papers relied on wood
engravings. Although photography had become

a commercial success by the 1840s, photographic
images could not be printed for decades. Artists
sketched on blocks of wood, then the images were
engraved into the hard wood by hand. The first
picture paper was the *Illustrated London News*.
Within six weeks of its appearance in 1842, the 16-
page weekly boasted a circulation of 20,000. Despite
moral claims to be a "family newspaper," it published
the first images of conflict, a series by artist Con-
stantin Guys portraying incidents from the 1848 Paris
Revolution that ended the Bourbon monarchy and led
to the Second Empire under Napoleon III.

British papers capitalized on the Crimean War of
1854-56, France's first significant conflict with a
major European opponent since Napoleon's defeat at
Waterloo in 1815. The war grew out of a conflict
between Orthodox and Roman Christians, aggra-
vated by Russia's demand to protect the Orthodox
Christians in Turkey, but behind it was Russia's desire
to gain access to the Mediterranean via the Strait
of Bosporus.

In July 1853 Russian troops approached the Turk-
ish border. The British government distrusted any
moves by Russia that might destabilize the balance
of power in Eastern Europe and thus threaten British
interests in India. Britain promised support to the
Turks. In October 1853 Turkish troops were sent to
the border in the Danubian principality of Romania,
and the British fleet sailed to Constantinople. By
October 4, the Turks had declared war on Russia. In
January 1854, the Russian Black Sea squadron
destroyed a Turkish naval flotilla near Sinope, a port

15

on the Turkish Black Sea coast. The British and French fleets entered the Black Sea in January and two months later declared war on Russia, the battleground a tiny peninsula in the north-central Black Sea called the Crimea.

London *Times* editor John Delane made a fateful decision. "As I was sitting at my desk in office one evening in February 1854," wrote one of his reporters, "I was informed that the editor, Mr. Delane, wished to see me.... The Government had resolved to show Russia that England was in earnest in supporting the Sultan against aggression, and that she would, if necessary, send an expedition to the East. It was decided, he said, that I was the best man to represent the paper on the occasion." Delane promised, said the reporter, that he would "have a pleasant trip for a few weeks only." Those few weeks turned into 22 months that forever altered the role of the journalist in wartime. The first war correspondents began the 19th century without influence. In a little more than 50 years, they became indispensable. All this because William Howard Russell answered Delane's call to go to the front.

Russell's direct and often critical firsthand observations demonstrated the power of the press. He started unknown but gained international acclaim, his opinion sought by Britain's prime minister. Although he hated war and the title of "war correspondent," Russell elevated the role of combat journalist. He became intimate with world leaders ("Don't kneel, Billy, just stoop," said King Edward VII when he made Russell a Commander of the Royal Victorian Order). He was knighted in his old age and was a role model for many who followed.

Conflict surrounded Russell. He was born in 1820, the son of a Protestant father and a Catholic mother in fiercely sectarian Ireland. His family moved to Liverpool, and he grew up scuffling with schoolmates and watching soldiers drill nearby. He had courage of two kinds—to face danger and to tell the truth. A soldier in the Crimea called him "a vulgar low Irishman" who "sings a good song, drinks

anyone's brandy and water and smokes as many cigars as a Jolly Good Fellow. He is just the sort of chap to get information, particularly out of young-sters." That final quality proved valuable in the Crimea. The British commander refused to speak to him. The army at first gave him no rations or trans-portation. Without official connections, Russell had to talk to anyone who would respond.

Russell saw his first battle in the Crimea on September 20, 1854, north of the Russian naval base of Sebastopol. An Allied force of more than 60,000 British, French, and Turkish troops had landed and set out toward Sebastopol. Blocking their advance were 36,400 Russian forces on the heights of the Alma River, which the Allies reached on September 20. The French were to attack to turn the Russian left flank, then the British would assault the heights. Confusion resulted: The British launched their attack before the French had completed theirs. The 65-year-old British commander, Lord Raglan—who had last fought at Waterloo—advanced so far forward that he found himself behind the Russian front lines. After three hours of hard fighting, the Russians were com-pletely routed. They fell back into Sebastopol. The Allies failed to pursue them. The Russians began to plan Sebastopol's defense.

Russell witnessed the entire battle. The next morning he awoke at first light to write, using a quill pen and a dead Russian's account book. He lay on the ground, until a friendly officer created a desk for him, a plank across two barrels. Russell questioned officers and enlisted men and pieced together many points of view in a broad, detailed narrative. His dis-patch, like all of his stories from the Crimea, took the form of a letter to Delane in vivid, clear, plain English. Appearing in the *Times* on October 10, it was entirely supportive, ignoring supply problems, weak command, and war brutality. His next letters corrected the imbalance, as he described how surgeons worked "with humane barbarity."

Russell had the talent to find colorful yet truthful details that appealed to a British audience.

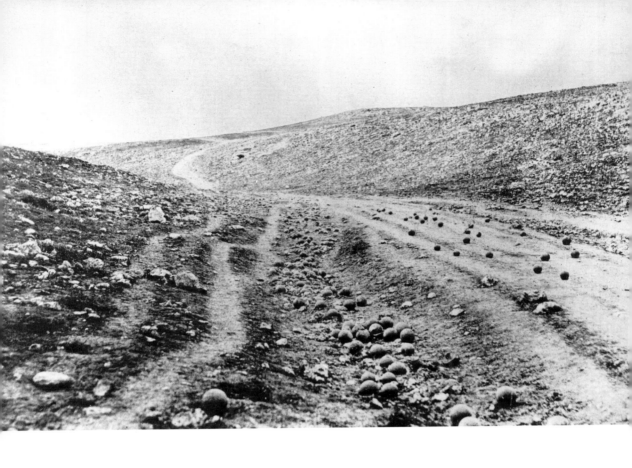

After the Russian retreat to Sebastopol, the Allies marched southeast and occupied Balaklava Harbor, where they seized guns and supplies. From Balaklava they began to bombard Sebastopol. On October 25 the Russians launched an assault on Allied lines in an area lightly defended by Turks. Russell observed from a fine vantage point atop a ridge. The Russians routed the first line of defense. The Turks fought bravely for two hours before being driven back, then faced the 93rd Highlanders, hastily assembled by Sir Colin Campbell, the only troops between the oncoming Russians and the British base at Balaklava. Russell recorded that the Russians "drew breath for a moment, and then in one grand line dashed at the

In 1855 Roger Fenton photographed the battle scene above and called it "The Valley of the Shadow of Death." Following pages: The first picture taken of wartime dead was by Felice Beato after the slaughter at Secundra Bagh palace during the Indian Mutiny of 1857. Historians believe that locals rearranged the mutineers' skeletons to improve the photograph.

Highlanders... gathering speed at every stride, they dash on towards that thin red streak topped with a line of steel." The phrase became a Victorian cliché, altered slightly into "the thin red line" that separated order from chaos.

In the second British action of the day, Gen. Sir James Yorke Scarlett led the men of the British Heavy Cavalry Brigade in a gallant, if unwise, uphill charge. The Russians halted and retreated. British and Russian roles were reversed in the next phase of battle. Lord Raglan issued a vaguely worded order for the Light Brigade to move forward and prevent the Russians from removing captured Turkish cannons from nearby earthworks. The commander of the Light Brigade, Lord Cardigan, evidently misunderstood the order to mean that he should charge Russian batteries at the far end of the valley. His men charged straight into Russian fire.

Russell wrote this report to the *Times:* "At ten minutes past eleven, our Light Cavalry Brigade advanced.... At a distance of 1200 yards the whole

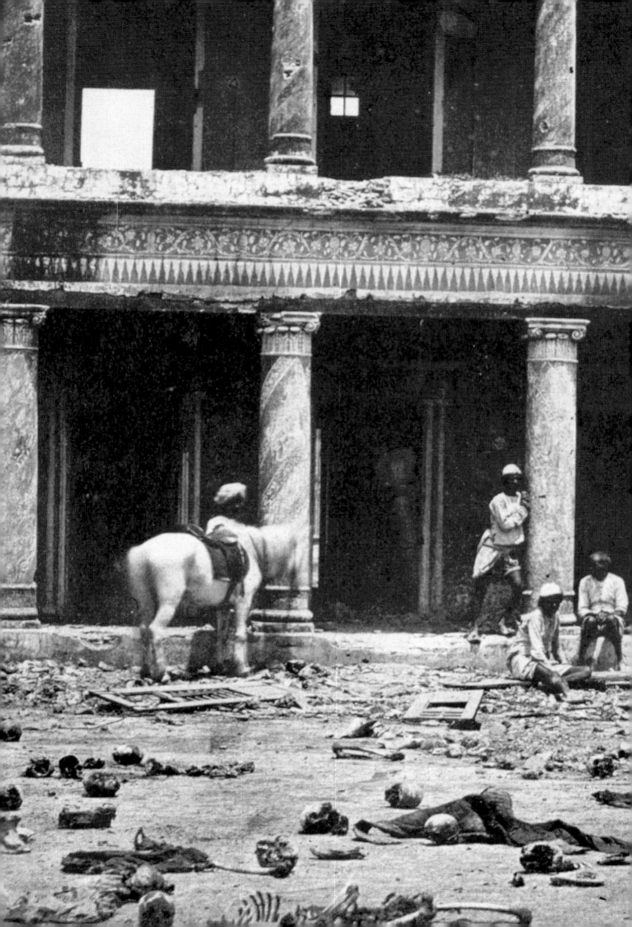

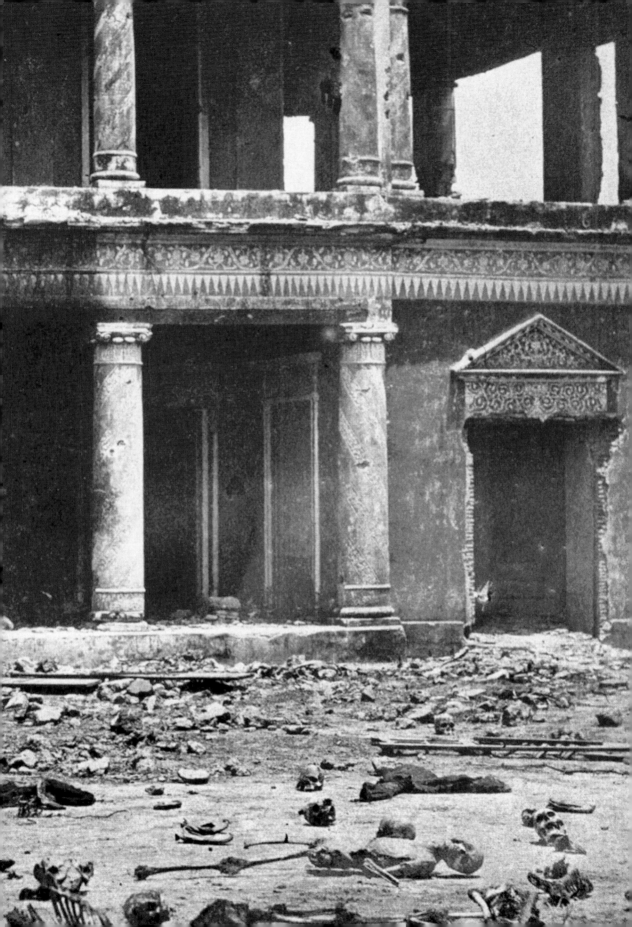

THE UNITED STATES CIVIL WAR
1861-1865

BRITISH NORTH AMERICA

PACIFIC OCEAN

WASHINGTON TERRITORY

OREGON

DAKOTA TERRITORY

MINN.

WIS.

MICHIGAN

NEW YORK

VT.

N.H.

Boston
MASS.
R.I.
CONN.

NEVADA TERR.

UTAH TERRITORY

NEBRASKA TERRITORY

IOWA

Chicago

IND.

ILL.

OHIO

PA.

N.J.

New York

Philadelphia

Baltimore MD.

DEL.

CALIFORNIA

COLORADO TERRITORY

KANSAS

MO.

KY.

VA.

WASHINGTON

FREDERICK

RICHMOND

COLD HARB

SIEGE OF PETERSBU
mid June 1864-
early Apr. 1865

CHANCELLORSVILLE
May 1-4, 1863

GETTYSBURG
July 1-3, 1863

ANTIETAM
(Sharpsburg)
Sept. 17, 1862

1ST AND 2ND MANASSAS
(Bull Run)
July 21, 1861;
Aug. 29-30, 1862

WILDERNESS
May 5-6, 1864

APPOMATTOX COURT HOUSE
Apr. 9, 1865

N.C.

NEW MEXICO TERRITORY

PUBLIC LAND STRIP

INDIAN TERRITORY

Boundary of Confederate States

CHICKAMAUGA
Sept. 19-20, 1863

Chattanooga

Memphis

TENN.

ARK.

S.C.

SHILOH
Apr. 6-7, 1862

MISS.

ALA.

Atlanta

GA.

Savannah

Charleston
FORT SUMTER
Apr. 12-13, 1861

SIEGE OF VICKSBURG
May 18-July 4, 1863

Vicksburg

Mobile

CHATTANOOGA
Nov. 23-25, 1863

ATLANTIC OCEAN

TEXAS

LA.

FLA.

New Orleans

MEXICO

miles 0 — 400
km 0 — 600

State and territory boundaries as of late 1861

Legend:
- Slave states that seceded
- Slave states and regions remaining in the Union
- Free states
- United States territories
- Selected major battle

line of the enemy belched forth, from thirty iron mouths, a flood of smoke and flame, through which hissed the deadly balls.... With a halo of flashing steel above their heads, and with a cheer that was many a noble fellow's death-cry, they flew into the smoke of the batteries, but ere they were lost from view the plain was strewed with their bodies and with the carcasses of horses.... Wounded men and dismounted troops flying towards us told the sad tale.... At thirty-five minutes past eleven not a British soldier, except the dead and dying, was left in front of those bloody Muscovite guns."

It was a disaster. The charge began with 673 men. Fewer than 200 returned. Yet Russell's words inflamed British pride, and the *Times's* circulation swelled to over 70,000. Alfred, Lord Tennyson, based his immortal poem on Russell's report:

Half a league, half a league,
Half a league onward,
All in the valley of Death

Rode the six hundred.
"Forward, the Light Brigade!
Charge for the guns!" he said.
Into the valley of Death
Rode the six hundred.

Russell himself was not romantic about death and destruction. He wrote in his diary three years later, "War, war, let no women or poets deify thee— motherhood and poetry die in thy bloody strife." In his dispatches he detailed the spread of cholera, dysentery, and camp fevers, as well as the lack of medical facilities for the sick and wounded. During the winter of 1854-55, he also wrote of flimsy tents and clothing inadequate for the Russian icebox. British soldiers in the trenches, huddled in mud and water sometimes a foot deep, had meager rations and no fuel in the treeless Crimea. Many died of exposure. To the *Times's* credit, it supported disclosure, stating, "The people of England will look for safety in publicity rather than concealment." The

same held true for deficiencies of leadership. Russell described Raglan as incompetent and army organization as poor. But the British government did not want to hear such truths. The Secretary for War and Prince Albert denounced Russell's letters and complained privately about "that detestable *Times.*" Queen Victoria said the newspapers had disgraced themselves. She later softened her opinion.

Reporter Thomas Chenery, the *Times* correspondent in Constantinople, echoed Russell. In a dispatch published October 12, 1854, Chenery described the Scutari army hospital: "Not only are there not sufficient surgeons—that, it might be urged, was unavoidable—not only are there no dressers and nurses—that might be a defect of system for which no one is to blame—but what will be said when it is known that there is not even linen to make bandages for the wounded?" He asked who had "so greatly neglected their duty." Florence Nightingale responded to both Russell's and Chenery's stories. "I do not mean to say I believe the *Times* accounts, but I do believe that we may be of use to the wounded wretches," she wrote a friend, the wife of the war secretary, Sidney Herbert, who then asked her to form a government nursing service for the Crimea. She became "the lady with the lamp" who ministered to the wounded with a relief fund set up by the *Times.*

On September 8, 1855, the Allies again attacked Sebastopol. Using synchronized watches for perhaps the first time in military history, three French columns surged forward and captured one stronghold. The Russians evacuated Sebastopol, and the war in the Crimea was effectively over. But soon the government that Russell had criticized fell from power. In January 1855, a radical member of the House of Commons introduced a motion that amounted to a vote of no confidence. When Lord Aberdeen's government lost by an astonishing vote of 305-148, he resigned, replaced by Lord Palmerston. Aberdeen's war secretary told Russell later, "It was you who turned out the government." The final treaty was signed in the spring of 1856. Weeks before the end, Britain's new commander-in-chief, Sir William Codrington, drafted an order to expel reporters whose writings might help the enemy. It came too late to be enforced.

Earlier, the British government had taken a different approach to counter Russell and the *Times*'s criticisms. Pictures could not lie, believed the government. They could offset words. The result was wartime photojournalism. Photographers had gone to war before. In the Mexican-American War, one adventurous photographer used Frenchman Louis Daguerre's process to create a handful of images, but his photographs could not be reproduced. Improvements by the mid-1850s allowed multiple prints from glass negatives using the collodion, or wet-plate, method. Entrepreneurs sold original prints of the Crimean War, and sketches from them illustrated newspapers and magazines. In March 1854 amateur photographer Gilbert Elliott sailed on a naval vessel. His pictures of fortifications received wide acclaim for their sharpness, but Elliott was no journalist.

The first Crimean War photographer probably was Karl Baptist von Szathmari, a painter in

21

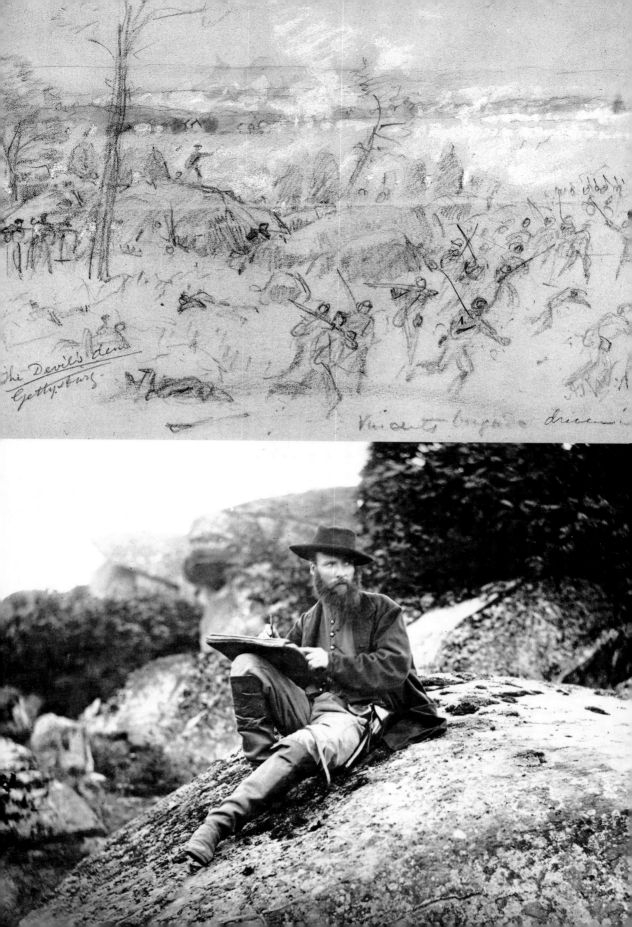

The Devil's den
Gettysburg.

Vincent's brigade driven

Bucharest who had a camera, but all but one of his portraits and images of camp life have been lost. Roger Fenton, an Englishman who helped found the Photographic Society of London and took pictures of the Royal Family, did take significant Crimean photographs that still exist today.

Late in 1854, the British War Office turned to London publisher Thomas Agnew and Sons for photographs to refute the *Times* reports. Agnew hired Fenton. With letters of introduction from Prince Albert, Fenton gained access to the officers who had snubbed Russell. Although Fenton found camps in the Crimea "one great pigsty," his pictures convey an image of calm and command. Fenton traveled throughout the southern Crimea in 1855 in a former wine wagon. Its light color, chosen to reflect the heat, made it a constant target. Stored inside were Fenton's five cameras, lenses including one with a focal length of 20 inches, 700 glass slides, photographic chemicals, a still to purify water, and equipment to print and develop. The wagon had to be pulled to within a hundred yards of whatever Fenton wished to photograph. To make a picture, he first would prepare a glass slide with light-sensitive chemicals. Exposed plates had be developed within five minutes, even faster in the heat of summer. A particle of dust could ruin everything.

Exposures required 3 to 60 seconds, which ruled out action shots. While Fenton's subjects had to freeze, his pictures of people do not seem awkward. He photographed a staged meeting of the French, English, and Turkish military leaders—all wearing dandified headgear and sitting at a cloth-covered table. His most famous image had no people in it. Entitled "The Valley of the Shadow of Death," it showed in detail a barren, rocky ravine behind a landmark that the Russian Army constantly bombarded. It is often confused with the scene of the charge of the Light Brigade, but Fenton had reasons not to picture the valley chronicled in Russell's famous dispatch and Tennyson's poem. He visited there but was so horrified he did not unpack his camera. "We came upon many skeletons half buried," Fenton wrote in a letter. "One was lying as if he had raised himself upon his elbow, the bare skull sticking up with still enough flesh left in the muscles to prevent its falling from the shoulders. Another man's ... hands were out of the ground and the flesh gone."

The first photographer to portray war death was Felice Beato. Primarily a landscape photographer, Beato photographed Lucknow, India, after the Indian Mutiny of 1857, which began when the colonial government changed policies toward the Sepoys, Indians serving under the British in the East India Company army. Rumors that the cartridges for new British Enfield rifles were greased with pork and cow fat, unclean for both Hindus and Muslims, turned Sepoy unrest into rebellion. They rose and murdered their officers at Meerut on May 10, 1857. Local rulers supported the mutiny, which spread to Lucknow, Cawnpore, and Delhi. Beato's "Interior of the Secundra Bagh after the Slaughter of 2000 Rebels by the 93rd Highlanders and the 4th Punjab Regiment, 1857, Lucknow" depicts a European-style

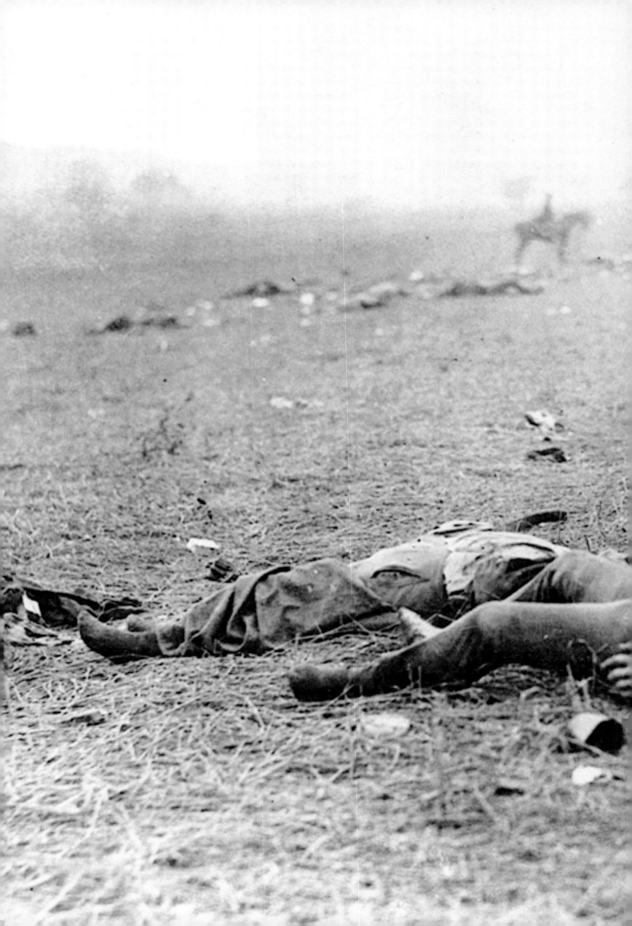

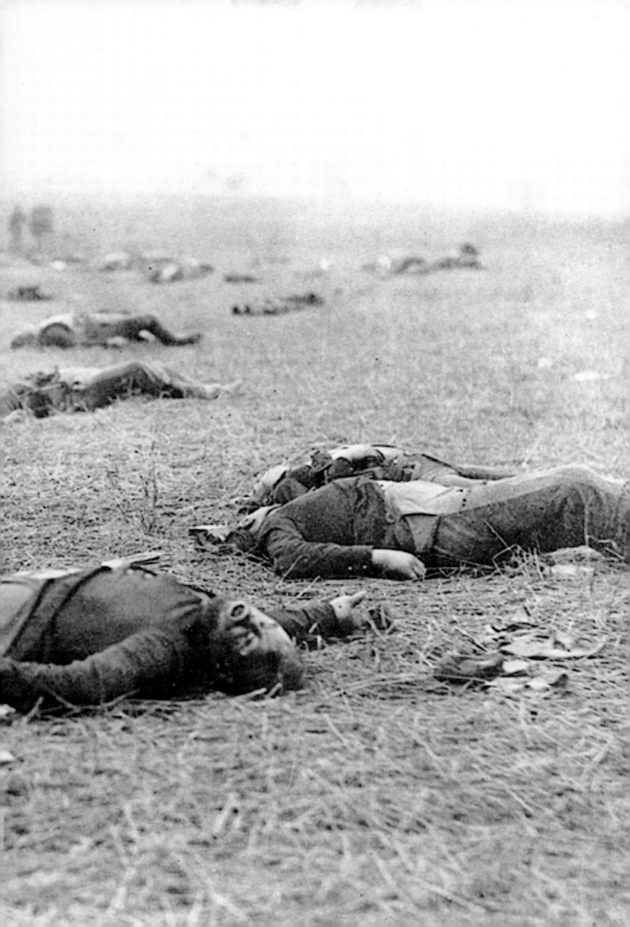

pavilion with a macabre foreground. Historians think that Beato had local Indians arrange the mutineers' skeletons and pose by them to create a photograph that would appeal to public memory.

The desire to improve on reality tempts many a journalist who goes to war. In early war coverage, though, the journalists with courage to share the truth had the most impact. The power to shape public opinion lay in an independent and often critical press. Nearly 50 years later, one Crimean War correspondent wrote that with their work, he and his colleagues "brought home to the War Office the fact that the public had something to say about the conduct of wars."

William Howard Russell traveled to other wars— the Indian Mutiny, the American Civil War, the Franco-Prussian War of 1870-71, and the Zulu War of 1879. He went to America early in 1861 and chatted with President Abraham Lincoln, who told him that the London *Times* was the greatest force in the world "except, perhaps, for the Mississippi River." Secretary of State William Henry Seward and other government officials wooed him in hopes of winning *Times* support for the North. After one battle, though, they saw Russell as a persona non grata.

The American Civil War exploded soon after the election of Republican Party candidate Abraham Lincoln as President. The conflict was fueled by long-simmering questions over slavery and differences between the agrarian culture of the South and the industrial culture of the North. Lincoln's election was the final straw, and southern states seceded in early 1861 to form the Confederates States of America. In April their President, Jefferson Davis, moved his capital to Richmond, Virginia. The war began in April 1861 with the Confederate attack on Fort Sumter, held by a small Federal garrison in South Carolina's Charleston Harbor. The North and South began training armies. Horace Greeley's *New York Tribune* called for action: "Forward to Richmond! Forward to Richmond! The Rebel Congress must not be allowed to meet there on the 20th of July."

On July 16, the Union Army approached the key railroad junction at Manassas, Virginia. Russell went along, following rumors of a great battle. He encountered Pennsylvania militiamen marching east because their three-month enlistment had expired. At about three o'clock, Russell rode toward the guns.

At that point the battle—called Manassas by the South and Bull Run by the North—was going well for the Union. Reporter William Shaw telegraphed the *New York Herald* that the rebels were "totally routed." Two hours later, Union Gen. Irwin McDowell sent a similar report to the War Department in Washington, which was then telegraphed to the nation's newspapers.

New York papers hit the streets with "extras" proclaiming a Northern victory. Henry Raymond, a *New York Times* editor who had been a war correspondent in the Austro-Italian War of 1859, wired a report that "the enemy's guns and equipment are in the hands of our forces." He returned to find that the battle had turned, the South had won, and Federal troops had simply walked off the field. Raymond tried to wire news of the reversal, but the State and

War Departments censored all dispatches from Bull Run until the next morning.

Russell did not see the battle. He was stopped three miles east of the engagement by the rush of humanity in full retreat: Union soldiers, civilians on horseback, government officials and their wives who had been watching the sport of war. Russell kept trying to force his way toward battle only to be pushed back by carts, horses, and soldiers on the run. "There was no choice but for me to resign any further researches," he wrote. Alarmed, Russell sent a factual, insightful report to the *Times* by packet boat.

Four weeks later, Russell's story appeared in newspapers in the States. American memory had grown foggy, and Russell was accused of grossly exaggerating the panic. Some Northern editors said he had lied, others that he had led the retreat, but Gen. William Tecumseh Sherman, a veteran of the battle, vouched for his reporting. Still, Russell was denied permission to travel with Union troops, and he returned to England.

During the four-year-long Civil War, both sides sought to reap the benefits of war correspondence without suffering the drawbacks. As the first mass effort at censorship was being organized, readers worldwide clamored for fresh news. The North imposed strong censorship in 1862 as President Lincoln allowed newly appointed Secretary of War Edwin Stanton to reroute telegraph lines into the room next to his office. Stanton created a secret police force, presided over political arrests, and made the War Department off-limits to reporters. In 1864 he began sending his own war press releases over the wires. The South also had its forms of censorship. Nevertheless, war coverage dominated the pages of American and European newspapers.

About 50,000 miles of telegraph wires had been strung in the eastern states by the start of the war. At least 350 reporters covered the war for the Union, 150 for the Confederacy. Some newpapers hired "specials"—soldiers paid to write letters for publication. Papers took war stories from one of the new

cooperatives, such as the New York Associated Press, started in 1848 and destined to become the modern AP wire service. In the South, the Southern Associated Press and the Press Association of the Confederate States of America played a similar role.

The war was extensively photographed. Southern photographers, lacking in financial resources and deprived of photographic material by the Union blockade, concentrated on portraits. From his offices in the North, Mathew Brady directed a group of photographers. Using the long-exposure, collodion process, they took startlingly sharp pictures. An exhibit of the Brady Studio's 1862 images of Antietam, the first to show the carnage of a major battle, caused a sensation in New York.

Artists also drew scenes of camp life and battle. *Frank Leslie's Illustrated Newspaper* published more than 3,000 war-related images during the four-year conflict. Frank Vizetelly sketched the war from the Southern side for the *Illustrated London News,* whose circulation swelled to 300,000 copies per week in 1863. British brothers Alfred and William Waud also were field artists, Alfred for the *New York Illustrated News,* then *Harper's Weekly,* and William for *Frank Leslie's* and *Harper's.* William Waud sketched Confederate President Davis's inauguration.

The list of war correspondents included poet Walt Whitman, already celebrated for *Leaves of Grass,* who worked in Northern hospitals and wrote letters about the wounded to the *New York Times* and the *Brooklyn Eagle.* Winslow Homer drew scenes of camp life for *Harper's Weekly.* Thomas Nast—later creator of the Democratic donkey and the Republican elephant—honed his skills during the Civil War. His iconic Santa Claus first appeared in *Harper's,* visiting Union troops.

"Telegraph fully all news you can get and when there is no news send rumours," the *Chicago Times* ordered its correspondent. But the telegraph was unreliable. Troops cut lines; rival papers monopolized the wires. The correspondent who first arrived at a telegraph line often held it while finishing a story.

Northern reporters faced unsympathetic Union officers. Gen. Henry Halleck kicked 30 out of his camp. Grant tried to have William Swinton of the *New York Times* shot for revealing too much about military movements. The notoriously ill-tempered Sherman wanted to hang Thomas W. Knox of the *Herald,* but a board of officers merely expelled him. Still, Sherman considered most reporters "a dirty set of scribblers who have the impudence of Satan" and ought to be treated as spies.

Battlefield reporting was dangerous. Lorenzo Crounse of the *New York Times* had two horses shot out from under him. A *Herald* reporter died of illness after covering Vicksburg, another by falling from a Union gunboat. A Southern soldier-correspondent at Vicksburg said the Union blockade had cut off food supplies, turning rats into dinner. *Tribune* reporter George Washburn Smalley suffered bullet injuries to get the story acclaimed as the best of the war, written after he witnessed the bloodiest day in American history in a remote corner of Maryland.

The Battle of Antietam, called Sharpsburg by the Confederates, pitted the armies of Union Gen. George McClellan against those of Confederate Gen. Robert E. Lee. Fresh from a string of victories over invading Federal Armies in Virginia, Lee planned to launch a major raid into the North. Low in manpower and supplies, Lee's army marched down the Shenandoah Valley and crossed the Potomac into Maryland in September 1862. In a windfall, the Northern Army had found Southern operational orders wrapped around a bundle of lost cigars, yet McClellan failed to coordinate attacks and the battle ended in a draw. Technically Lee held his position, but McLellan's troops inflicted casualties heavy enough that Confederate forces withdrew.

Smalley watched the campaign amid a hail of bullets as he ran errands for Union Gen. Joseph Hooker. He rode six hours after dark to the nearest telegraph office, where he sent a short dispatch to Washington. Lincoln and Stanton read it before sending it to the *Tribune.* Yet to write the full story, Smalley caught

one train to Baltimore, then a military train to New York. He wrote by oil lamp and handed his manuscript to compositors at the *Tribune* at five a.m. It was two nights and a day after he had left Antietam; still the paper was the first on the streets of New York with full news of the battle. Fourteen hundred papers reprinted the story. Lincoln's personal secretary said it was better than any official dispatch.

"The battle began with the dawn," Smalley wrote. "Morning found both armies just as they had slept, almost close enough to look into each other's eyes. The left of Meade's reserves and the right of Rickett's line became engaged at nearly the same moment, one with artillery, the other with infantry. A battery was almost immediately pushed forward beyond the central woods, over a plowed field.... On this open field, in the corn beyond, and in the woods which stretched forward into the broad fields, like a promontory into the ocean, were the hardest and deadliest struggles of the day."

Smalley blamed McClellan and another general, Ambrose Burnside, for mismanaging the battle, but admired the courage of General Hooker, who rode ahead to survey the land near a woods where "the musketry fire" was "extremely hot" and "the air was alive with bullets," as Smalley put it. "As [Hooker] put his foot in the stirrup a fresh volley of rifle bullets came whizzing by," he reported. "Remounting on this hill he had not ridden five steps when he was struck in the foot by a ball. Three men were shot down at the same moment by his side.... He kept on his horse for a few moments, though the wound was severe and excessively painful, and would not dismount till he had given his last order to advance."

Henry Wing, a cub reporter for the *New York Tribune,* disguised himself as a plantation owner and moved freely between Northern and Southern camps. He was the first journalist with the full story of the

Battle of the Wilderness in May 1864, when for two days the armies of Grant and Lee fought brutally in tangled thickets near central Virginia's Rapidan River. When the underbrush caught fire, many on both sides suffocated or burned to death. Wing tried to wire his dispatch of the carnage from the small town of Union Mills, but censors blocked it, and Stanton ordered him arrested as a spy.

Lincoln countermanded the order. The President had been waiting three days for a battle report from Grant. Lincoln telegraphed to ask Wing to report to Washington. Wing requested, and received, permission first to send one hundred words to the *Tribune.* In Washington the next day, Wing privately shared what he knew, including a message from Grant to Lincoln that "there would be no turning back." That was what Lincoln wanted to hear. He kissed Wing in jubilation.

Wing also scooped the news of the Southern surrender at Appomattox in April 1865. Before Grant and Lee entered the farmhouse where the surrender was to occur, Wing had arranged for a Union officer to mop his brow three times if Lee capitulated as expected. Seeing the signal, Wing rode away to file a two-word bulletin: "War over."

Soldier-correspondents, although less reliable than journalists, had their moments. Cpl. James Henry Gooding, a whaler who joined the 54th Massachusetts Volunteers, wrote letters to the *New Bedford Mercury* about his regiment of black troops, filling letters with details of their hot, sweaty patrols in South Carolina. "If a person were to ask me what I saw of the South, I should tell him stink weed, sand, rattlesnakes, and alligators."

Gooding took part in the assault on Battery Wagner, which guarded Charleston Harbor. As depicted in the film *Glory,* soldiers from three Union brigades died trying to take the fortress, which never fell. Gooding said that one black soldier told his white commanding officer, Col. Robert Gould Shaw, "I will stay by you till I die." Gooding himself was captured in 1864 and died in prison at Andersonville.

Following pages: Mathew Brady's Studio is credited for this image of the ruins of a flour mill in Richmond, Virginia, at war's end in April 1865.

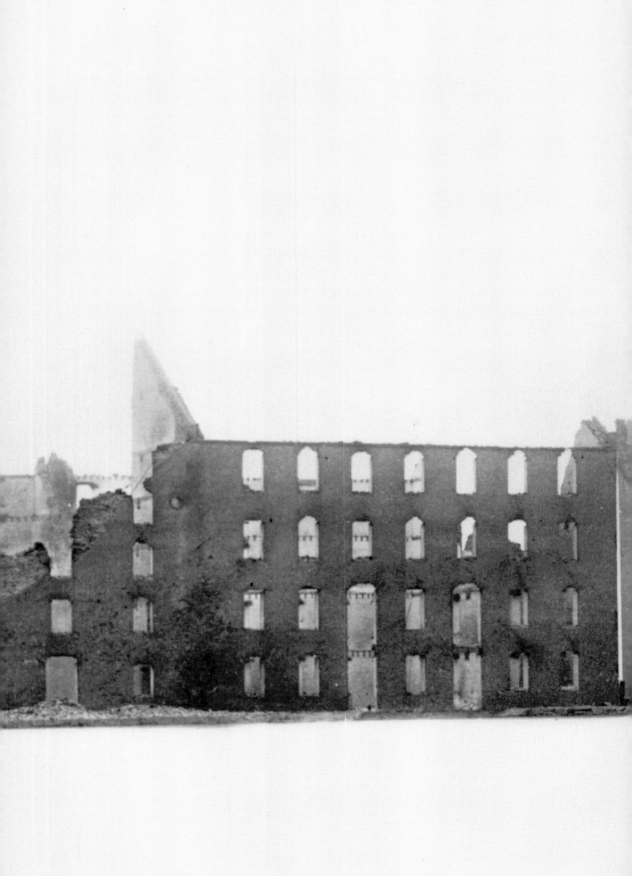

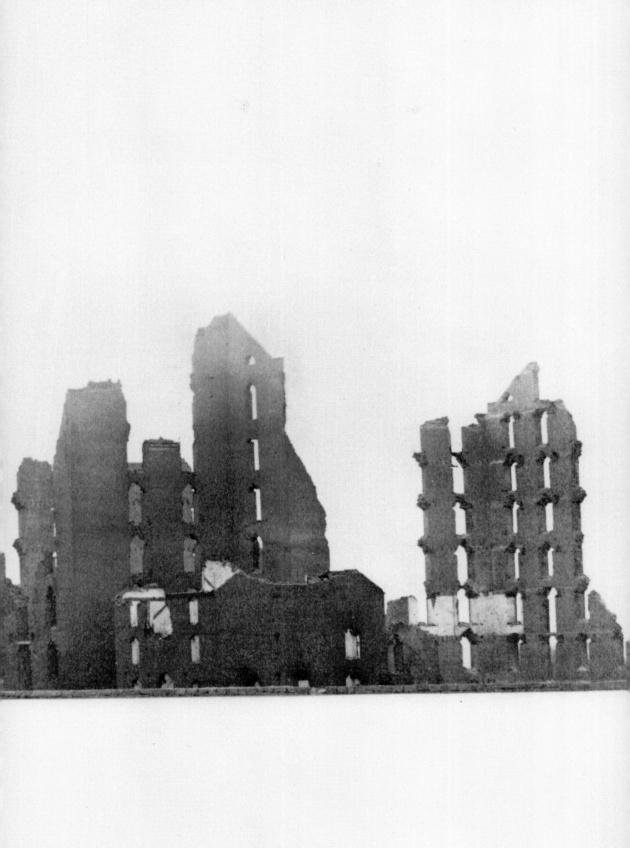

ALEXANDER GARDNER

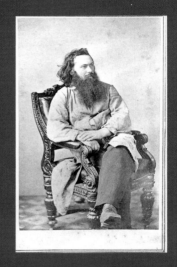

AN EXPERT IN WET-PLATE PHOTOGRAPHY, Scottish-born Alexander Gardner (1821-1882) sailed to New York in 1856 to work for Mathew Brady. Gardner began managing Brady's gallery in Washington two years later. Working out of a darkroom wagon, he took many of the early war photographs often attributed to Brady. Gardner opened his own Washington gallery in the spring of 1863. He disliked having his picture taken, but posed for a *carte de visite,* above, at that time. He copied maps for the secret service and occasionally photographed battle scenes. Many famous photographs were produced by his employees, including his son, James, and Timothy O'Sullivan. Gardner took a job as photographer for the Union Pacific Railroad after the war and died "of a wasting disease."

Gardner's *Photographic Sketch Book* (1866), above, was the first published collection of photographs of the Civil War. The artistically inclined Gardner refused to reduce his images to woodcut engravings. Instead, the one hundred images were positive prints pasted onto the pages. The cost of the sketch book proved too high, and memories of the war too fresh, to make the product a commercial success.

Mortar Dictator.

...

THIS monster mortar, cast by Mr. Charles Knapp, at his celebrated iron works in Pittsburg, Pa., was used for a short time in the summer of 1864, during the siege operations in front of Petersburg. Owing to its immense weight, 17,120 pounds, it was transported from City Point on a railway truck along the City Point and Petersburg Railroad, to a point in the ravine in rear of what is now generally known as Battery No. 5, near the Jordan House, a side track from the main road being constructed especially for the purpose of moving it. The position selected from which to fire it, was admirably concealed from the ever-vigilant eye of the enemy. The truck was so strong and substantially built as to answer as a platform for the mortar.

The Dictator is a 13-inch mortar, firing a shell weighing two hundred pounds, with a charge of twenty pounds of powder. At an angle of elevation of forty-five degrees the range is set down in the Ordnance Manual at 4,325 yards; but, if it is true that the shell thrown by it reached Centre Hill, in Petersburg, as the writer was informed by a very reliable gentleman of that city, then it must have been carried at least 2.7 miles, or 4,752 yards. The bursting of the shell was described as terrific, an immense crater being formed in the ground where it fell, and earth, stones, and sod being scattered in every direction, much to the consternation of the inhabitants of the place.

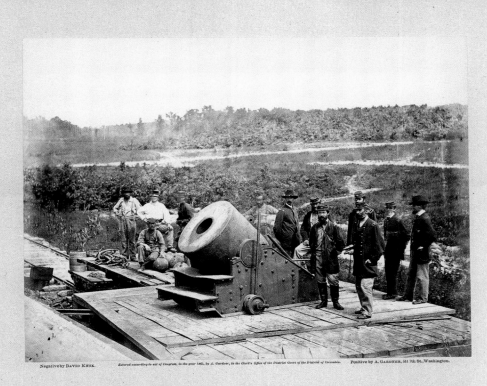

Negative by DAVID KNOX. Entered according to act of Congress, in the year 1865, by A. Gardner, in the Clerk's Office of the District Court of the District of Columbia. Positive by A. GARDNER, 511 7th St., Washington.

MORTAR DICTATOR, IN FRONT OF PETERSBURG.

October 1864.

Gardner's sketch book, above, mixed photographs
he took for Brady as well as for his own studio.
The result is a historical record—not only of the war,
but also of Gardner's fiercely pro-Union sympathies.
Captions referred to Southerners as "rebels" with
a small "r" and to Northerners as "patriots." Above
right, a 17,120-pound "Mortar Dictator" fired a
200-pound shell.

"IT WAS RICHARD HARDING DAVIS WHO GAVE US OUR FIRST OPPORTUNITY TO SHOOT BACK WITH EFFECT. HE WAS BEHAVING PRECISELY LIKE MY OFFICERS."
Col. Theodore Roosevelt, Rough Rider

CHAPTER TWO

"SPLENDID
LITTLE WARS"

CHAPTER TWO

STEPHEN CRANE AND RICHARD HARDING DAVIS were drinking in Ponce, Puerto Rico, on July 25, 1898, the first day of its occupation by American troops, and discussing their "splendid little war"—the sobriquet coined by Col. Theodore Roosevelt for the war declared by the world's newest great power on a crumbling Spanish Empire.

The conflict began in 1895 when Cubans rose against Spanish rule. In January 1898 a wary America sent the battleship U.S.S. *Maine* to Cuba to protect her interests. A month later the *Maine* mysteriously exploded. America blamed Spain, pursued its holdings, and had wrested control in Cuba and the Philippines by July 1898. As Davis and Crane saw it, little stood in the way of a walkover in Puerto Rico. Spanish troops offered token resistance; the natives welcomed the liberators. It seemed that anyone could capture a town merely by marching into it. The idea fermented in the mind of Davis, the most gentlemanly and sporting of journalists.

39

Preceding pages: Alphonse Marie de Neuville's "Le Bourget" depicts French soldiers leaving a church surrounded by conquering Prussians in the Franco-Prussian War of 1870-71. New York Journal *publisher William Randolph Hearst, left, is lampooned in 1898 as a warmongering version of the Yellow Kid—the comic strip character for whom "yellow journalism" is named.*

Capturing a Puerto Rican town would be the kind of action Crane craved. Over drinks, the two men agreed that at sunrise they would conquer Juana Diaz, a village midway between Ponce and Coamo. Davis slept in; Crane went by himself. The mayor handed him the keys to the jail, and Crane divided the town's men into two groups. "Anyone of whose appearance Crane did not approve... was listed as a 'suspect,'" Davis wrote later. "The 'good fellows' he graciously permitted to act as his host and body-guard." American troops arrived the next day. Crane boasted that he had captured the town by himself. Shortly afterward, when Davis and three other correspondents rode into Coamo ahead of the American advance, the mayor surrendered the town flag, and for 20 minutes Davis was military governor.

The Spanish-American War was representative of late-19th-century Wars of Empire. Major powers such as Britain, Germany, and Russia expanded colonial holdings and faced native resistance. From Puerto Rico to Africa, wars broke out—in the public eye, "splendid little wars" of adventure, romance, even chivalry. The news story drove it all. Reporters didn't just observe the news—they helped make it. For the sake of a story, *New York Journal* owner William Randolph Hearst sent a reporter to present a gold-plated sword to a rebel leader in Cuba. Such stories made combat at the end of the 19th century seem like a dashing escapade.

Correspondents and the military generally agreed that war reporting required discretion. Davis criticized a peer's exposure of U.S. soldiers' poor

equipment and clothes in the Spanish-American War—such facts should not be revealed in wartime. If he told the truth, he said, "it would open up a hell of an outcry from all the families of the boys who volunteered." Gen. Hector MacDonald promised to give reporters in Sudan "good sport."

During the Franco-Prussian War the telegraph became central to the scoop. American George Washburn Smalley, who wrote the *Tribune* story on Antietam, established bureaus in European capitals to organize news reporting and funnel stories to New York via the new transatlantic cable. Smalley's reporters were in place when France and Prussia, the largest German state, went to war in 1870. Now the *London Daily News* and the *Tribune* shared stories, the first such international arrangement.

In 1866, Prussia had defeated Austria-Hungary in the Seven Weeks' War. Prussian Chancellor Otto von Bismarck united Germany's northern principalities, threatening France's dominance in Europe. French Emperor Napoleon III, alarmed at the new coalition between Prussia and Spain, declared war on Prussia on July 19, 1870.

Napoleon's generals were convinced that recent reorganization and the *mitrailleuse,* an early machine gun, made their army superior to Prussia's. Allying with German states in the south, Prussia gained numerical superiority and efficiently moved 380,000 soldiers to the front in about two weeks.

The French government refused to let reporters accompany armies. Journalists instead gathered information outside military lines or from the more

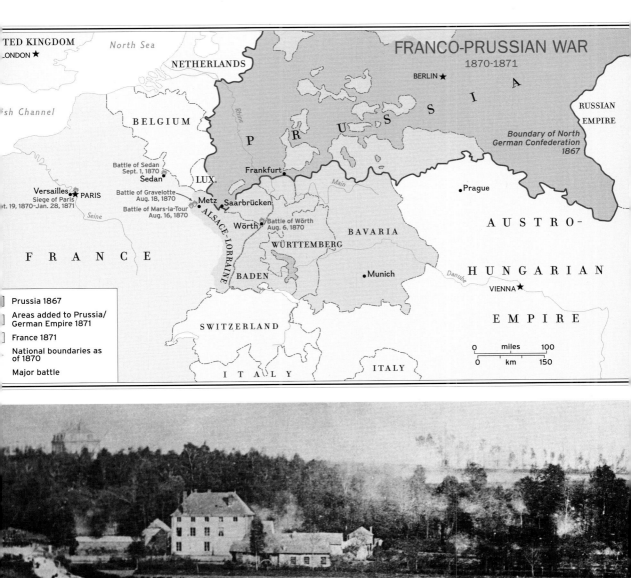

FRANCO-PRUSSIAN WAR
1870-1871

UNITED KINGDOM
LONDON ★

North Sea

English Channel

NETHERLANDS

BELGIUM

P R U S S I A

BERLIN ★

RUSSIAN
EMPIRE

Rhine

Boundary of North
German Confederation
1867

Battle of Sedan
Sept. 1, 1870
Sedan

LUX.

Frankfurt

Prague

Versailles ★ PARIS
Siege of Paris
Oct. 19, 1870-Jan. 28, 1871

Battle of Gravelotte
Aug. 18, 1870

Battle of Mars-la-Tour
Aug. 16, 1870

Metz Saarbrücken

Main

AUSTRO-

Seine

Wörth Battle of Wörth
Aug. 6, 1870

ALSACE-LORRAINE

BAVARIA

F R A N C E

WÜRTTEMBERG

HUNGARIAN

Munich

Danube

BADEN

VIENNA ★

SWITZERLAND

miles 100
0

0 km 150

EMPIRE

Prussia 1867

Areas added to Prussia/
German Empire 1871

France 1871

National boundaries as
of 1870

Major battle

ITALY

ITALY

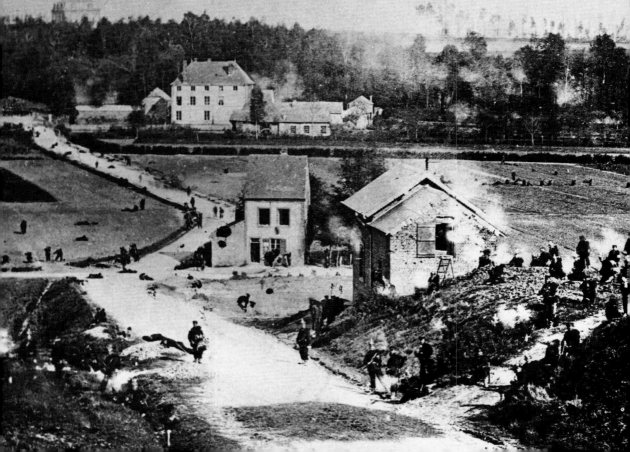

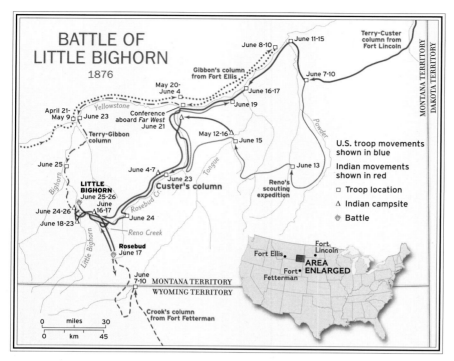

BATTLE OF
LITTLE BIGHORN
1876

June 8-10
June 11-15
Terry-Custer
column from
Fort Lincoln

Gibbon's column
from Fort Ellis

June 7-10

May 20-
June 4

June 16-17

April 21-
May 9
June 23

Yellowstone

June 19

Conference
aboard *Far West*
June 21

Terry-Gibbon
column

Powder

May 12-16
June 15

MONTANA TERRITORY
DAKOTA TERRITORY

June 25

June 4-7

Tongue

June 23
Custer's column

June 13

U.S. troop movements
shown in blue

Indian movements
shown in red

LITTLE
BIGHORN
June 25-26

Rosebud Cr.

Reno's
scouting
expedition

□ Troop location

△ Indian campsite

June 24-26
June
16-17

June 24

June 18-23

Reno Creek

Bighorn

Little Bighorn

Rosebud
June 17

June
7-10

MONTANA TERRITORY
WYOMING TERRITORY

Battle

Fort
Lincoln

Fort Ellis
AREA
ENLARGED

Fort
Fetterman

0 miles 30
0 km 45

Crook's column
from Fort Fetterman

A reconnaissance expedition led by American Gen. George Armstrong Custer in 1874, right, winds through the Dakotas, home to Lakota and Cheyenne. Gold found here compelled the U.S. government to remove the Indians to reservations. In 1876 the Indians rebelled, and in mid-June, map, left, they fought troops under Gen. Alfred Terry at Rosebud Creek. Days later they wiped out Custer's forces at Little Big Horn.

accommodating Prussians. Murat Halstead of the *Cincinnati Commercial* approached German lines in a hay wagon, finding the officers unfailingly polite. Prussia received favorable press coverage—just what Bismarck had in mind.

On August 6, 1870, the French right wing fell back to the west and Prussian forces drove the left wing from its position near Saarbrücken. Heading toward the fortress city of Metz, the French came upon more Germans. After winning two confused and bloody battles at Mars-la-Tour and Gravillote, the Germans withdrew to Metz. The rest of the world knew more about French setbacks than did the French, thanks to the volume of news coming out of Europe. Smalley's network of reporters cabled stories back to London. Syndicate reporter Holt White crossed army lines to file the war's biggest story: the incredible September 1 collapse of the French Army at Sedan in northeast France, the surrender of 83,000 soldiers, and the capture of Napoleon III. White arrived bone-tired at Smalley's London office

and hammered out six columns about the defeat that redrew the map of Europe.

Archibald Forbes, a Scottish freelancer for the *London Morning Advertiser,* had served in the Royal Dragoons. He also knew German. Two weeks after a new French republican government assumed power, in September 1870, the Germans bombarded Paris. French leader Leon Gambetta escaped in a balloon. The Germans cut telegraph and rail lines, then told Forbes they planned to shell Saint-Denis, a suburb. He sent the story to London and at the first cannon's boom yelled "Go ahead!" to the key operator at field headquarters. At the other end of the wire, presses printed the news of the shelling as it happened.

Equally ingenious correspondents were sealed in Paris during the war's final four months. Henry Labouchere's dispatches got to the *Daily News* via French government balloons. Henry Vizetelly reported and sketched from Paris for the *Illustrated London News.* Brother of the Civil War artist, he made three photographs of a drawing to send off in

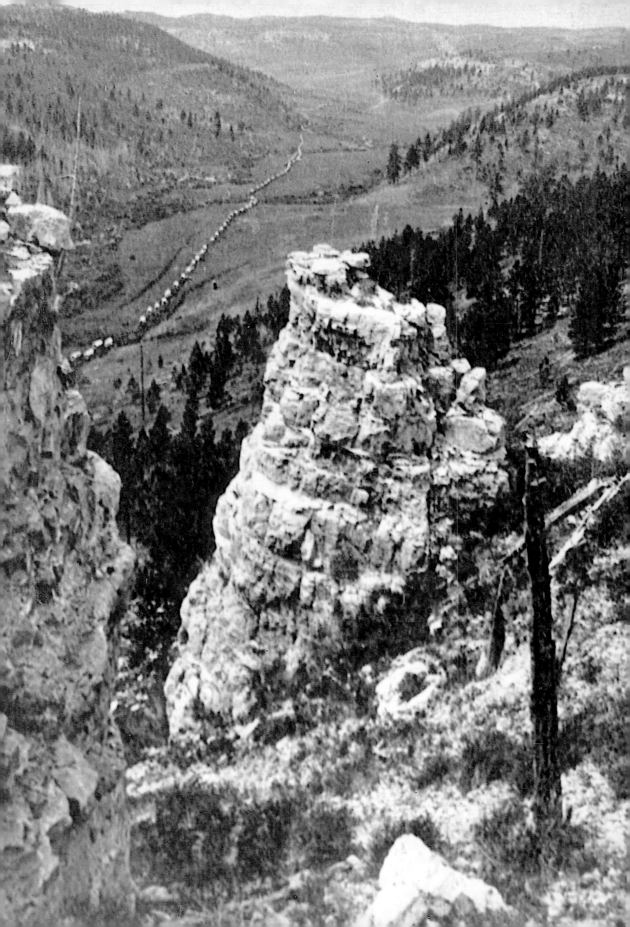

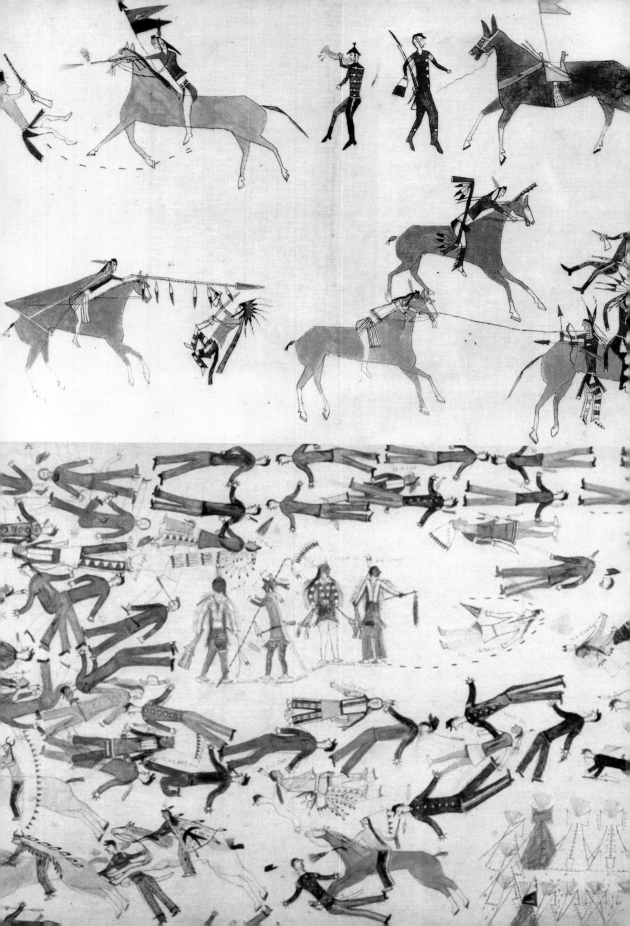

four balloons, hoping that one would get to England. Most did. The Germans kept a stranglehold on Paris, and the city surrendered in January 1871. In the treaty signed at Versailles, France gave Germany five billion francs and control of Alsace-Lorraine.

The siege of Paris was the first major story covered by Januarius Aloysius MacGahan, a *New York Herald* stringer who was thrown into a French prison and sentenced to death, only to be saved by an American diplomat. After the Franco-Prussian War, McGahan befriended members of the Russian court. In St. Petersburg, he heard that the tsar was mustering his army to subdue Khiva, Central Asia's last autonomous Muslim khanate, near the Aral Sea.

In 1717 Peter the Great had begun pressuring the Caspian khanates. In 1839 a second expedition of 5,000 Russians and Cossacks marched into the region, but exposure and lack of supplies forced them to turn back. By the 1860s Russian forces had seized ancient silk-road cities, leaving only Khiva unconquered. The khanate was on the Oxus River, surrounded by desert and hostile tribes, yet General Kaufman was determined to make an assault.

Russian authorities forbade journalists to accompany the troops, but that did not stop the *Herald's* MacGahan. He journeyed to Kazala, but Kaufman and his troops were already 300 miles onto the steppe. MacGahan set out after them on April 30, 1873, with a Tartar interpreter, a guide, and a servant. He chased the Russian Army hundreds of miles east—and was chased in turn by Cossacks with orders to detain him. After 29 days of hard riding, MacGahan found the army at Khiva, surrounded by Turcoman warriors. *"Vui kto?*—Who are you?" a Russian officer demanded. MacGahan replied, *"Americanetz,"* and told his story, to which Kaufman replied, *"Molodyetz*—Brave fellow."

On May 28, the Russians bombarded Khiva's earthen walls with new German-made artillery. The khan fled and Kaufman's troops marched in. MacGahan witnessed the signing of capitulation papers and later interviewed the khan. Next he joined a Russian unit in a punitive raid on the Turcomans. "Down the little descent we plunge, our horses sinking to their knees in the yielding sand, and across the plain we sweep like a tornado," he reported. "It is a scene of the wildest confusion."

In 1867 European powers had forced the Turks to withdraw from Serbia, but the Turkish Ottoman Empire had maintained a foothold in the Balkans. In April 1876 Bulgarian nationalists rebelled. Reports of atrocities by Turkish troops surfaced.

The *London Daily News* published a June 23 story by its Constantinople correspondent, Sir Edwin Pears, that raised many questions. Pears named 34 villages destroyed by the Turks, but he had not investigated the scene for himself. The Turks branded the story a lie, and the conservative British prime minister Benjamin Disraeli accused the *News* of aiding Russia. The *News* hired the fearless, well-connected MacGahan. Scores of eyewitnesses described the slaughter to him. Between 60 and 70 villages had been burned. Thousands had died: Germans, Greeks, Armenians, and even Turks.

45

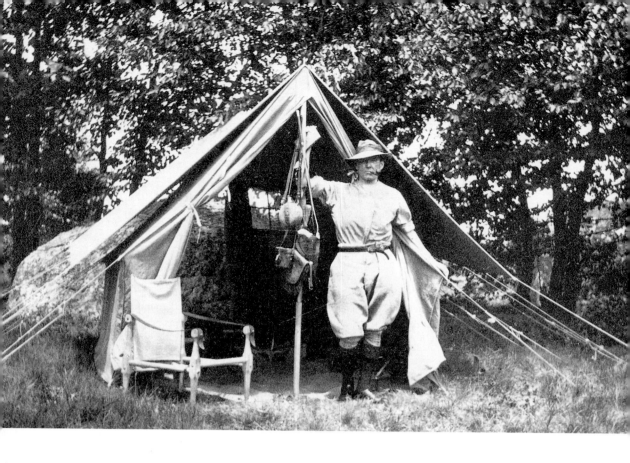

In the town of Panagurishte, he wrote, bearded Turks picked infants up out of their cradles with their bayonets and flung them at their shrieking mothers. Women were subjected to "outrages" in their houses and outside. "We came to an object that filled us with pity and horror," wrote MacGahan. "It was the skeleton of a young girl not more than fifteen ... a sight to haunt one through life." He 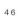 found nearly a thousand corpses in one churchyard, "little curly heads there in the festering mass, crushed down by heavy stones; ... little baby hands stretch out as if for help." The American consul-general in Turkey corroborated the stories, which helped oust Disraeli, put liberal William Gladstone in office, and prompted Christian Russia to defend its co-religionists against Turkey.

In late 1876 Serbia, joined by the tiny province of Montenegro, went to war against the Turks. Bolstered by Russian volunteers, the Serbians drove the Turkish Army back. In April 1877 Russia declared war on Turkey. More than 275,000 marched into Romania while another 70,000 entered the Turkish Caucasus. The Russian advance was massive but inept and lethargic. Desperate, the tsar put Gen. Frantz Todleben, who had brilliantly engineered the defense of Sebastopol in the Crimea, in command. By December the Turks surrendered the city of Plevna. By January 1878 the Russians threatened the Turkish capital and the sultan sued for peace.

The conflict was a challenge to correspondents. Archibald Forbes had started a syndicate of the *Daily News* and the *Herald*, for which MacGahan reported. The Russians accredited about 80 correspondents, insisting at first that the journalists wear bright yellow uniforms. MacGahan objected, and the Army agreed to armbands instead. Journalism independent of Russian control was difficult. To avoid the Russian censor at Bucharest, the *News* set up a pony express over the Carpathian Mountains but used it only once. In general, journalists cooperated with authorities and promised not to reveal military secrets. In return, Forbes received tips from

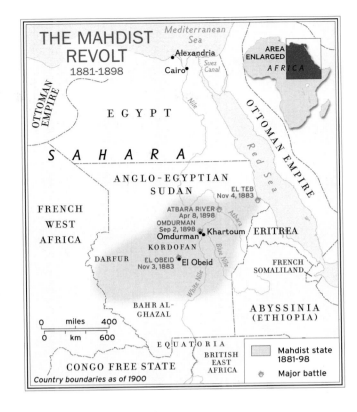

Reporter Richard Harding Davis, left, carried cooking gear, a folding rubber bathtub, and a mosquito head-bag. The Mahdist revolt in North Africa, map, right, was reported by young Winston Churchill. Following pages: Charles E. Tripp's painting depicts Britain's 1879 battle against Zulu warriors.

THE MAHDIST REVOLT
1881-1898

Mediterranean Sea
Alexandria
Cairo
Suez Canal
AREA ENLARGED
AFRICA
OTTOMAN EMPIRE
EGYPT
Nile
OTTOMAN EMPIRE
Red Sea
SAHARA
ANGLO-EGYPTIAN SUDAN
EL TEB Nov 4, 1883
Atbara
ATBARA RIVER Apr 8, 1898
OMDURMAN Sep 2, 1898
Omdurman • Khartoum
ERITREA
FRENCH WEST AFRICA
KORDOFAN
Blue Nile
DARFUR
EL OBEID Nov 3, 1883 • El Obeid
FRENCH SOMALILAND
White Nile
0 miles 400
0 km 600
BAHR AL-GHAZAL
ABYSSINIA (ETHIOPIA)
EQUATORIA
BRITISH EAST AFRICA
CONGO FREE STATE
Country boundaries as of 1900
Mahdist state 1881-98
Major battle

officers about coming battles. After witnessing the start of the attack at Plevna, he reported firsthand to the tsar. For helping wounded soldiers, he received Russia's Order of St. Stanislaus. At first the Turks refused to accept any journalists, but they needed to muster public sympathy. Allowed an intimate view, artist Melton Prior sketched forts on the Bosporus.

The December 1877 siege of Plevna ended the fighting. The Treaty of San Stefano, granting Bulgaria independence, was signed in March 1878. MacGahan dispatched the story. He died of typhoid fever on June 9, three days before his 34th birthday. Fellow correspondents Frank Millett and Frederic Villiers helped lower his body into a grave at Pera, surrounded by dignitaries from 12 nations. Forbes proclaimed him the author of the Russo-Turkish War, and Gladstone cited him and the *News* for revealing Bulgaria's problems. Five years later, MacGahan's body went home, was laid in state in New York City, and was then reburied in his Ohio hometown.

Meanwhile, reports from America's Western Plains were unsettling readers in the East. One day after the centennial of the Declaration of Independence, an Associated Press wire story from Salt Lake City, Utah, said that Gen. George Armstrong Custer and five companies of soldiers had been massacred in Montana. Further reports the next day confirmed the worst.

In the spring of 1876, gold was discovered in the Black Hills of Dakota territory, a region sacred to the Lakota, called Sioux by the whites. The federal government tried to buy the land. The Indians refused. In response, the government ordered the Lakota and their Cheyenne allies onto reservations. They ignored the order; federal troops forced them; and Lakota chiefs Crazy Horse and Sitting Bull led their people, joined by the Cheyenne, in a massive revolt. On March 17, 1876, Brig. Gen. George Crook led a column through the Big Horn Mountains. The Indians drove back Crook's soldiers in fierce fighting. In June, three columns under the

47

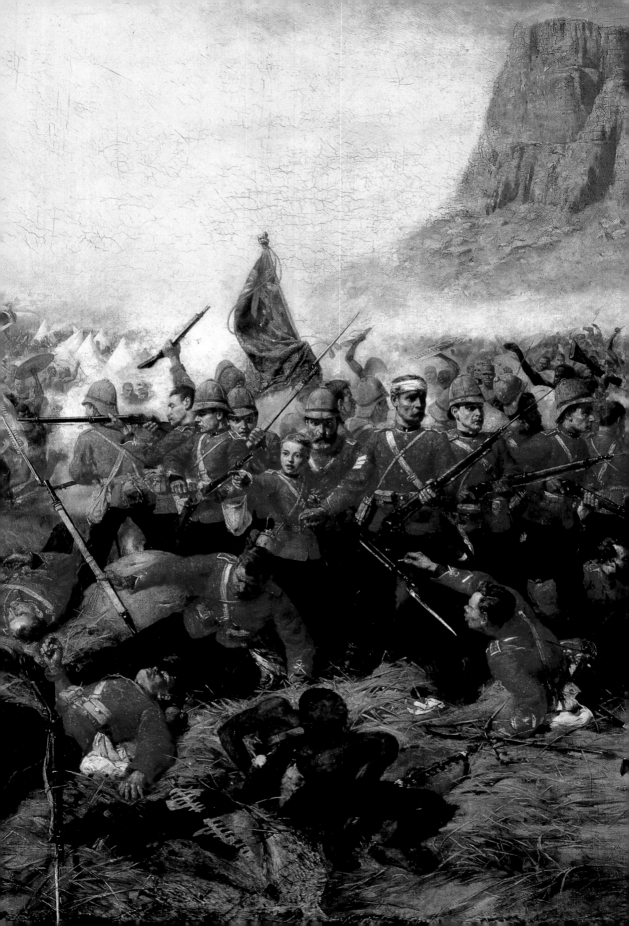

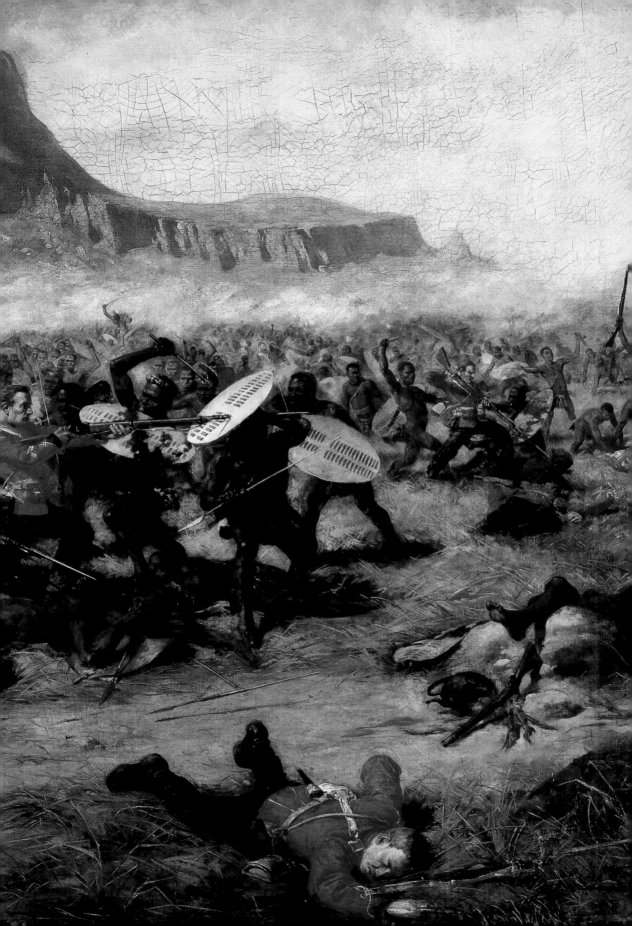

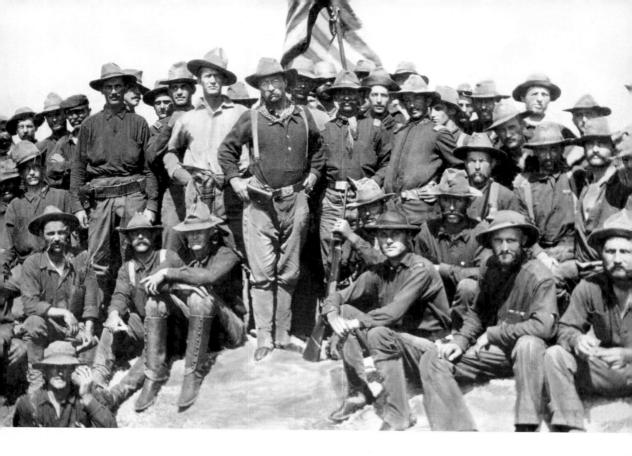

overall command of Gen. Alfred Terry converged. On June 25, 1876, Custer's Seventh Cavalry attacked a force of Lakota and Cheyenne at least five times its size.

With Custer was a journalist writing for papers in Chicago, New York, and Bismarck, Montana. Mark Kellogg's reports fawned over Custer, calling him a "brave" and "dashing" man with an "electric mental capacity." "By the time this reaches you we will have met and fought the red devils, with what results remains to be seen," he wrote his editor. "I go with Custer and will be at the death." Kellogg's decomposed body could be identified only by his boots.

Correspondents during the Indian conflicts from 1866 to 1891 faced new hardships. Unlike the Civil War armies, troops moved in a vast, open space, their foes nomadic tribes that relied on hit-and-run tactics. With no front, there could be no rear—no safe haven for journalists. Correspondents sweated and strained with the cavalry. They carried guns, and they used them.

The most famous correspondents in the Indian Wars were Frederic Remington and Henry Stanley. Writer-artist Remington reported for *Harper's Weekly* on the Sioux at South Dakota's Pine Ridge Reservation in 1890-91, the close of the Indian Wars. He arrived as the troubles began: An aged Sitting Bull led a desperate movement to renew the Indian Nations. Remington arrived in time to sketch the Ghost Dance, a religious ceremony meant to revive dead warriors and restore bison herds. Soon thereafter, authorities ordered the old chief's arrest. Resisting, he was killed by Indian police; leadership fell to Chief Big Foot. When troopers approached, Big Foot resisted, too. On December 29, 1890, he and his followers were killed at Wounded Knee.

Writing for the *Missouri Democrat* in 1867, Stanley had chronicled negotiations that led to the Comanche-Kiowa Treaty of Medicine Lodge, by which the Indians gave up rights to 60,000 square miles. He quoted the speech of Kiowa chief Satank verbatim: "The white man once came to trade; he

now comes as a soldier.... He now covers his face
with the cloud of jealousy and anger and tells us to
be gone, as an offended master speaks to his dog."

The best Indian Wars correspondents were
Edward Fox and John F. Finerty. Fox, an English-
man and yachting editor for the *New York Herald*,
was sent to the California-Oregon border in 1872,
when the Modoc tribe threatened war to avoid the
reservation. Forbidden to join a peace commission
seeking the Modoc chief, Fox followed their tracks
in the snow and got his story. The Modoc told him of
mistreatment on reservations and of being forced to
eat their own horses. Finerty, the "Fighting Irish
Pencil Pusher," covered wars against the Sioux, Ute,
and Apache for the *Chicago Times*. He risked his life
to report on the Battle of the Rosebud, which pre-
ceded Custer's Last Stand. Journalists who rode
with the forces, he wrote, had to "go sometimes on
half rations, sleep on the ground with small cover-
ing, roast, sweat, [and] freeze," and "be ready to
fight Sitting Bull or Satan." Stories by Finerty and
his peers were remarkably accurate, though. General
Crook's 1880 annual report did not detail Ute vio-
lence because, he wrote, the newspapers had given
such "exhaustive and accurate narrations."

IN AFRICA, the British also fought motivated and
mobile natives. Archibald Forbes and William
Howard Russell reported the Zulu War of 1879-80.
In 1877 the British government of the Cape Colony
annexed the Boer South African Republic, settled by
descendants of Dutch colonists, and inherited Boer
border squabbles with the neighboring Zulu nation
in Natal. That same year the Cape's governor, Sir
Henry Bartle Frere, an unabashed empire builder,
seized power from the Zulu monarch Cetewayo.
Cetewayo tried to negotiate, but Bartle Frere sent
5,000 Imperial troops and more than 8,000 native
auxiliaries into Zululand.

On January 21, 1879, troops led by Gen.
Frederick Thesiger, Viscount Chelmsford, encamped
below a table bluff called Isandlwana. He and a small
scouting expedition were attacked by a massive
Zulu *Impi*, or army. Carrying short stabbing spears
and hide shields, the Zulus overwhelmed the British,
killing more than 1,700 Europeans and natives. At a
mission station near a river crossing called Rorke's
Drift, the small 24th Regiment of Foot stood off
Zulu assaults for ten hours in a celebrated battle.

British revenge came at the Battle of Ulundi.
Forbes watched as soldiers fired artillery, Gatling
guns, and rifles into waves of warriors. When the
Zulus abandoned their capital, Ulundi, Forbes
rushed the news to the nearest telegraph line, 120
miles away. He risked death, then fought fatigue
through 20 hours in the saddle. His dispatch was
read aloud in London, and Parliament cheered.

Not until late 1879 did Forbes arrive at
Isandlwana. Scattered in the high grass he found
personal letters, photographs, books, and corpses
slashed with stab wounds. Skeletons rattled when
his boots clipped the bones. Historian Phillip
Knightley suggests that his calm reporting of the
grisly scene was evidence of emotional detachment

51

and that Forbes died, in 1900, in a war-inspired delirium. He raved at the end, "Those guns, man, those guns, don't you hear those guns?"

IN 1863, Ismail Pasha became viceroy of Egypt. Educated in Egypt and Europe, he found investors in Western Europe and launched modern, Western-style projects including the Suez Canal. To expand Egyptian power, Ismail launched an expedition up the White Nile in 1869. West of the Nile an established slave trade was run by Zubayr Rahma Mansur, or Zubayr Pasha, whom the khedive, as Ismail now called himself, appointed governor. In 1874 the khedive offered the governorship of the Equatoria province to English Gen. Charles George "Chinese" Gordon, famous for suppressing the Chinese Taiping Rebellion in the 1860s. Soon Gordon became governor-general of the Sudan. His crusade against the slave trade damaged the local economy; his fervent Christianity alienated Muslim elite. Opposition swept the Sudan. Soon Egypt's economy collapsed. The khedive went into exile and Gordon resigned, leaving a dangerous situation in the Sudan. In 1881 Ahmet Arabi, an Egyptian, led a rebellion against foreign influence. The Royal Navy bombarded Alexandria, defeating Arabi.

Far up the Nile, Muhammad Ahmad ibn 'Abd Allah, the Sufi-educated son of a humble boat-builder who claimed descent from the Prophet, saw himself as a liberator chosen to regenerate Islam. In 1881 he declared himself the Mahdi—the divinely guided one. His followers, shock troops determined to purge the Sudan of infidels, were Baqqarah Arabs, nomadic herdsmen, and fierce Hadenoua and Dinka, Sudanese tribesmen famous for their head-long charges. In November 1883 the Mahdi's army twice defeated Egyptian troops under British leadership. Artist-reporter Frank Vizetelly of the *Graphic* and writer Edmond O'Donovan of the *London Daily News* accompanied the British command. Their bodies were never found. Vizetelly's sketches and O'Donovan's diary surfaced in the Mahdi's camp. One diary entry said, "I make my notes and write my reports, but who is going to take them home?"

By 1884, the Mahdi held all the Sudan but Khartoum. Frank le Poer Power pieced together the particulars of the British-led defeat and sent them to the *Times* of London, which urged the government to stand up to the Mahdi. The War Office ordered General Gordon to Khartoum in February 1884. "I come without soldiers, but with God on my side, to redress the evils of the Sudan," Power quoted Gordon. "I will not fight with any weapons, but with justice."

Soldiers would have been a good idea. In October, Britain's Gladstone government bowed to public pressure and ordered Gen. Sir Garnet Wolseley in to rescue Gordon. Wolseley hauled gunboats and supply vessels up the Nile cataracts. The Mahdi's armies resisted fiercely for three months, then unleashed an all-out assault. In January 1885 Khartoum was sacked and Gordon beheaded. Wrote Frederic Villiers of the *Weekly Graphic,* "All our fighting, all our maddening thirst, all our waste of

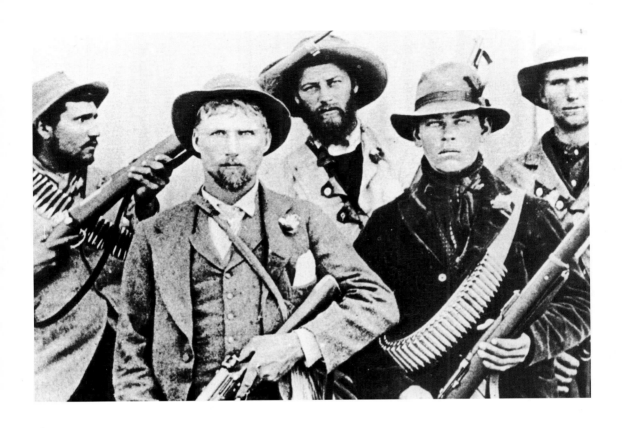

precious blood and weeks of misery, had availed naught." Fourteen years later, an Anglo-Egyptian army under Gen. Sir Horatio Herbert Kitchener defeated a large Mahdist army at the Atbara River on April 8, 1898, and advanced on Omdurman.

Villiers was there, and so was a young lieutenant of the 21st Lancers who also wrote for the *London Morning Post*. Winston Churchill had sent dispatches from the Cuban revolution in 1895 when he was 21. He had a genius for finding adventure and for self-promotion. Kitchener's campaign offered both. Kitchener's army of about 25,000 met the Mahdi's 60,000 outside the city walls on September 2, 1898. Britain's modern artillery secured a decisive defeat with heavy losses. Churchill's lancers charged. He shot a Mahdi soldier from one yard and offered the story to Reuters, the British wire service, on the condition that his name appear.

A little more than a year later, in the Boer War of 1899, Churchill earned his greatest fame as a journalist. The Boers, pious farmers descended from

Dutch settlers in southern Africa, occupied lands rich in soil, gold, and diamonds. Neighboring British colonies agitated against their practice of slavery and their poor treatment of British residents. Still writing for the *Morning Post,* Churchill boarded a British armored train and told someone as it was being attacked, "This will be good for my paper." Captured and imprisoned in Pretoria, he soon escaped—with a roll of money and four slabs of chocolate. From Portuguese territory 300 miles to the north, Churchill sent his story to England. "I am very weak, but I am free," he wrote. Londoners celebrated his daring escape to freedom in a popular dance-hall song, naming him "the latest and greatest correspondent of the day."

The Boer War attracted many stars of journalism and literature: Rudyard Kipling wrote for an army paper, Arthur Conan Doyle worked as a doctor and gathered notes for books. Newlywed Richard Harding Davis reported from both sides, using his travels as an exotic honeymoon with his bride. Still

photography was gaining in war journalism, assisted by the 1880 invention of the halftone. Now photos could be printed directly. Newspapers still used artists' sketches, which eliminated distractions and focused on key figures or scenes. By the end of the 19th century, dry plates replaced wet. The handy Eastman Kodak camera could take ordinary snapshots, but big cameras and large negatives were still required for fine-grained images.

For the first time, motion-picture cameramen shot troop movements and activities away from the fighting. W. L. K. Dickson joined British troops, but bulky equipment kept him from recording battle scenes. His suitcase-sized camera traveled by horse-drawn cart and stood on a heavy tripod. He photographed armored trains, Boer prisoners, the Royal Fusiliers striking camp, and portraits, including that of Lord Baden-Powell.

During the brief Greco-Turkish conflict of 1897, Frederic Villiers had probably been the first to use a motion-picture camera in war. He also used one during Kitchener's 1898 march on Khartoum. Movie cameras covered the Spanish-American War that year, too, the first action war news seen by the public. Thomas Edison and the Vitagraph Company produced a short film with the U.S.S. *Maine's* exploded hulk in Havana Harbor and the service at Arlington Cemetery for those killed aboard.

Vitagraph photographers Albert E. Smith and J. Stuart Blackton, in Cuba in July 1898, recorded a deliberate march through a heavy thicket that conflicted with reporters' stories of a heroic charge. "Nothing glamorous or hip-hip hooray," Smith wrote afterward. "Many historians have given it a Hollywood flavor, but there was vastly more bravery in the tortuous advance against this enemy who could see and not be seen."

Smith, Blackton, and other newsreel photographers sometimes faked images. For less than two dollars they constructed a movie set of the Battle of Santiago Bay. Cut-out warships floated in a tub, Blackton's wife puffed on a cigarette, and exploded pinches of gunpowder simulated battle fire. Crude lenses and film obscured the artifice. The two-minute film played to enthusiastic audiences.

Despite photography, the Cuban conflict was a wordsmith's war. At the time, American newspapers were themselves at war—for circulation. In New York City, the chief combatants were the *Journal,* published by William Randolph Hearst, and the *World,* published by Joseph Pulitzer.

Hearst, a huge man with a tiny voice and the sad-eyed face of a hunting dog, redesigned the *San Francisco Examiner* until it fairly shouted the news, then turned the *New York Journal* into a sensation sheet that cost a penny and scooped all rivals. Pulitzer, the son of a Hungarian grain broker, restlessly curious about everything, had built up the *St. Louis Post-Dispatch* with solid reporting and public-spirited editorials. His *World* attacked corruption and exposed injustice—and sought scoops. During the Cuban insurrection against Spain in 1895 and the subsequent Spanish-American War, the public demand for sensational news pushed the circulation of both the *Journal* and the *World* beyond one million each.

The competition began well before America entered the war in Cuba. Papers fought for stories, sometimes making up a good yarn when facts were dull. Frederick W. Lawrence of the *Journal* reported a running battle involving 25,000 nonexistent rebels. He said they burned two cities, 300 miles apart, on a single night. *Journal* writers created news and transformed routine stories into sensations. Hearst had reporter Ralph Paine take a $2,000 sword to Cuba's rebel leader Maximo Gomez after a *Journal*-sponsored event had named him the "world's greatest living soldier."

Reporters played on American sympathies for the Cuban underdogs. *Journal* reporter James Creelman documented Spanish killing of civilians. He slipped out of Havana one night, guided by two Cubans who dug up evidence. "The hands of the slain Cubans were tied behind their backs," wrote

Creelman. "I made a vow at that moment that I would help to extinguish Spanish sovereignty in Cuba, if I had to shed my blood for it." He would get his wish two years later. Laid out by a Spanish bullet and waiting for a surgeon, Creelman opened his eyes to see Hearst standing over him, clutching a notebook and gushing about the "splendid fight."

"I really believe I brought on the war," Hearst said later. It wasn't true. The press had little influence on decision-makers in Washington, D.C. The event that led most directly to a declaration of war was shocking enough on its own.

On February 15, 1898, the U.S. battleship *Maine* exploded in Havana Harbor. Sylvester Scovel of the *World* was quickly on the scene, along with a blank telegraph form already stamped with the censor's seal of approval, which he kept handy for just such an emergency. Scovel cabled a story, saying, "There is some doubt as to whether the explosion took place ON the Maine." The cause of the explosion has never been determined. Spain seemed to have no reason to provoke America into war, yet a U.S. Navy Court of Inquiry concluded that a submerged mine caused the blast. More likely a fire in the coal bunker ignited the ship's magazine. Regardless, the public cried out for war. Hearst ran a front-page drawing of the *Maine* floating over a mine wired to Spanish forts on the shore. Pulitzer showed the ship's hull flying apart, bodies shooting skyward.

Congress issued resolutions affirming Cuba's right to independence, demanded that Spain withdraw, and authorized President McKinley to use force if necessary. On April 24, 1898, Spain declared war on the United States. The conflict was pathetically one-sided; neither Spain's Army nor Navy was equal to that of the formidable U.S. The elusive Spanish Caribbean fleet in Cuba's Santiago Harbor was quickly blockaded by a U.S. squadron. A force of regular troops, National Guard, and volunteers—including Theodore Roosevelt's Rough Riders—landed in heavy fog and advanced westward to Santiago to force the Spanish fleet out of the

harbor. Spanish ships were destroyed and left beached, burning, or sinking. Santiago surrendered on July 17, and the war ended.

Another war story came from the Philippines, when Commodore George Dewey's squadron destroyed the Spanish fleet at Manila Bay. Dewey's ships arrived in Hong Kong six days later, and Edward Walker Harden of the *Chicago Tribune* and *New York World* cabled an urgent story, $9.90 per word: "Just arrived from Manila.... Entire Spanish fleet destroyed. Eleven ships. Spanish loss three hundred killed, four hundred wounded. Our loss none killed, six slightly wounded. Ships uninjured."

The war was the story that mattered. Stephen Crane said reporters were reminded that "the American people were a collection of super-nervous idiots who would immediately have convulsions if we did not throw them some news—any news." Perhaps 400 artists and writers, including at least two women, descended on Cuba and Florida early in the summer of 1898. Skirmishes in Cuba became great battles. The *Journal* reported the death of an officer, Col. Reflipe W. Thenuz. The *World* copied the story, then the *Journal* crowed that the name was a near-anagram of "We pilfer the news," never expressing shame for having fabricated the story in the first place.

Reporter Richard Harding Davis helped make Teddy Roosevelt a hero. Roosevelt's Rough Riders, an odd mix of western outdoorsmen and eastern socialites and athletes, provided colorful copy. Davis's *New York Herald* account of the Rough Riders' assault on Kettle Hill (which he mixed up with adjacent San Juan Hill) captured the American imagination. He said Roosevelt was the only mounted man in the charge, and the sight of him "made you feel that you would like to cheer."

Stephen Crane's stories for the *World* conveyed the confusion. He called the ambush a "blunder." The Rough Riders "advanced at daylight without any particular plan of action as to how to strike the enemy," he wrote. "The men marched noisily

through the narrow road in the woods, talking volubly, when suddenly they struck the Spanish lines.... They suffered a heavy loss ... due to the remarkably wrong idea of how the Spanish bushwhack."

Fittingly, the final story out of Cuba was distorted. Santiago was surrendered to troops commanded by Gen. William Rufus Shafter, a 63-year-old, 330-pound martinet. Shafter said reporters would "goddamned never" be allowed at the ceremony, but changed his mind. Sylvester Scovel shinnied up a tree for a better view until officers ordered him down. Later, Shafter called him a "son of a bitch" and reporters "goddamned nuisances."

"You shouldn't use such language to me, sir," Scovel replied. Shafter hit him in the face. Without thinking, Scovel swung back. Marines grabbed and detained him until tempers cooled. Eager to smear his rival paper, a *Herald* reporter wrote as if Scovel had landed the first and only punch. Scovel was fired. "Poor man, that story followed him until, and after, his death," his widow wrote years later. "It never happened as it was told, but it was too good a story to be corrected."

The Spanish-American War was the last "splendid little war" of the 19th century and the golden hour of free-for-all war correspondence. Journalists traveled with the combatants up to the fighting. Their dispatches suffered limited interference. Granted, officers controlled telegraph lines, gave out press credentials, and could expel or imprison correspondents. Some stories were censored. Friendly government and military sources leaked information to the press, though, and it wasn't hard to dispatch stories and illustrations to unrestricted telegraph offices or to mail them.

In the next major conflict, the ravages of war would hit home, and freedoms of correspondence would end. During the Russo-Japanese War of 1904-05, the Japanese kept journalists out of combat, offered only official press statements, required press pools, and delayed and censored reports in order to shape a positive image of Japan. Journalists scored scoops by evading Japanese handlers. An AP reporter in China, beyond the reach of censors, interviewed witnesses to the Port Arthur sneak attack that started the war. Photographer Jimmy Hare of *Collier's* magazine sneaked away from press officers near the Yalu River to photograph artillery in action, infantry charges, and wounded soldiers.

Reporters left the region in disgust over the Japanese regulations. An Italian, Luigi Barzini, remained in Manchuria, the only one to roam the Mukden battlefield where month-long combat cost 71,000 Japanese and 85,000 Russian lives. He took photos and wrote 700 pages of notes, the ink freezing in his pen. His stories in Milan's *Corriere della Sera* depicted war's tragedy, not "splendid" glory and fun. Newsboys in Milan sold the paper not by yelling the headlines but by shouting, "Article by Barzini." For those who would listen, Barzini's accounts hinted at the total war coming a decade later. And those who marveled at the efficiency of Japan's press control saw a harbinger of the censorship that would dominate the news of World War I.

NEWSREELS

THE FIRST MOTION-PICTURE AUDIENCES WEREN'T PICKY. Mesmerized by the novelty of seeing images that moved, first in nickelodeon parlors and later in vaudeville theaters and carnivals, they devoured everyday scenes of beaches, trains, and picnics. These nonfiction "actualities" led to the creation of short films of news events in the mid-1890s, such as a boxing match at Thomas Edison's studio and Frenchman Charles Pathé's "The Czar's Arrival in Paris." Pathé's company began producing newsreels, a marriage of journalism and entertainment intended for regular viewing in theaters, in 1908. Newsreels appeared in America in 1911 and remained a staple of motion picture viewing until 1967. As viewers grew more sophisticated, they demanded compelling images. "Never send pictures that do not tell their own story," a 1915 Pathé News booklet, above, urged cameramen. "Pictures that require lengthy explanatory titles never can be interesting." The best newsreel footage included Charles Lindbergh leaving on his transatlantic flight in 1927 and the destruction of the zeppelin *Hindenburg* in 1937. When real events proved too difficult to film, newsreel producers often resorted to fakery. Many battle scenes in the Spanish-American War were filmed on the shores of New Jersey, and film producer James Williamson shot some Boer War scenes on a golf course in Great Britain.

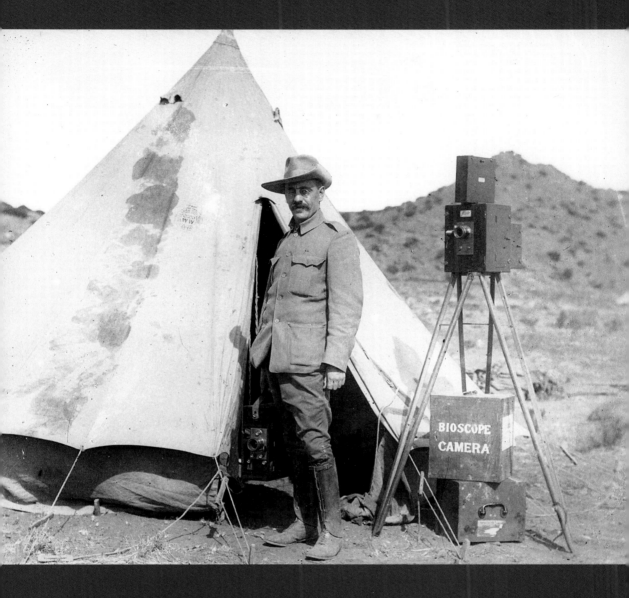

Joseph Rosenthal of the Warwick Trading Company,
above, earned a reputation in the Boer War for
getting powerful images from any location, such as
at the river crossing on the following page. A rival,
W.K.L. Dickson, who had helped create the first
motion-picture cameras and projectors, managed to
get a few pictures of Boer soldiers as seen from
the British lines.

The British Army generally
cooperated with cameramen.
When Rosenthal made these
images of a South African
river crossing, right, the offi-
cers stood in position for sev-
eral frames. Another time,
Lord Roberts, commander in
South Africa, moved outdoors
when a photographer requested
more light. Once telegraph
operators delayed a message
until Dickson could film it
being keyed. A low point in
military-media relations came
in 1914, when Mutual Film
Corporation contracted with
Mexican revolutionary Pancho
Villa to arrange battles at
convenient hours. The *New
York Times* said Villa "must see
to it … that a satisfactory part
of the killing and dying is
done in focus."

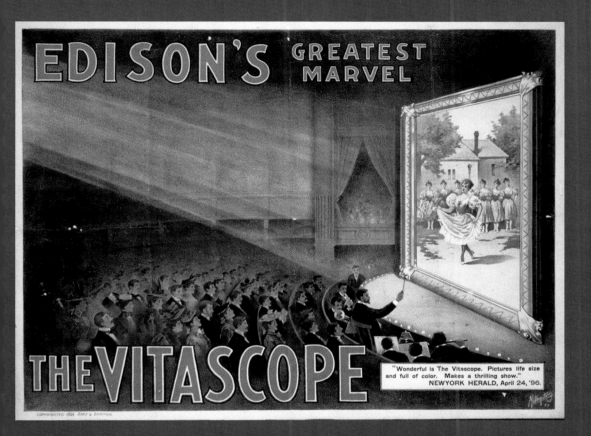

The market for motion pictures, indicated in an 1896 advertisement for the Vitascope projector, above, was fed by a steady supply of novel and sensational images. Increasingly, however, censors restricted wartime films. During World War I, independent newsreels were controlled. Military cameramen shot nearly all the battles on the Western Front, but much of the footage never appeared in theaters.

"THE DEAD SLEEP COLD IN SPAIN TONIGHT. SNOW BLOWS THROUGH
THE OLIVE GROVES, SIFTING AGAINST THE TREE ROOTS.
SNOW DRIFTS OVER THE MOUNDS WITH THE SMALL HEADBOARDS.
(WHEN THERE WAS TIME FOR HEADBOARDS.)"
Ernest Hemingway, North American Newspaper Alliance

CHAPTER THREE

TOTAL WAR

Le Petit Journal

ADMINISTRATION
61, RUE LAFAYETTE, 61

Les manuscrits ne sont pas rendus

On s'abonne sans frais
dans tous les bureaux de poste

5 CENT. SUPPLÉMENT ILLUSTRÉ **5** CENT.

27me Année — ✠ — Numéro 1.709

DIMANCHE 23 JANVIER 1916

ABONNEMENTS

SEINE et SEINE-ET-OISE.. 2 fr. 3 fr. 50
DÉPARTEMENTS............. 2 fr. 4 fr. »
ÉTRANGER 2 50 5 fr. »

"SERAIT - CE MON TOUR ?..."

CHAPTER THREE

...OOK A WHILE for the american army and navy to learn the art of war, Philippine

... Perhaps they were lulled by the opening engagement of what came to be called

...hilippine Insurrection.

...On February 10, 1899, American shells punched the earthworks of Filipino

...s near Manila. Volunteer troops from Kansas cut down the fleeing rebels "like

...," the *New York Times* reported. The Filipinos knew that big armies beat small

...s when playing by big army rules, so they adopted a form of warfare that baffled

...nraged the Americans. Wearing civilian clothes, they hid in plain sight in

...ges or melted into the jungles. They set booby traps of poison arrows and

...ened spears. They avoided confrontations unless they had surprise on their

...In a few months the Americans captured the rebel capital of Malolos, Filipino

...rs harassing them all the while. Frederick Palmer, a *New York World* and *Collier's*

...ly reporter, asked Brig. Gen. Arthur MacArthur a conventional-war kind

...estion: Would the capture of Malolos "break the backbone" of the rebellion?

...general smiled and answered, "I am not yet convinced that this rebellion is a

...brate organism."

67

Pre... ...pages: World War I doughboys are silhouetted against the dawn.
"W... ...e my turn?" Kaiser Wilhelm II, left, asks the Grim Reaper in 1918,
the... ...r of World War I, in Le Petit Journal, *a Parisian paper.*

Slowly, the significance of guerrilla warfare dawned on Palmer. He had seen the Greco-Turkish War of 1897, but this was different. "One guerrilla can harass a dozen soldiers," he wrote. "No country is pacified as long as there is a man in every bush."

The Filipinos had fought with America against Spain in 1898, hoping that victory would mean independence, but Spain gave control of the Philippines, Guam, and Puerto Rico to the United States. A month later, Filipino leader Emilio Aguinaldo declared an independent Philippine Republic. Within two weeks, the former allies were at war.

To Filipino lightning raids and ambushes, the 100,000 Americans there responded, Palmer said, like a big man striking at air. Gen. Jacob W. Smith ordered his troops to kill everyone older than ten. "The more you kill and burn the better you will please me," he said. Smith later was convicted in a court martial.

Under MacArthur, the Americans opened schools; improved medical, penal, and sanitation systems; and championed Philippine independence. Once Aguinaldo was captured in March 1901, fighting tapered off. President Theodore Roosevelt declared the islands pacified on July 4, 1902, although small uprisings still flared among the Moros, Muslims on Mindinao and Jolo. By the end 4,243 Americans were killed and 2,800 wounded. Perhaps 16,000 Filipinos died fighting. Another 100,000, including civilians, starved.

America made the Philippines a commonwealth in 1935. Full independence came in 1946, after MacArthur's son, Douglas, helped liberate the country from its next occupier, Japan.

Guerrilla uprisings, especially to topple a ruling government, became common in the 20th century. The strategy is ancient. "Keep [the enemy] under a strain and wear him down," wrote a Chinese military genius of the fourth century B.C. The word guerrilla, or "little war," appeared in the first decade of the 19th century, when Spanish and Portuguese partisans helped expel Napoleon's troops from the Iberian Peninsula. In battles of weak vs. strong, the weak took a lesson from history, and morale became a weapon.

Total war between the major powers was the other landmark of the 20th century. Total warfare meant new, powerful weapons—machine guns, aircraft, and tanks; complete economic and industrial mobilization; and giant citizen armies, navies, and air forces. It caused unprecedented death and destruction. Napoleon marched into Russia in 1812 with 600,000 troops—a lot for the time. A century later, the Allies lost that same number in one five-month battle during World War I.

The Mexican Revolution (1911-1920) brought guerrilla war tactics close to America. A popular uprising toppled Porfirio Diaz in May 1911 and replaced him with Francisco Madero, but the revolutionary fire—and the desire for land and labor reforms—kept burning. American businesses with big investments in Mexico watched nervously. Fighting nearly drew the United States into war. But a new Mexican constitution in 1917 and a greater conflict in Europe diverted America's attention.

In 1913 Francisco "Pancho" Villa raised a guerrilla army in the north. The colorful Villa defeated Mexican federal troops, set up a rebel government,

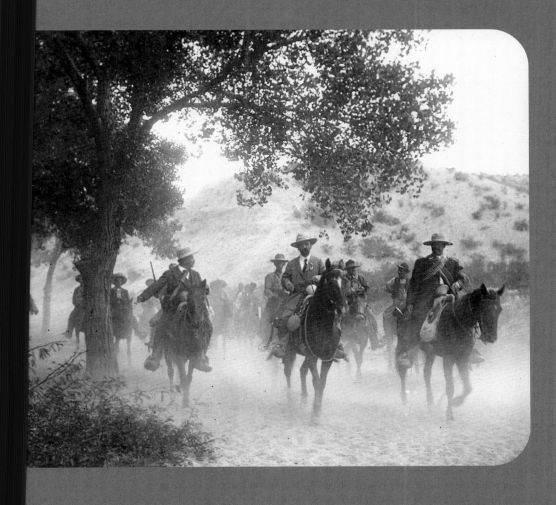

Serbian nationalist Gavrilo Princip, a schoolboy of 19, is arrested, left, after assassinating Archduke Franz Ferdinand and his wife in Sarajevo, Bosnia, in June 1914. The act precipitated World War I, maps, right. Following pages: At war's start, German reservists head for France on a train from "Elsass Lothringen"—Alsace-Lorraine, the disputed territory between Germany and France.

and gave the poor money, land, and food. A natural self-promoter, Villa offered American film companies the rights to his battles. On January 3, 1914, Mutual Film Corporation agreed to $25,000 and a 50 percent royalty of profits. When practical, Villa would fight in daylight for the cameramen.

American print journalists and still photographers flocked to the border to cover Pancho Villa, including John Reed, a Harvard graduate and Communist from Portland, Oregon. For four months, Reed rode the sun-scorched plains and slept on the ground with the rebels. He described Villa receiving a medal: "He was dressed in an old plain khaki uniform.... He hadn't recently shaved, wore no hat, and his hair had not been brushed. He walked a little pigeon-toed, humped over, with his hands in his trouser pockets."

Reporting in Mexico became more difficult after March 9, 1916, when Villa and 500 men raided Columbus, New Mexico, home of the 13th Cavalry Regiment, and then, with southern revolutionary leader Emiliano Zapata, briefly captured Mexico City.

Gen. John J. "Black Jack" Pershing and his troops chased Villa for hundreds of miles. Pershing imposed strict censorship. Images had to be approved by a military censor, and the Army Signal Corps provided its own. Pershing never caught Villa, who led small rebellions until 1920, when a coup left the president of Mexico dead. Villa risked a larger rebellion but failed. In 1923 he was assassinated.

In 1914 American war correspondents saw the prospect of bigger game afoot: total war in Europe. It started small. On a hot Sunday in June 1914, the Archduke Franz Ferdinand, heir to the Austro-Hungarian throne, and his duchess toured the Bosnian capital of Sarajevo. Bosnia recently had been absorbed into the Austrian Empire. When the Archduke's driver made a wrong turn, Gavrilo Princip, a Bosnian Serb agitator who wanted to free his homeland from foreign rule, approached the car and shot the couple to death. From this isolated incident in a faraway corner of the world sprang the first global war.

WORLD WAR I
1914-1918

Legend:
- Allied nations
- Central powers
- Neutral nations
- --- Farthest advance by Central powers
- Trench lines
- Armistice lines
- Major battles

Map labels: NORWAY, SWEDEN, PETROGRAD (St. Petersburg), Moscow, DENMARK, North Sea, Baltic Sea, UNITED KINGDOM, JUTLAND 1916, RIGA OFFENSIVE 1917, LAKE NAROCH 1916, MASURIAN LAKES 1914, TANNENBERG 1914, AUGUSTOW 1915, BARANOVICHI 1916, RUSSIA, LONDON, NETHERLANDS, BERLIN, LODZ 1914, WARSAW 1914, KOMAROW 1914, 1918, English Channel, GERMANY, Eastern Front, BELGIUM LUX., KRASNIK 1914, LUTSK 1916, PARIS, AREA ENLARGED TOP RIGHT, TARNOW-GORLICE 1915, BRUSILOV OFFENSIVE 1916, KERENSKY OFFENSIVE 1917, Bay of Biscay, Western Front, TRENTINO 1915, 1916, GALICIA OFFENSIVES 1915, VIENNA, PRZEMYSL 1915, FRANCE, SWITZ., CAPORETTO 1917, AUSTRIA-HUNGARY, ISONZO 1915-1917, Bolshevik Revolution, Nov. 1917 Russians sign armistice, December 1917, Caspian Sea, VITTORIO VENETO 1918, PIAVE RIVER 1917-1918, INVASION OF SERBIA 1914-1916, ROMANIA, INVASION OF ROMANIA 1916-1917, Black Sea, 1918, SARIKAMISCH 1914-1915, SPAIN, Corsica, MONTENEGRO, Sarajevo, SERBIA, BULGARIA, Farthest Russian advance 1916-1917, CONSTANTINOPLE, ERZURUM 1916, PERSIA, Sardinia, ALBANIA, VARDAR 1918, GALLIPOLI 1915, MOSUL 1918, KIRKUK 1918, SPANISH MOROCCO (SPAIN), Mediterranean, MONASTIR 1916, SALONIKA FRONT 1916-1918, OTTOMAN EMPIRE, GREECE, ALEPPO 1918, KUT-AL-AMARAH 1915, 16, 17, ALGERIA (FR.), Sicily, MALTA (U.K.), Crete, CYPRUS (U.K.), MEGIDDO 1918, DAMASCUS 1918, BAGHDAD 1916, 1917, NASIRIYA 1915, TUNISIA (FRANCE), LIBYA (ITALY), GAZA 1917, ARABIA, miles 400, kilometers 600

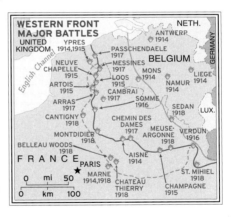

WESTERN FRONT MAJOR BATTLES

Inset map labels: UNITED KINGDOM, English Channel, NETH., ANTWERP 1914, YPRES 1914,1915, PASSCHENDAELE 1917, MESSINES 1917, BELGIUM, NEUVE CHAPELLE 1915, LOOS 1915, MONS 1914, LIEGE 1914, ARTOIS 1915, CAMBRAI 1917, NAMUR 1914, GERMANY, ARRAS 1917, SOMME 1916, SEDAN 1918, LUX., CANTIGNY 1918, CHEMIN DES DAMES 1917, MEUSE-ARGONNE 1918, VERDUN 1916, MONTDIDIER 1918, BELLEAU WOODS 1918, FRANCE, PARIS, MARNE 1914,1918, AISNE 1914, ST. MIHIEL 1918, CHATEAU THIERRY 1918, CHAMPAGNE 1915, mi 50, km 100

Secret alliances and mutual defense treaties came to play. Escalation was inevitable. Historian Barbara [Tu]chman described Europe then as "a heap of swords [tie]d as delicately as jackstraws." Germany had a [tre]aty with Austria-Hungary; France and Russia were [mi]litary allies. Russia saw itself protector of the Slavs. [A]ustria threatened reprisals against Serbia, and the [fi]rst jackstraws were pulled from the heap. Austria, [ea]ger for influence in the Balkans, issued an ultima-[tu]m, which the Serbs rejected. The straws fell faster. [T]he Serbs mobilized on July 23. On July 25, Germans [s]treamed through Berlin, shouting, "Krieg!—War!" [R]ussia pledged to aid Serbia, France agreed to sup-[p]ort Russia, Germany announced that if Russia mobi-[l]ized troops, it would too. On July 30, Russia did so.

Britain had been the driving force behind an [i]ndependent Belgium, a buffer between Germany and [F]rance. As the continental powers mobilized in the [s]ummer of 1914, the London *Times* said, "We can no [m]ore afford to see France crushed by Germany, or the [b]alance of power upset against France, than Germany can afford to see Austria-Hungary crushed by Russia and that balance upset against Austrian and Hungarian interest." The warning proved prophetic. Germany planned to enter France through Belgium and attack from the west, while smaller forces held the Russians at bay in the east. The Germans assumed that the unwieldy Russian Army would mobilize slowly. They asked permission to pass through Belgium, promised not to keep any of its territory, and began to march.

American adventurer Granville Fortescue traveled to Brussels once the invasion appeared imminent. In his story—which some historians think is too good

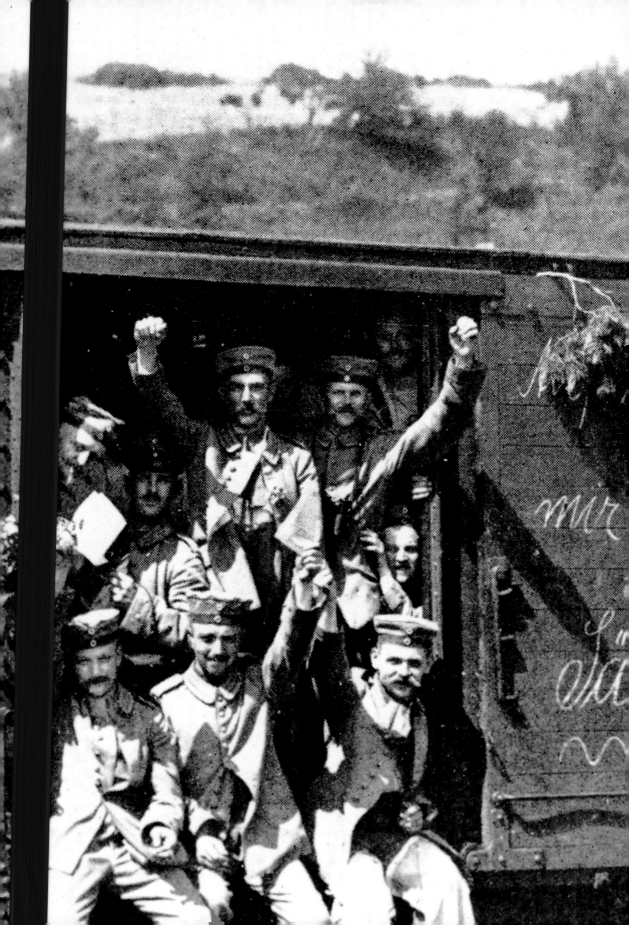

to be true—Fortescue by chance wandered into the U.S. Embassy in Brussels at 9 a.m. on August 4. A porter was speaking Flemish to a local peasant, who kept pointing east and saying, "Allemand." Fortescue realized he had the first major scoop of the war. He called the *Daily Telegraph* in London and related what he had learned; then the line went dead. Britain declared war on Germany that evening. The *Telegraph* ran the story and hired Fortescue full-time.

Germany and Austria-Hungary found themselves facing enemies on two fronts: France, Belgium, and Britain on the west; Russia on the east. Russia accredited half a dozen Russian and foreign journalists. The German Army, under the command of the elderly Gen. Paul von Hindenburg and his lieutenant Gen. Erich Ludendorf, approached the eastern front. On August 24, the three poorly led Russian Army corps of Gen. Alexander Samsonov collided with the Germans at Orlau-Frankenau, then halted their advance. That evening the Germans intercepted Russian radio messages and learned their battle plan. Shifting south on August 26, the Germans attacked at Tannenburg. By August 31 Samsonov's Second Army was destroyed and its leader had committed suicide.

Germany's *Kriegpresseamt*—war press office— shaped news for the populace. Editors received carefully filtered items and had to write supportive editorials. Germany tolerated foreign journalists from neutral countries such as the United States. In Brussels, Richard Harding Davis was covering his final war: He would die of heart failure in 1916. Reporting for the Wheeler Syndicate and *Scribner's* magazine, he

witnessed the August arrival in Louvain of three uniformed Germans on bicycles leading long infantry lines. Davis sent his story to England, then was accused of being a spy. Released after harsh questioning, Davis looked back out the train windows to see a glow in the sky. The Germans had torched Louvain.

In August 1914, expecting a direct attack, France sent an army of one million eastward for an invasion of Germany through Alsace-Lorraine. The Germans held the French border and marched into Belgium, then advanced swiftly toward Paris. From the French viewpoint, news was bad. Journalists were refused accreditation. French papers carried no facts about the battle from August 9-18. In the vacuum, rumors spread—antiwar riots in Berlin, low morale in the German Army. Finally French authorities decided that limited news was better than no news at all and began issuing official bulletins with no real news. The Bureau de la Presse allowed frontline reporting only by accredited journalists who were citizens of France, England, Belgium, or Russia, and traveled with an official guide. Furthermore, all Western correspondents had to show "perfect knowledge" of French by passing a test that even fluent speakers failed.

That left British journalists to do the bulk of the early World War I reporting. The head of Britain's War Cabinet was Lord Kitchener, who "hated" reporters and "thought the press ought to be throttled in times of war," said Philip Gibbs of the *Daily Chronicle*. Kitchener banned journalists from the front lines. Still, American and British journalists wandered on their own, mostly in the rear of the western front.

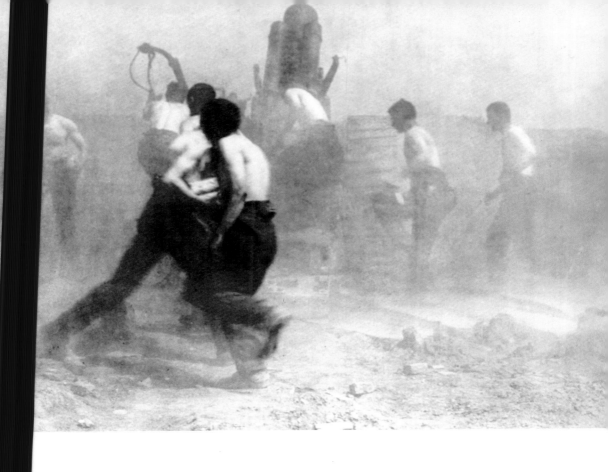

rough August, Germans pushed south, colliding
h the 100,000 British troops in Belgium. Badly out-
nbered, the British escaped during the night.

On August 29, dispatches from W. Arthur Moore
the *Times* and Hamilton Fyffe of the *Daily Mail*
iched London, saying the British Expeditionary
rce had been crushed by the German advance. The
itors deleted inflammatory passages and submitted
em to War Office censors. Surprisingly, they came
ick approved for publication. Censor F. E. Smith
en added: "Is an army of exhaustless valor to be
orne down by the sheer weight of numbers while
oung Englishmen at home play golf and cricket? We
ant men and we want them now." The stories elec-
ified the country. Kitchener visited the front and met
ith Sir John French, then returned to London with
plan: He would give those nosy journalists news,
ll right. He appointed Maj. Ernest D. Swinton, an
engineer, to write daily accounts from France. The
plan was to build confidence and shelter the army
from independent journalists.

Swinton's dispatches—censored at the front, then
vetted by Kitchener himself—carried the byline "Eye-
witness." Press critics dubbed them "eyewash," they
contained so little real news. He wrote, for example,
about how a staff-car chauffeur washed and combed
his hair outdoors using a saucepan and nail brush. A
washout correspondent, Swinton later proved a valu-
able military visionary: He designed the first tanks
introduced on the western front in September 1916.

Britain allowed one American correspondent at
war's beginning in 1914. William Jennings Bryan,
the American Secretary of State, picked Frederick
Palmer to represent all three major wire services—
Associated Press, United Press, and International
News Service. On September 4, when the Germans
advanced toward the nearby Marne River, Palmer and
other correspondents roamed Paris's deserted streets.
At the War Ministry they discovered fleets of waiting
taxicabs, ordered by the government to transport 6,000
soldiers to the critical Battle of the Marne. No
correspondents watched as the French checked the

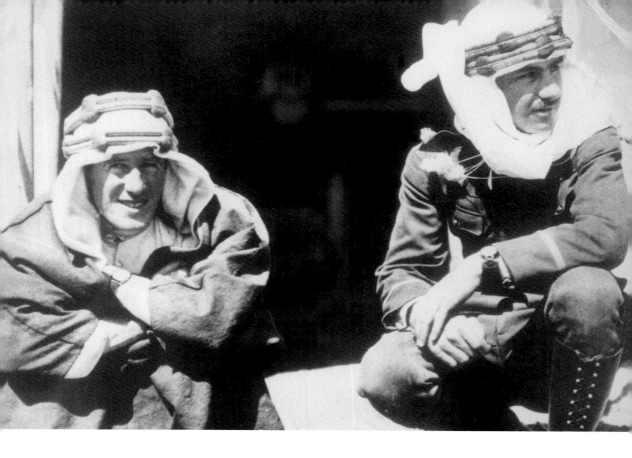

German advance on September 6-9, but Palmer and the AP's Elmer Roberts later filed reports on soldiers going to the front in cabs. Thus was born the legend of the taxicab army that saved Paris.

After the Battle of the Marne, the German and Allied armies raced to the sea. As the winter of 1914-15 began, both sides dug in to wage trench warfare, with its poison gas, incessant shelling, and machine-gun fire. Parallel trenches protected by barbed wire stretched from the English Channel to the Vosges Mountains on the Swiss border. Villiers, the British artist, watched the trenches being hewn into the chalky Flemish soil. He could not understand the intense Allied censorship. German spies were so good, they didn't need the press to learn about the enemy, he said. By early 1915, journalists scouting the war zone were sure to be arrested. Prevented from gathering facts, many journalists made up stories. The British press, recalled the *Chronicle's* Philip Gibbs, printed "any wild statement, rumor, fairy tale, or deliberate lie, … and the liars had a great time."

Resourceful journalists did what they could. When French publisher Georges Clemenceau published a story about illness in the trenches, his paper, *L'Homme Libre (The Free Man)* was suspended for a week. It reappeared two days later as *L'Homme Enchainé (The Bound Man)*. Agitating for more guns and men at the front and better care for the wounded, the paper was suppressed again. In 1917 Clemenceau became the head of the French government.

Will Irwin of the *New York Tribune* had a hand in two major stories—but with a price. About the October 1914 First Battle of Ypres in Flanders, he wrote, "Europe lost as many men as the North lost in the whole Civil War." In fact, by December 1914, the Allies alone had lost nearly a million. His story ran in New York, then Britain. The British and French blacklisted Irwin for most of the war.

He shared a second scoop with William Shepherd, Swinton, and a British commander. In April 1915, during the Second Battle of Ypres, the Germans released more than 50,000 cylinders of chlorine gas. Two

nch divisions took the brunt of it. Censors hered Shepherd's dispatch. British commander n French's brief dispatch noted "asphyxiating" gas accused the Germans of violating the 1907 Hague nvention. Irwin wrote two *Tribune* stories about aling the gas. Swinton produced an uncharacter- cally sharp narrative: "The heavy colored vapor red relentlessly into the [French] trenches, filled m and passed on. For a few seconds, nothing ppened; the sweet smelling stuff merely tickled ir nostrils.... Then, with inconceivable rapidity, the s worked and blind panic spread. Hundreds, after dreadful fight for air, became unconscious and died here they lay." Soon all the soldiers on the western ont carried gas masks.

STORY that appeared despite military censorship vealed the futility of Allied tactics in 1915 in Turkey, hich, with Germany and Austria-Hungary, formed e Central Powers. To relieve pressure on the armies n France, Kitchener and Churchill planned to open

the Turk-guarded Dardanelles, the strait between the Mediterranean and the Black Sea. The move could force Turkey out of the war and help Russia into the Mediterranean. First a Franco-British naval fleet attacked the powerful fortifications on both sides of the straits. Then the fleet commander, Rear Adm. John de Robeck, took 16 ships and a host of smaller craft into the Dardanelles. Mines sank three ships and the fleet withdrew.

On April 25, British and ANZAC (Australian and New Zealand Army Corps) troops under Gen. Ian Hamilton landed at Gallipoli's beaches on the north side of the Dardanelles, while French troops landed on the western, Asiatic side. After three months of bitter fighting, more Allied troops landed. ANZAC and British troops died in ill-advised frontal assaults. From late December to the first week of January 1916, over 35,000 men and their equipment were secretly evacuated—thanks in part to a reporter. Keith Murdoch, an Australian reporter for the *Sydney Sun,* witnessed the fighting and resolved to do something

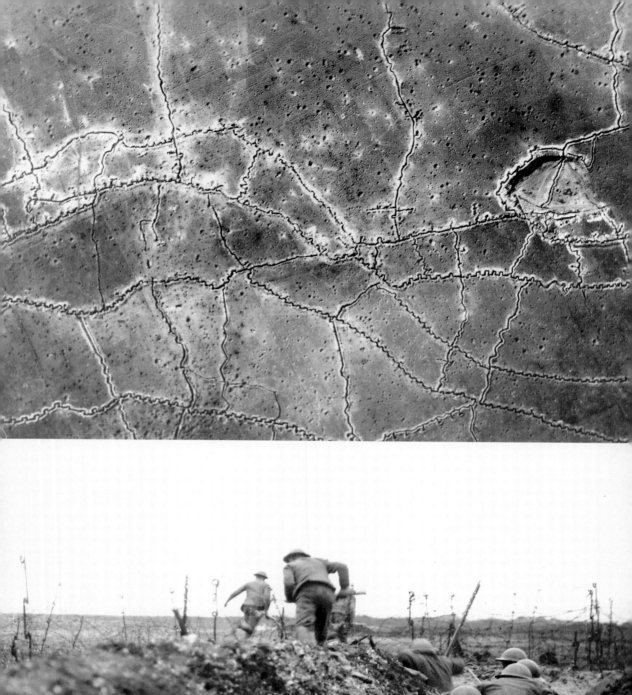
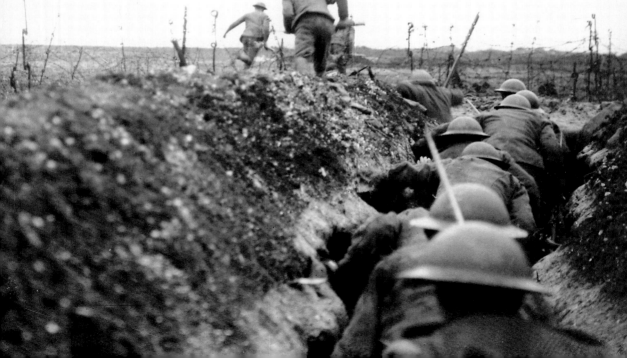

such senseless slaughter. British censors seized
...tters of protest to Australia's prime minister. Ellis
...head-Bartlett, a British reporter who shared his
...erns, gave Murdoch a letter to smuggle to
...don. He got as far as France, where his letter was
...iscated, then continued on to England, rewriting
...mead-Bartlett's dispatch from memory.

With the help of Lord Northcliffe, Murdoch
...ived an audience with David Lloyd George, a
...mber of the war cabinet. Rather than publishing
...letter in Northcliffe's papers, Lloyd George cir-
...ated it among British officials. Kitchener called it
...ssue of lies, but a committee of inquiry substanti-
...d most of its charges. Sir Ian Hamilton, the
...ficer in charge of the invasion, was sacked; his
...placement began withdrawing troops. In 1916,
...oyd George replaced Prime Minister Herbert Asquith,
...e Gallipoli report influencing the change. Murdoch
...overed the rest of the war for papers in Australia.

Allied troops in the trenches began producing their
...wn trench newspapers. Many were handwritten and
...opied one at a time by soldiers pressing sheets onto
...tencil-inked gelatin in metal trays. The trench papers
...gave a true look at death at the front lines: "I can see
...hose men who just now were two living beings and
...now, one is nothing but a mass of mud and blood, the
...other this long stiff body.... The awfulness of this
...body!" The American machine gunners' *Tripod*
became the prototype for the Army's *Stars and Stripes*.

In January 1915 former President Theodore Roo-
sevelt complained to Britain that censorship had "cer-
tainly helped the Germans in American public opin-

ion" but had not hurt the German military. The rules
slowly relaxed. Five British journalists including
Philip Gibbs toured the front in March 1915. The
British War Office still did not trust them and sug-
gested testing their private letters for invisible ink.

Allied papers carried atrocity stories of Germans
bayoneting babies, chopping off children's hands, cru-
cifying Canadian soldiers, and mutilating French girls,
all despite a lack of hard evidence. The German press
struck back. The *Norddeutsche Allgemeine Zeitung*
reported that Britain's Gurkha and Sikh troops slit
throats and drank blood; the *Weser Zeitung* quoted a
boy who saw a bucketful of German soldiers' eyes.

Chicago Tribune reporter Floyd Gibbons booked
passage on the *Laconia*, like the *Lusitania* a British
Cunard liner that passed through the war zone. He
brought along flashlights, a life preserver, and flasks
of brandy and water, and reacted cheerfully when a
U-boat's torpedo slammed into the ship's side on
February 25, 1917, killing 13. Gibbons and the
survivors arrived soaked and frozen in Queenstown,
Ireland, where the reporter cranked out his story.

Within six weeks Congress declared war, yet pub-
lic sentiment was slow to build. President Woodrow
Wilson created the Committee on Public Informa-
tion, which issued press releases, produced patriotic
pamphlets and films, and organized a nationwide
speaking tour about the war. The CPI emphasized
domestic publicity but kept a hand in overseas news
too. When the first American troops arrived in France
on June 26, 1917, CPI releases announced their safe
arrival despite attacks by U-boats. All other accounts

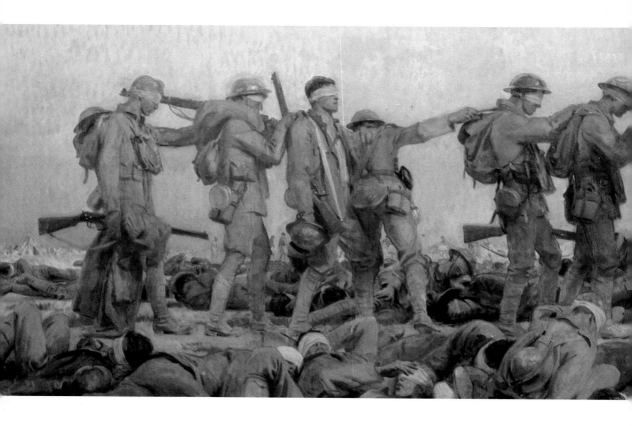

described an uneventful landfall. Pressed by investigators, George Creel, head of the CPI, said he had "elaborated" to boost patriotic fervor.

Creel endorsed filmmaker Lowell Thomas's attempts to find a good story about the war, but Thomas found that trench combat did not make good theater. He headed for the Middle East, where the British Army was organizing Arab resistance against the Turks. The Arabs hoped for independence, inspired by a shy Oxford scholar, Col. T. E. Lawrence. Thomas called Lawrence's technique "jujitsu"—the turning of Turkish military strength against itself—but in fact it was brilliant guerrilla warfare.

"Battles in Arabia were a mistake," Lawrence wrote later. "Our cards were speed and time, not hitting power." Lawrence's raiders blew up railroad tracks, destroyed bridges, and captured enemy strongholds, including Aqaba, by surprise and guile. Thomas's cameras loved the pale-eyed, white-robed Englishman. News of Lawrence's exploits broke in a French paper, *Echo de Soir,* in September 1918.

London papers printed a translation. British censors requested that no publication print his photograph, as Lawrence's face was unknown to the Turks. After the war, Thomas brought Lawrence to the attention of the world through lectures, lantern slides, and films. He earned a million dollars and created the legend of "Lawrence of Arabia."

American troops arriving in France were accompanied by some of the day's best war correspondents. Heywood Broun of the *New York Tribune,* whimsical and big-hearted, wrote up the supply blunders he witnessed—and then his accreditation was revoked. So, too, were the credentials of Wythe Williams of the *New York Times,* who submitted a story to *Collier's Weekly* without showing it to the censors. His information about a failed French offensive came from Clemenceau, but the story hurt U.S.-French relations.

For American accreditation, a journalist had to post a $3,000 bond and deposit $1,000 with the adjutant-general; wear an Army uniform with a green arm band displaying the letter "C"; and submit

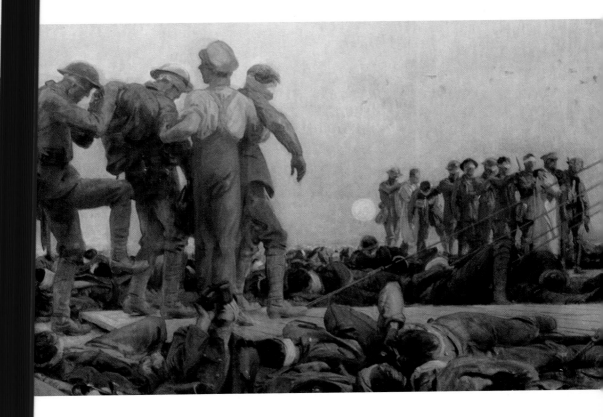

ies for military censorship. Many journalists
ed without accreditation, and as many as 400 vis-
war scenes. Only one black American journalist,
ph W. Tyler, working in France for the War Depart-
nt, sent dispatches to papers for black Americans.
out a dozen women joined the ranks. Reporters
tested the advantages of Henrietta "Peggy" Hull of
El Paso Times, friend to Army General Pershing
ce she had covered his pursuit of Pancho Villa. Per-
ng let Hull write personal pieces about the soldiers
Neufchâteau. She received accreditation in Sep-
nber 1918, two months before war's end, and was
Russia when the armistice was signed.

Very little authentic newsreel footage was shot
the Allied side at the western front. Military

inger Sargent painted "Gassed," above, after visiting
nt in 1918. The realities of war were not easy to
Complained Sargent, "The more dramatic the
on, the more it becomes an empty landscape."
ing pages: Sargent's words might have described
ttlefield at Passchendaele, in Belgium.

photographers such as Edward Steichen worked for
reconnaissance, communications, and intelligence,
but not for the American public. Photographs that
might hurt morale never made it home. Censors
banned photos of black and white soldiers together.

On November 7, 1918, the head of the United
Press, Roy W. Howard, published what he thought
was an exclusive story on the war's end. In fact, it was
false. Other wire services denied the story, and UP
filed a correction. The war ended for real on Novem-
ber 11, after three days of negotiations in a railway
car. German soldiers cautiously emerged from their
trenches. Americans cheered as if at a college sport-
ing event. Germans, British, and French joined in.

But the reporting was not over. Five correspon-
dents— Lincoln Eyre of the *New York World,* Fred
Smith of the *Chicago Tribune,* Herbert Corey of the
AP, Cal Lyon of the Newspaper Enterprise Associa-
tion, and George Seldes of the Marshall Syndicate—
traveled east from Luxembourg into Germany on
November 21, determined to interview Paul von

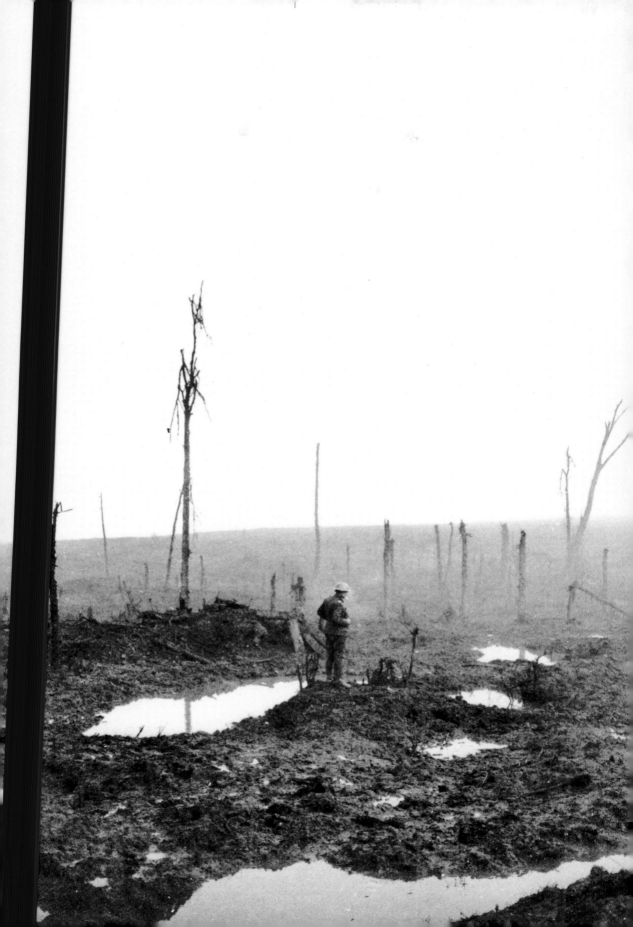

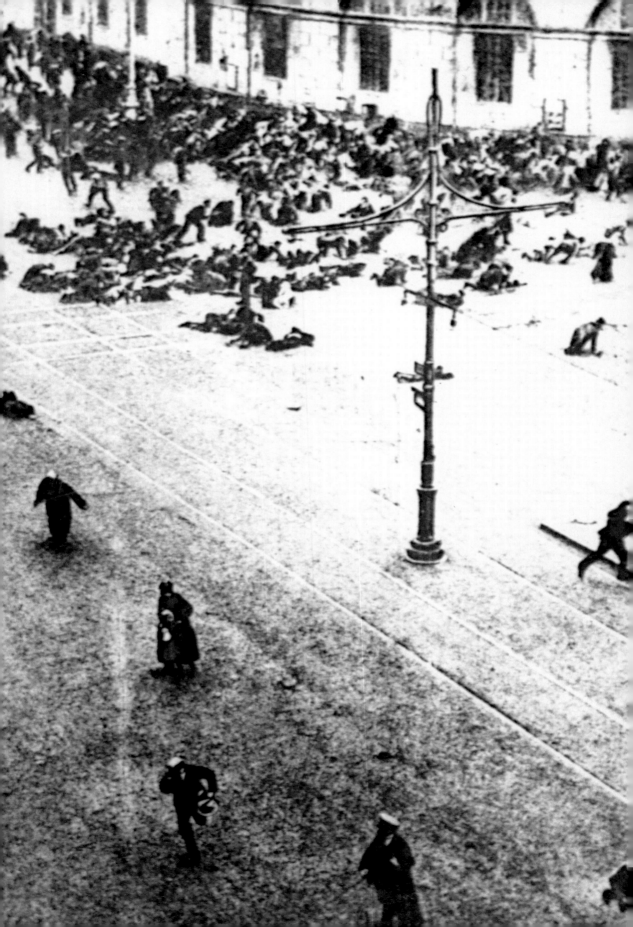

[Hind]enburg, virtual dictator of Germany at war's end.
"[Th]e Americans are splendid soldiers," Hindenburg
[called] them. "Each American division came in fresh and
[bold a]nd on the offensive.... The American attack won
[the] war." In the end, perhaps 8 to 10 million people
[die]d and 21 million were wounded in the world's first
[tota]l war. It would not be the last.

In Russia, Tsar Nicholas II abdicated in March
[19]17, replaced by a democratic leader, Alexander
[Ke]rensky. In April, the Germans sent Vladimir
[Ul]yanov, a revolutionary known as Lenin, from
[Sw]itzerland to his Russian homeland, hoping that his
[m]ischief would turn to Germany's advantage. While
[L]enin organized his Bolshevik followers, German
[at]tacks demoralized the Russian Army. A million
[R]ussian soldiers deserted late that summer.

In the fall, Lenin led the Bolsheviks in revolution.
[T]hey stormed Petrograd's Winter Palace on October
[2]5, taking over Kerensky's government. Few corre-
spondents witnessed or understood the revolution.
Only John Reed of the *Metropolitan* and *New York
Call* and Philips Price of the *Manchester Guardian*
were on hand to record what Reed called "Ten Days
That Shook the World." Reed, whose life would be
chronicled in the film *Reds,* witnessed the triumph of
Lenin, "gripping the edge of the reading stand, let-
ting his little winking eyes travel over the crowd"
during a long ovation, then announcing, 'We shall now
proceed to construct the Socialist order!'"

TO CAREFUL OBSERVERS, the signs of a second global
conflict announced themselves in two regional wars
of the 1930s: the Ethiopian War of 1935-36 and the
Spanish Civil War of 1936-39.

The Ethiopian War was the first major war since 1918.
Fascist Italy, expanding its empire and testing its new
army, sent 250,000 troops into East Africa against bare-
foot warriors armed with swords and old bolt-action rifles.
The war was brief, the slaughter horrific. Webb Miller
of the United Press and Floyd Gibbons of the *Chicago
Tribune,* the first two outsiders with Italian forces, set
typewriters atop sandbags above the Asamo Plain and
watched the invasion start at 5 a.m. on October 3. Other
journalists flew to Addis Ababa, the Ethiopian capital, to
report on Emperor Haile Selassie's troops mobilizing.

Temperatures reached 118°F in the shade, the air
was thin at 8,000 to 9,000 feet, and cables cost half a
crown per word. No Western reporters spoke Amharic,
which put them at the mercy of their translators. Fox
Movietone newsreel cameraman Laurence Stallings
rode 50,000 feet of film into battle on a Red Indian
motorcycle but got no decent combat shots. Print
journalists included British novelist Evelyn Waugh,
representing the *Daily Mail.* His pro-Italian sympa-
thies made his stories hard to sell. Waugh had never
covered a war before. He missed a story right under
his nose when Emperor Selassie tried to sell his coun-
try's oil rights to remove a major motivation for the
invasion. Waugh saved his best journalism for his
1937 roman-à-clef novel, *Scoop,* about a war in
"Ishmaelia" as seen by clueless correspondents.

The world eagerly awaited news of the fighting.
Italian columns captured the Ethiopian fortress of
Makalle in November 1935. Then the Italians stopped

to reorganize, and operations ceased until April. Most reporters in Addis Ababa never saw a battle, and only a few watched the Italian Army roll into the capital at war's end in May 1936. The deaths of 750,000 Ethiopians therefore went underreported.

TWO MONTHS LATER, the Spanish Civil War began. Army generals led by Francisco Franco rebelled against the left-wing Republican government, which in 1931 had overthrown King Alfonso XIII. The Republicans championed workers and the educated middle class, but after the coup Spain suffered through the worldwide Depression of the 1930s. The country split between old-order conservatives—the Catholic Church, the military, big business—and liberal Republicans. After their first coup attempt failed, Franco's revolutionaries—called Nationalists, Insurgents, or Fascists—welcomed foreign aid. Frank Kluckhorn of the *New York Times* reported in August 1936 that German planes had airlifted Franco forces to safety. The story was true, but the Nationalists pulled Kluckhorn's accreditation.

Soon German Condor Legion "volunteers" arrived with bombers and fighters. Russian Red Air Force "volunteers," Soviet tanks, and armored vehicles arrived into Spain's east-coast ports, joined by the International Brigades—volunteers from Europe and America. Soviet military advice swiftly turned the Nationalists into an efficient fighting force, although Communist associations scared off potential supporters.

Newspaper and radio correspondents fought chaos in the countryside and struggled against censorship, partisanship, and false information. Battlefield broadcasting debuted: a single experimental report on September 3, 1936, from H. V. Kaltenborn of CBS, from a haystack just across the French border. The war also gave birth to wartime radio propaganda: "We are forging a new Spain for all who will love and serve her. Arriba España!," said a typical Nationalist broadcast. Republicans jammed Nationalist stations and ordered civilians to stop listening.

Many mainstream publications initially backed Franco, who cast himself as the defender of the Catholic Church and the old order against the anarchy of a new socialist regime.

Most journalists in the field supported the Republicans. "We knew, we just knew, that Spain was the place to stop Fascism," *Collier's Weekly* reporter Martha Gellhorn said. She traveled to the Republican lines to help and, before taking up journalism, drove blood supplies to hospitals. Herbert Matthews of the *New York Times,* fresh from the slaughter in Ethiopia, agreed that the Republicans had decency and justice on their side. Ernest Hemingway covered the war for *Ken* and *New Masses* magazines and the North American Newspaper Alliance. He wrote descriptive pieces on war's human element, squirreling away observations for a future novel, *For Whom the Bell Tolls,* and squiring Gellhorn, whom he later married.

British socialist George Orwell, who went on to write the novels *Animal Farm* and *1984,* traveled to Spain as a freelance newspaper reporter. The *New Statesman* refused to print his reports, which criticized authorities on both sides. "Early in life I have noticed that no event is ever correctly reported in a newspaper," he wrote in 1943, "but in Spain, for the first time, I saw newspaper reports which did not bear any relation to the facts, not even the relationship that is implied in an ordinary lie. I saw great battles reported where there was no fighting, and complete silence where hundreds of men had been killed." Frustrated, he took up arms for the Republicans.

ONE OF THE MOST famous photographs of this war, and any war, may have been tainted by propaganda or fakery. Renowned American photographer Robert Capa, born André Friedmann in Hungary in 1913, began taking pictures at age 19 for magazines. Around September 6, 1936, he made a picture known as "Falling Soldier" or "Death of a Loyalist Soldier." The shutter appears to have clicked as a bullet struck a rifleman, who flung back his arms and began to crumple to the ground. The image evokes sympathy and

...sion. The stretched-out arms vaguely recall the
...ed Jesus.

...e picture first appeared that month in *Vu,*
...ch magazine, then caused a sensation when
...ed in *Life* in July 1937. Capa never published
...n account of the photograph. Other sources
...t: O. D. Gallegher of the *London Daily Express*
...epublican troops allowed Capa to stage a fake,
...ohn Hersey wrote that Capa watched a real
...t from a trench, raised his camera, and snapped
...erfectly framed negative without looking.
...orn and Matthews considered the picture authen-
...nother Capa picture published in *Vu* seems to
...y the same rifleman celebrating victory with
...w soldiers. The sequence of Capa's negatives is
...own. Recently the case for authenticity was
...ered when the man in the image was identified
...omeone known to have died in combat on
...ember 5, 1936. In any event, the image helped
...te Capa's reputation and became an icon of war.

...The most twisted journalism in Spain came from
...typewriter of British reporter Harold Adrian
...ssell "Kim" Philby, who wrote from the National-
...side while funneling information about the
...cists to the Soviet Union. Philby seemed a good
...oice to get close to the enemy. From the upper class,
...was educated at Cambridge and secretly became
...Communist while publicly espousing conservative
...ews. With the Soviets' blessing, he looked for a
...per to sponsor him in Spain. Editors at the *Times*
...st said they would look at any freelance pieces he
...red to send.

...Philby's big break came at Guernica, a Basque
...own in northern Spain. The Basques allied with the
...epublicans. In April 1937, German planes bombed
...e city of Guernica to rubble, killing one to two
...housand civilians. Controversy raged—and still
...continues—over whether it was a legitimate military

action or an exercise in terror. Clearly it was a dress
rehearsal for the *Luftwaffe,* the German Air Force,
whose tactics would include massive bombings of
heavily populated targets during World War II.
Franco's forces entered Guernica days later and
charged that much of the damage was caused by the
Basques, hoping to blacken the Nationalists' reputa-
tion. Keeping his Republican sympathies secret,
Philby filed a report with a pro-Nationalist slant. The
Soviets secretly applauded as the report won him
friends among the Nationalists. The *Times* made
him a full-time correspondent.

That autumn Philby reported the fall of Gijón, the
last Republican stronghold in northwestern Spain. On
New Year's Eve 1937, with the temperature at 18
degrees below zero, Philby and four other journalists
drove toward the town of Teruel. Just outside, they
stopped near a Nationalist artillery battery and a barn
to ask a group of soldiers for news. Without warning
they heard the swish of an incoming shell, a crash,
and the clatter of debris. Philby and Karl Robson of
the *London Daily Telegraph* survived, but Richard
Sheepshanks of Reuters, *Newsweek* photographer
Bradish Johnson, and Edward Neil of the AP were
killed. Robson figured that a Republican artillery
observer assumed that they were Nationalist staff
officers. On March 2, Philby received the Cross of
Military Merit from Franco himself—the best cover
possible for an anti-Franco Soviet agent. At a bull-
fight in Córdoba in the spring of 1937, guards noted
that Philby did not have a pass to be in the city.
They accused him of being a spy and searched his
suitcase. Only by throwing his wallet across the
interrogation table to divert their attention did Philby
swallow, unnoticed, the coded rice-paper message
from his Russian contacts.

Philby's Spanish Civil War journalism cemented
his standing with Soviet intelligence. He joined the
British intelligence service in 1940 and served for
more than two decades, all the while sending infor-
mation to Moscow. He defected in 1962 to avoid
exposure and arrest.

ROBERT CAPA

"IF YOUR PICTURES AREN'T GOOD ENOUGH, you aren't close enough," Robert Capa (1913-1954) told his fellow photographers. Capa, above, born André Friedmann in Budapest—later an American citizen—got plenty close. After leaving Hungary in 1931, he took a darkroom job in Berlin. He got his first break by sneaking a tiny Leica into a Copenhagen hall and capturing exclusive, close-in pictures of the camera-shy Leon Trotsky during a speech. As the Nazi regime took hold in Germany, Capa, who was Jewish, left Berlin for Paris in 1933. In World War II he dodged bullets on Omaha Beach on D-Day and jumped out of airplanes. In China he witnessed the resistance to Japanese occupation; in Israel, the fierce determination of immigrants in forging a homeland, every third person tattooed with a blue concentration camp number. In Vietnam, Capa's mantra proved his undoing. Stepping on a land mine, he died clutching his camera.

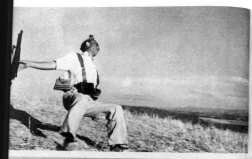

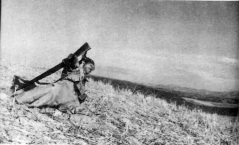

COMMENT
ILS
ONT FUI

Telle une reine calquée sur la Bible, la vision de ces raia fugitives au visage douloureux évoque les exodes tragiques de l'Ancien Testament. —PHOTO CAPA

C'est la migration du peuple d'une province tout entière, au pas lent des mulets lourdement chargés, parmi les cris des enfants sous le dur soleil. —PHOTO CAPA

Longeant les rails infinis, les enfants, insoucieux, croient à une promenade joyeuse, mais leur mère, d'un long regard, contemple une dernière fois le village embrasé. —PHOTO NAMARD

Peut-être viennent-ils heureux, peut-être coulaient-ils des jours paisibles dans un calme village. La guerre civile est venue et avec elle la déroute. L'écroulement d'un foyer dans la misère. CAPA

Solitaire, les larmes coulant sans bruit sur ses joues, cette pèlerine emporte avec elle tout son humble bien. —PHOTO CAPA

...first war was the Spanish Civil War in 1936.
...t because he hated the Fascism of Nationalist
...r Franco. Eschewing heavy equipment, he
...is 35-mm camera an extension of himself
...ok new kinds of pictures. "The pictures are
...nd you just take them," he said. His most
...s photograph, "The Falling Soldier," above
...llowing pages, first appeared in 1936 in *Vu*
...ine. In the 1970s historians questioned its
...nticity, but recently Capa's biographer, Richard
...n, published strong evidence that the soldier
...erico Borrell Garcia, who died September 5,
...in Cerro Muriano. A forensics expert has also
...that the curled fingers of his left hand indicate
...he muscles are limp, a sign that he is dead.

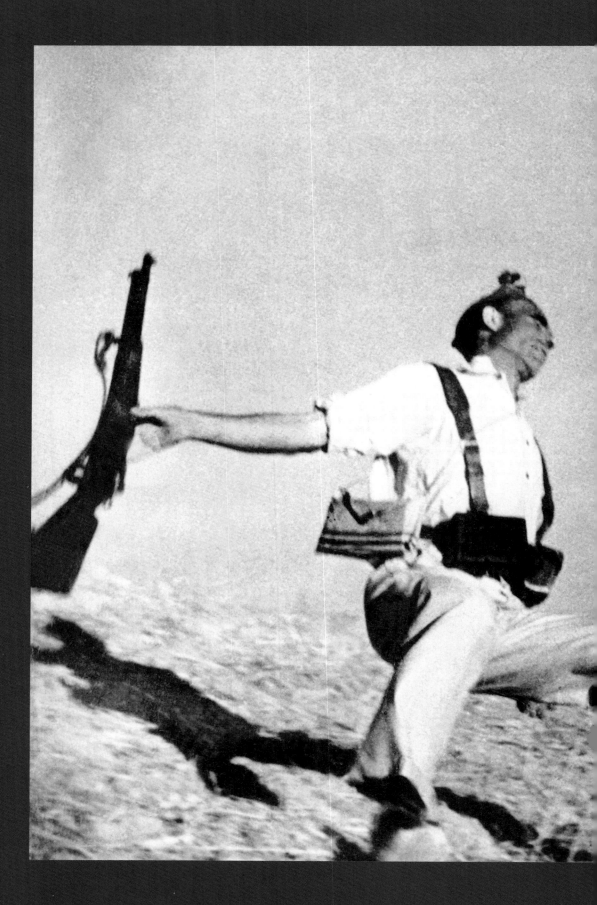

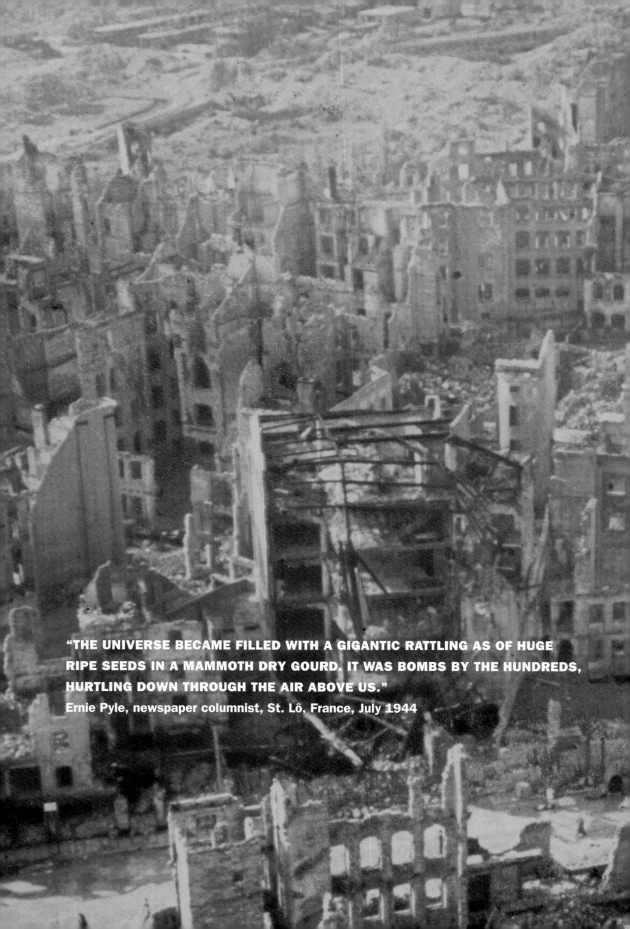

"THE UNIVERSE BECAME FILLED WITH A GIGANTIC RATTLING AS OF HUGE
RIPE SEEDS IN A MAMMOTH DRY GOURD. IT WAS BOMBS BY THE HUNDREDS,
HURTLING DOWN THROUGH THE AIR ABOVE US."
Ernie Pyle, newspaper columnist, St. Lô, France, July 1944

WORLD WAR II

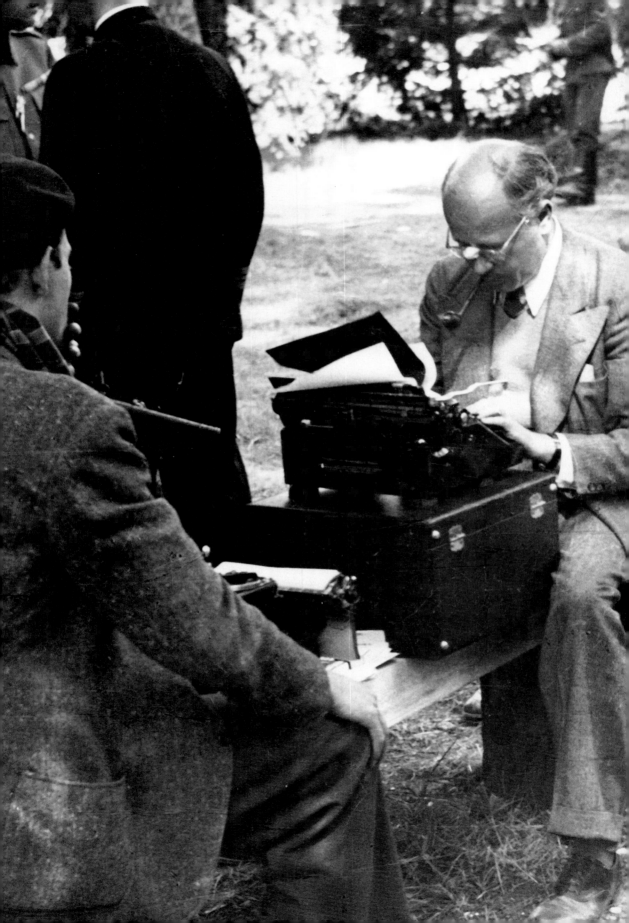

CHAPTER FOUR

AT 8 P.M. NEW YORK TIME, Sunday, March 13, 1938, radio journalism received its baptism of fire. The monumental half-hour program, *The World Today*, began precisely on the hour, springing from the aggression of the world's most dangerous dictator and the ambition of the brooding young man who would soon become the world's most celebrated broadcaster.

During the Depression era of the 1930s, listeners who gathered around their crackling, boxy radios heard sermons, music, comedy, drama—and the fireside chats of Franklin D. Roosevelt, the first President to broadcast directly to the nation. In 1933, though, the year of Roosevelt's inauguration, newspaper publishers feared that radio might replace the press for news. Amid this so-called "Press-Radio War," the fledgling broadcasting industry agreed to limit daily news to two five-minute summaries, one after 9:30 a.m. and one after 9 p.m. Golden-throated announcers such as NBC's Lowell Thomas and CBS's Boake Carter provided analysis and anecdotes, but no news. One NBC executive said Thomas "had a million-dollar voice but not a nickel's worth of news."

Preceding pages: A still-erect statue looks out over Dresden, Germany, after it was gutted by Allied firebombing in February 1945. The city had no bomb shelters. Left, in the early stages of World War II, June 1940, CBS correspondent William L. Shirer reports from the scene of the French surrender to the Germans. Adolf Hitler arrived in a black Mercedes and had a "spring in his step," Shirer said.

*A Sudeten woman tearfully acknowled[ges]
the new order, left, after Hitler annexe[d her]
homeland in 1938. Right: German inf[antry march]
through a town in Norway in spring 19[40].
The surprise invasion advanced so swi[ftly that]
few Western journalists were able to c[over it.]
Following pages: The war spread acro[ss Europ]e
and throughout the Pacific.*

One winter day in 1938, 29-year-old Edward R. Murrow, just installed in Vienna by CBS, received a new assignment. Born Egbert Roscoe Murrow to a dirt-poor farm family in North Carolina, he had moved to Washington State when he was six. He drove a bus, worked as a lumberjack, flirted with radical politics, and sang union songs. At Washington State College, he had majored in speech. His rich baritone, controlled pace and tone, and flair for connecting with audiences made him a natural communicator.

CBS assigned him to line up expert speakers from Europe. Murrow's first catch was William L. Shirer, a 33-year-old, pipe-smoking bon vivant. Shirer had been in Berlin for a dozen years, spoke excellent German, and knew a lot about Adolf Hitler and the Nazis. When William Randolph Hearst closed his Berlin wire service office, Shirer lost his job. His voice was as flat as his home state of Iowa, but Murrow believed listeners would value his knowledge and forgive his voice.

Hitler turned toward Austria in 1938. Austria's Chancellor Kurt Schuschnigg had jailed Nazi leaders, but when Hitler pressured him to free them and put Austria's top Nazi in his cabinet, Schuschnigg agreed. Next Hitler demanded *Anschluss* (annexation) to create a Greater Germany. Schuschnigg scheduled a public vote on the issue for March 13, but on March 11 the German Army marched in. Germany formally annexed Austria, in violation of the Versailles Treaty. Murrow told Shirer to fly to London, get a transmitter, and report the news to

the world. CBS President William Paley [liked] Shirer's eyewitness account and wanted re[ports] from across Europe. Shirer in London and M[urrow] in Vienna had seven hours to organize a live evening roundup.

On a Sunday afternoon, it was nearly imp[ossible] to find speakers. The broadcast would have [to go] blindly from phone to phone, city to city, w[ith] overlaps or silences. It had never bee[n done] before—and Murrow and Shirer pulled it off[.]

They lined up a Labour Party mem[ber in] London, a Chicago newspaperman in Pari[s,] reporters in Berlin and Rome, and Mur[row in] Vienna. The man who would become the v[oice of] World War II radio told America that the Vi[ennese] were in a holiday mood. "Young storm troop[ers are] riding about the streets ... singing and t[ossing] oranges to the crowd." The broadcast was [calm,] authoritative, and detailed.

Two months later, Hitler alleged persecu[tion of] ethnic Germans in Czechoslovakia. British [Prime] Minister Neville Chamberlain and French P[remier] Edouard Daladier agreed that Germany [could] annex the Czechoslovakia's Sudetenland—b[ut] left the Czechs out of the discussion. Chamb[erlain] said the Anglo-German friendship document s[igned] by Hitler guaranteed "peace in our time."

Hitler's troops ignored the agreemen[t and] annexed the rest of Czechoslovakia in March [1939.] Hitler secretly planned an invasion of Pol[and to] gain more *Lebensraum*, or living space. S[hirer] broadcast from Germany under Nazi cens[orship.]

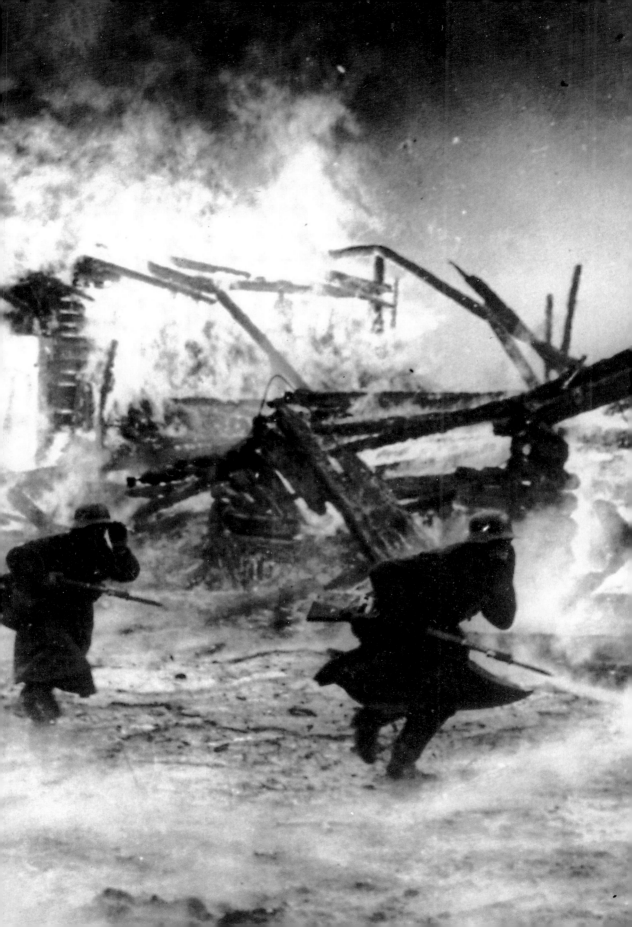

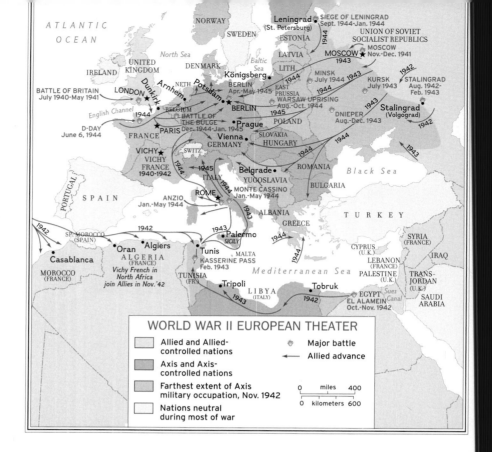

and Murrow broadcast from London. In November 1938, they reported on *Kristallnacht,* the "night of broken glass" when dozens of German Jews were killed, 800 Jewish-owned businesses destroyed, and thousands shipped off to concentration camps. Consumed with gloom, running on cigarettes and adrenaline, Murrow slept irregularly, yet his programs took on a strong, comfortable, regular tone. "This is London," he began. On the advice of Ida Lou Anderson, his Washington State speech professor, he emphasized the first word. It became his trademark.

On August 27, 1939, Hitler and Soviet leader Josef Stalin signed a non-aggression pact and divided Poland. On August 31 Shirer simultaneously translated Germany's broadcast of terms for Polish peace. The Nazis obviously meant to invade. Shirer awoke the next morning to a call from the *Chicago Tribune's* Berlin correspondent, Sigrid Schultz. At 5:11 a.m., September 1, the German Army had crossed the Polish border. Members of the elite

Nazi security guard, the *Schutzstaffel*—"S short—had staged a mock raid on a radio sta the border. Wearing Polish uniforms, they the station, broadcast threats in Polish, and l casualty—a concentration camp inmate th also dressed in Polish uniform. Fighter bombers of the Luftwaffe attacked Polish The Polish Air Force was virtually destroyed bombers attacked road and rail. Britain, F Australia, and New Zealand declared w Germany on September 3.

WORLD WAR II opened with German tank planes crushing the Polish horse cavalry. It en the atomic age. It touched every continent e Antarctica and cost 50 to 60 million lives incl 15 million soldiers. Some estimate that 1 reporters covered the war's early months— soldier-journalists, such as the 12,000 Germa Russia. The sheer size of the conflict it impossible for any one person to observe

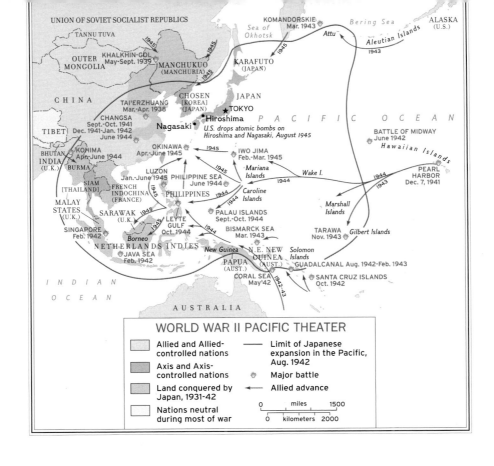

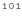

WORLD WAR II PACIFIC THEATER

Allied and Allied-controlled nations	—— Limit of Japanese expansion in the Pacific, Aug. 1942
Axis and Axis-controlled nations	Major battle
Land conquered by Japan, 1931-42	← Allied advance
Nations neutral during most of war	

0 — miles — 1500
0 — kilometers — 2000

battles and war at sea tested correspondents' skills. On the ground, a correspondent could move about, but that did not guarantee comprehensive coverage. Alan Moorehead, an Australian reporter who covered the Sahara war for the *London Daily Express,* called it "a knights' tournament in empty space," "a great deal of dust, noise, and confusion."

American novelist John Steinbeck, who wrote for the *New York Herald Tribune,* best described the correspondent's experience. "Those paintings reproduced in history books which show long lines of advancing troops are either idealized or else times and battles have changed.... What the correspondent really saw was dust and the nasty burst of shells, low bushes and slit trenches.... He lay on his stomach, if he had any sense, and watched ants crawling among the little sticks on the sand dune." The journalist smelled cordite, blood, and disinfectant; he saw dead children, crumpled houses, and pulverized farm animals. But at the end of the day, Steinbeck said, journalists

would take an army communiqué on faith and just write something like, "The Fifth Army advanced two kilometers."

Despite the challenges, World War II was probably history's best-reported war. Tens of thousands of images appeared in newspapers and the new photo-friendly magazines such as *Life.* Radio news gave listeners a ringside seat at much of the action. Print journalists, at least on the Allied side, enjoyed unprecedented levels of cooperation with the military and the government.

"News policy is a weapon of war," declared Nazi Propaganda Minister Joseph Goebbels. As long as the German Army advanced, Goebbels gave out facts from the front and tolerated neutral correspondents. Propaganda Kompanie (PK) units, commanded by the Wehrmacht, the German Armed Forces, took most of the surviving newsreels and still photos of the Polish and French invasions. The *Deutsche Allgemeine Zeitung* stretched credibility with its headline, "Poles Bombard Warsaw"—like

all papers, it wrote what it was told. Germans caught listening to Allied radio could be fined, jailed, or executed.

Extended punishment went to UP reporter Richard C. Hottelet. Raised in New York by German parents, he loved the Germans but "hated the Nazis' goddamn guts." He barked questions in perfect German at Gestapo agents whom he saw rounding up Jews. Early in 1941, agents arrested Hottelet in the middle of the night, held him in prison and interrogated him for weeks, then finally released him in return for Nazis held in America. Otto Tolischus, who reported for the *New York Times,* was kicked out of Berlin shortly after quoting army officers as saying that Germany and the Soviet Union faced "inevitable dispute."

The German Army crushed Poland "like a soft-boiled egg," wrote Tolischus. The new tactic of *blitzkrieg* ("lightning war") worked. Using surprise maneuvers and close air support, German infantry slashed through weak spots in enemy lines. The Poles fought gallantly, but the relentless German double pincers closed around their cities. The Soviet Army invaded Poland on September 17, and the Poles stopped fighting by October 6. Britain and France established a naval blockade and never attacked Germany's western defensive wall, not knowing how undermanned it really was.

In April 1940 the German Army invaded Norway and Denmark. Leland Stowe, a reporter for the *New York Herald Tribune,* had arrived in Oslo a few days earlier. On April 9, Germans landed and

spread into the interior, pushing Norwegian[...] into a fighting retreat. On April 20, a Franco-[...] force landed, and Stowe witnessed the [...] bungled attempt to repel the Nazis.

Stowe highlighted how pro-Nazi poli[...] Vidkun Quisling, the Norwegian Benedict A[...] collaborated with the enemy. Allied forces [...] drew by May 2, and Norway's king and g[...] ment evacuated to Britain. Writing from n[...] Sweden, Stowe reported that 1,500 Ge[...] occupied Oslo, a city of 300,000. His indictm[...] British ineptitude contributed to the down[...] Chamberlain, soon replaced by Winston Chu[...]

On May 10, Germany invaded the Nether[...] Belgium, and Luxembourg. Over two and [...] million men, including ten armored and [...] motorized divisions, assembled along the b[...] of France and the Low Countries. Germany [...] into Holland and Belgium and reached the E[...] Channel on May 21. At the same time, arm[...] units cut north through France to capture Boul[...] French censors kept any Allied retreat under v[...] approving only news on German losses. [...] Sevareid, recently hired at CBS, evaded cens[...] writing in code that the German Army was s[...] ing unchecked through France. British and F[...] troops numbering 335,000 fled across the En[...] Channel, and reporters on England's southern [...] reconstructed the scene.

On June 5 German forces marched on Paris[...] French government escaped on June 9, lea[...] Paris to fall to the Germans five days later. [...]

102

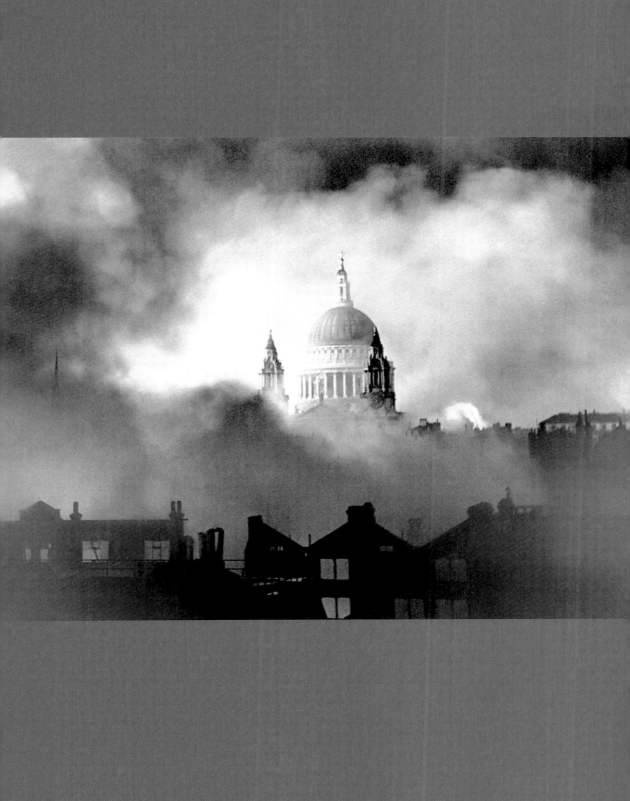

Minister Paul Reynard resigned; France's new leader, Marshal Philippe Pétain, asked for an armistice. Shirer headed to Paris on "the saddest assignment of my life." He watched as Hitler forced French generals to sign the terms of capitulation ordering French disarmament and German occupation of the northern three-fifths of France. The new French government moved south to Vichy. Hitler prohibited broadcasts of the surrender, but a technician threw the wrong switch, and Shirer's live report reached CBS and the world.

Next Hitler turned his attention to Britain—and the skies. The Luftwaffe could muster more than 2,800 modern fighters and bombers, while the RAF Fighter Command could assemble perhaps 650 aircraft, some older models. The Battle of Britain opened with German air attacks on ships and the coastline in the summer of 1940. Using radar, a new secret weapon, the Royal Air Force responded.

BBC reporter Charles Gardner, on the ground in Kent, reported a live dogfight in the skies above

him. "There's one coming down in flames .. coming down completely out of control—a streak of smoke—ah, the man's bailed out by chute." The BBC used news and commenta coax the United States out of neutrality. Br officials also lifted restrictions on the Americans covering the war in the skies. Star on August 22, the Germans focused on British fields, but the RAF kept on fighting, shooting d more than 1,700 German planes. On Septembe the Luftwaffe received new orders: Switch fi tactical to strategic bombing. Target London. Le the city and destroy British will.

For 57 consecutive nights, German bomb pounded London. The wail of air-raid sirens r onated through stories heard by American ra audiences. Murrow described smoke over t Thames and flames turning the moon blood-re The Air Ministry let him broadcast live during t bombings, and he caught the boom of antiaircr guns and the crump of German bombs showeri

Stunned airmen on the ground, left, watch the
U.S.S. Shaw *explode during Japan's surprise attack*
on Pearl Harbor, outside Honolulu, Hawaii,
on December 7, 1941.

shrapnel. "Now you'll hear two bursts a little nearer in a moment," he told radio listeners across the ocean. "There they are! That hard, stony sound." He held the microphone to the ground to catch the sound of bombs hitting the pavement. The broadcasts changed American opinion. In late 1940, the U.S. traded 50 destroyers for leases on British bases. Soon the Lend-Lease Act sent munitions to Britain. In doing so, Roosevelt had distorted the U.S. definition of neutrality. Britain accepted the aid and kept on fighting.

Meanwhile, journalists in Berlin picked up subtle signs that Hitler was planning to attack the Soviet Union. Howard K. Smith, a United Press reporter later with CBS, noticed in 1941 that a bookstore had changed its window display. Gone was the volume of Soviet short stories—*Schlaf Schneller, Genosse (Sleep Faster, Comrade)*—replaced by political books on the evils of Communism. Then Smith got a tip that all German Army leaves had been canceled. German censors struck every reference he made to Russia.

Josef Stalin heard warnings of a German attack, too, but still the June 22, 1941, invasion caught his army unprepared. The Germans' three-pronged attack on the 2,000-mile front worked. By September German troops captured more than 240,000 Russians, 2,500 tanks, and 1,100 guns in the south, near Kiev. In the center, they captured 290,000 Russians at Minsk and another 100,000 at Smolensk. General Semën Timoshenko's army was falling back toward Moscow in disarray. Two

million Germans advanced up to 50 miles a day. German planes flew over the battlefront, destroying about 2,000 Soviet aircraft.

The West received little news of the opening struggle. Two Americans, photographer Margaret Bourke-White and her husband, writer Erskine Caldwell, were already in Russia to do a feature story for *Life* magazine. The only Western photographer there, Bourke-White desperately wanted to capture the bombing of Moscow and the Red Army in action, but the army had ordered the execution of anyone with a camera. By the middle of July, Bourke-White had received permission. From the roof of the American Embassy, she photographed the magnesium flares, explosion flashes, and anti-aircraft bursts that colored the sky, she said, "as though the German pilots and Russian antiaircraft gunners had been handed enormous brushes dipped in radium paint."

The Germans encircled Kiev and captured 665,000 Russian soldiers by September 19. The advance slowed, yet the Wehrmacht edged toward Moscow and Leningrad. On October 9, Hitler's press chief, Dr. Otto Dietrich, announced at a Berlin press conference that the last ragged bits of the Red Army were being annihilated outside Moscow. *Volkischer Beobachter's* headline read, "Campaign in East Decided!"—but then the Red Army held. Could the Soviets stop Hitler's war machine? In Moscow, an interpreter told *Collier's* reporter Quentin Reynolds, quoting Tolstoy, "The maggot may gnaw at the cabbage, but the maggot

105

dies before it has killed the cabbage." Stalin appealed to his people to fight not for the Communist Revolution but for Mother Russia.

Winter proved a powerful ally for Russia, since the Wehrmacht had not prepared for a winter campaign. From the Pacific, Gen. Douglas MacArthur told CBS newsman Bill Dunn that Hitler should have studied Napoleon's ill-fated 1812 invasion of Russia. The Russians "have unlimited manpower, and they can retreat, mile by mile, clear across Siberia," he said, and he was right. The Soviets relocated their government more than 500 miles east in Kuybyshev. Stalin remained in Moscow. Heavy industry was transported east of the Urals, leaving the ice and thousands of guerrillas to harass the Germans. Sentries froze to death. Frostbite forced thousands of amputations. Marshal Georgi K. Zhukov, defending Moscow, launched a massive counterattack in temperatures down to 40° below zero and forced German units to hunker down along the front.

The Soviet Information Bureau called on Russian journalists to inspire the nation. Cameramen at the front produced 120 staged documentaries to convince the Allies that the Russians would survive. In the Russian Army's paper, *Red Star,* Vassili Grossman described the pivotal Battle of Stalingrad in surreal abstractions: "Yes, our soldiers have conquered the sun, they have conquered the daylight, they have conquered the right to walk erect over Stalingrad soil." In Stalingrad Alexander Werth, writing for a group of

British papers, saw waxen corpses and G[...] soldiers dying in their own filth.

Hitler wanted to capture Leningrad, form[...] Petersburg, birthplace of the Bolshevik Rev[...] and the key to northern Russia. Nazi troops[...] encircled the city in October 1941, but th[...] Army turned every Leningrad house into[...] according to Curzio Malaparte, reporter for[...] *Corriere della Sera.* For 900 days, Leningr[...] inaccessible except for a road over icy[...] Ladoga, which Malaparte crossed in Feb[...] 1942. "Under my shoes, imprinted in the ic[...] transparent crystal, was a line of beautiful [...] faces, a line of glass masks like a Byz[...] icon. They were looking at me, staring at me[...] images of Soviet soldiers who had fall[...] the attempt to cross the lake. Their poor b[...] imprisoned all winter by the ice, had been[...] away by the first spring currents. But their[...] remained printed in the pure, green-blue cry[...] Westerners would not know the extent of the[...] suffering until Harrison Salisbury's best-s[...] book, *The Siege of Leningrad,* appeared in 19[...]

On the southern front a new German comm[...] er, Gen. Eric von Manstein, recaptured Kh[...] before the spring mud. Hitler delayed his[...] attack, and the Red Air Force gained superi[...] Germany lost 70,000 men and 3,000 tanks. [...] Jacob of the *London Daily Express* reported[...] the Russians adapted to blitzkrieg: They le[...] German tanks pass over their foxholes, [...] emerged, wiped out the supporting infantry[...]

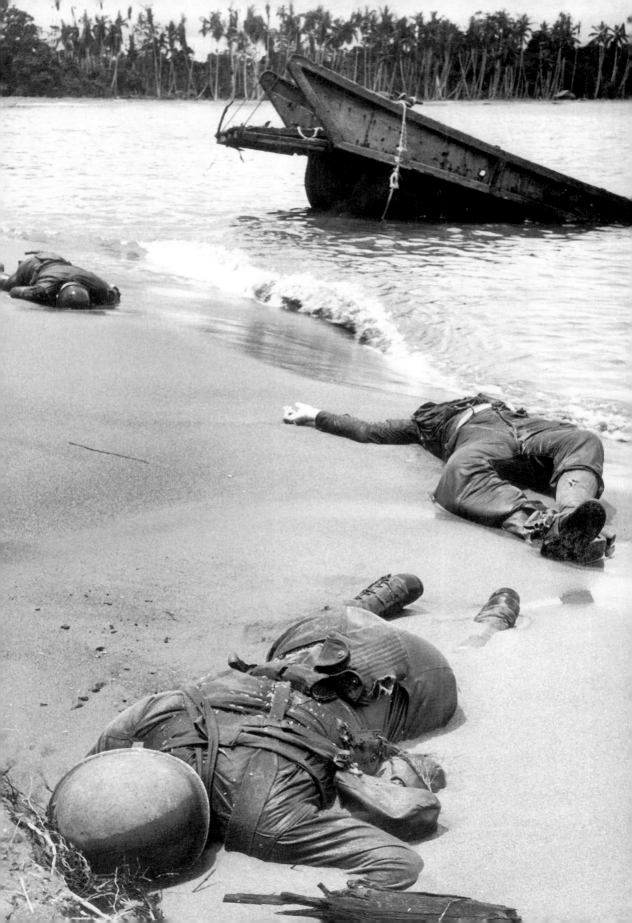

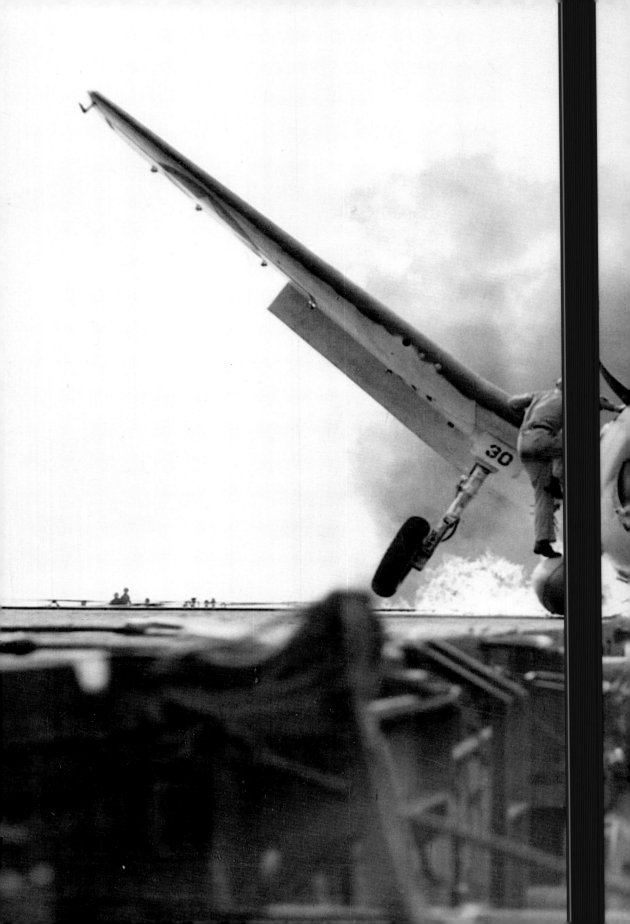

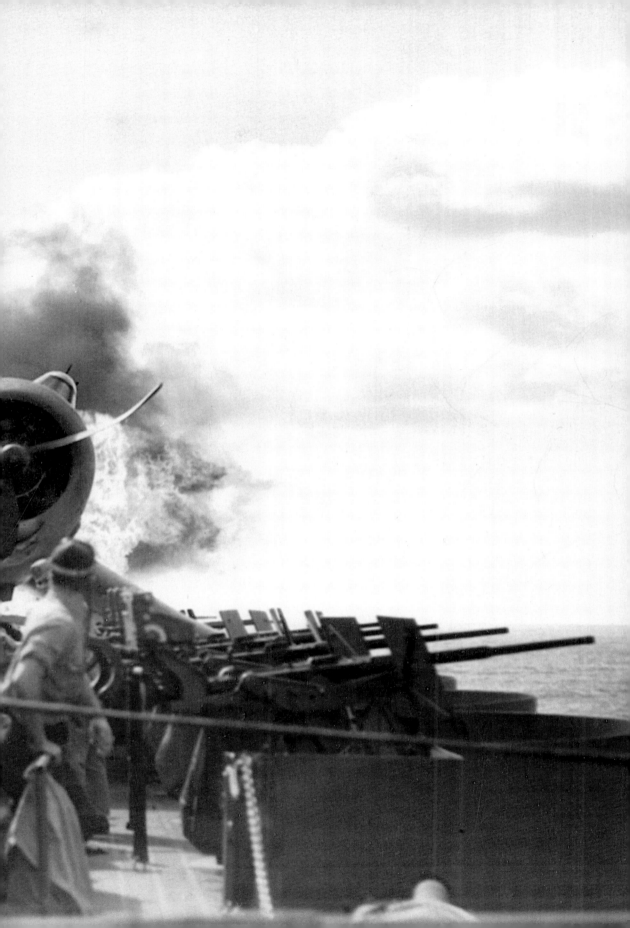

"I am a gambler. I decided to go in wi
Company E in the first wave," said Ro *a*
about D-Day, June 1944. Through a d
error, Capa's D-Day images turned ou *ally*
defective but impressionistically corre *t.*

picked off the 70-ton Tiger tanks by artillery, anti-
tank guns, and more maneuverable tanks.

Germany's final defeat was guaranteed not only
by the Soviets' toughness but by America's entrance
into the war. For the first 27 months of the war, the
isolationist movement was strong, but reasons for
Americans to prepare for war were mounting.
Europe was being devastated. Japan had been mak-
ing aggressive moves since 1931. On December 7,
1941, at 7:53 a.m., the Japanese attacked the
American naval base at Pearl Harbor, just west of
Honolulu, Hawaii, destroying much of the Pacific
Fleet, wrecking 200 planes, and costing more than
3,000 lives. The attack united Americans for war.

Americans had expected a Japanese attack, but
in the Philippines or the Dutch East Indies. Despite
theories to the contrary, Roosevelt almost certainly
did not know of the attack in advance. He had
invited the Murrows, Edward and his wife, Janet, to
dinner that night. Murrow was playing golf that
afternoon when a CBS messenger delivered a tele-
typed message: The Japanese had attacked Pearl
Harbor. The message came from Reuters. "Pay no
attention," said Murrow, but by the next hole, the
news was coming from everywhere.

Eleanor Roosevelt insisted that they come to the
White House for dinner anyway. The President did
not appear, but around 1 a.m. he asked to see
Murrow. Looking emotionally drained yet calm,
Roosevelt began by asking about London and
Churchill and observing that Britain and America
were finally "in the same boat." Then he railed

about losses at Pearl Harbor, citing deta
beyond the carefully worded White Hous
statements. American planes had been destr
he pounded his fist—"On the ground, by G
the ground!"

As *New York Herald Tribune* reporter
Bigart later observed, the attack was "a des
throw of the dice" by Japan's military leaders.
1930s they plotted to dominate East Asia a
Pacific. They manufactured pretexts for inv
Manchuria in 1931 and northern China in 19
1940, Japan signed the Tripartite Pact
Germany and Italy, pledging to oppose any c
that joined the Allies, especially the United S
major obstacle to Japan's vision of the "Gr
East Asia Co-Prosperity Sphere." Agreeing to
trality with the Soviet Union in 1941, Japan
Indochina from the helpless Vichy governm
America, Britain, and the Netherlands
Japanese assets and halted trade, leaving Jap
dire need of oil.

Japan planned a two-part offensive: Secur
oil fields of the Dutch East Indies and strike a
United States. If its Pacific fleet could be crus
America would have to agree to the new status
Some Japanese leaders voiced objections, par
larly Adm. Isoroku Yamamoto, who told ano
officer after the Pearl Harbor attack, "I fear tha
we have done is to awaken a sleeping giant."

In a hotel 15 miles east of Pearl Har
Joseph C. Harsch of the *Christian Science Mor*
heard planes on December 7 and told his wi

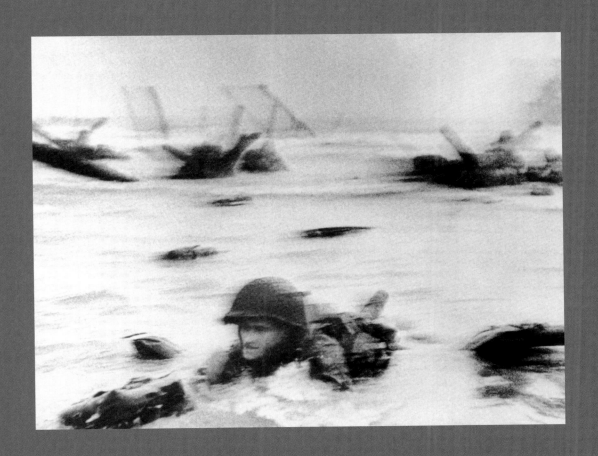

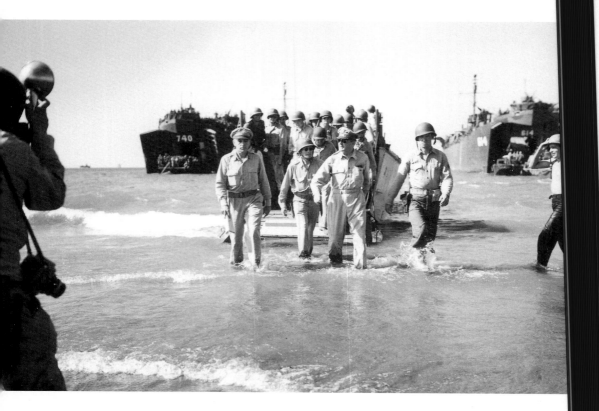

was an air raid. The United Press was the first to report the news. Waking to the sound of antiaircraft guns, reporter Frank Tremaine called an Army press officer, asking if it was the Germans. He dictated cable flashes to San Francisco and Manila and rushed to the scene. When the UP's San Francisco office called, Tremaine's wife, Kay, described the attack as it was happening. Censors from the Office of Naval Intelligence cut the conversation off.

On December 8, some 108 Japanese bombers demolished America's Clark Field air base in the Philippines. Japan managed a string of victories in Singapore, Malaya, Hong Kong, the Philippines, Borneo, New Guinea, and Java. In March 1942, MacArthur fled the Philippines for Australia, proclaiming at a press conference, "I shall return." American troops in the Philippines withdrew to the Bataan Peninsula, then the island of Corregidor, where they were defeated on May 6. With them was Shelley Mydans, a reporter for *Life*. The magazine

liked her stories about the retreat but asked that next dispatch "be on Americans on the offensi To that, Shelley Mydans replied: "Bitterly reg your request unavailable here." She and her h band, photographer Carl Mydans, were held capt in Manila for 21 months.

Japanese planes had sunk five battleships a damaged three at Pearl Harbor—although cens kept those details from the public—but some sh in the fleet remained. Aircraft carriers were the n key to naval power: called "flattops," these meg ships had runways so planes aboard could deploy short notice. No flattops had been anchored at Pe Harbor on December 7, and they represented th one ray of hope for America.

The first major naval engagement in the Pacifi the Battle of the Coral Sea, took place in early Ma 1942. A Japanese carrier task force took off planning to escort a landing force into New Guinea Intercepted messages alerted two U.S. carriers, the *Lexington* and the *Hornet*. For two days, American

and Japanese carrier-based planes pounded each other's ships. The *Lexington* sank in the second day of battle. The Japanese lost one carrier and another suffered severe damage. The fight was a draw, but Japan did cancel plans to strike at Australia.

The second major engagement devastated the Japanese Navy. On June 4, they attempted to seize Midway Island in the central Pacific but failed to suppress the island's defenses. American aircraft caught Japanese planes preparing for a second attack and left three Japanese carriers burnt wrecks. Japan's only remaining flattop, the *Hiryu,* crippled the U.S.S. *Yorktown,* but the *Enterprise* staged a counterstrike and sank the Japanese carrier. In one engagement, U.S. forces had destroyed Japan's naval carrier forces in the central Pacific. Tragically, a Japanese submarine sank the *Yorktown* on its return to Pearl Harbor.

Naval secrecy kept the Battle of Midway one of the most unheralded of the war. No Allied correspondents witnessed it except a film crew led by Hollywood director John Ford's Naval Volunteer Photographic Unit. His documentary won an Academy Award but distorted the victory by concentrating on Midway Island, when the key to victory was the sinking of four Japanese aircraft carriers hundreds of miles away.

It was a rare victory, David over Goliath. The Japanese fleet dominated in striking power, but America cracked the Japanese Navy's radio code and got advance word of the attack. *Chicago Tribune* reporter Stanley Johnston learned about the battle from a radio operator on a Navy transport ship. "Navy Had Word of Jap Plan to Strike at Sea," said Johnston's headline. The federal government convened a grand jury to prosecute Johnston for revealing sensitive information to the enemy, but prosecutors dropped their case and the Navy kept decoding.

All correspondents had to be accredited. Those who submitted stories and photos to censors got transportation, food, and security from the military. The Navy usually censored more, following Chief of Naval Operations Ernest King, who, Washington insiders joked, would prefer the Navy issue one press release at war's end to announce the winner. In the Army, MacArthur's censors often shaped the news to play up the general's role. Gen. Dwight D. Eisenhower, U.S. commander in Europe and North Africa, saw correspondents as "quasi–staff officers." Such freedom gave the public a robust picture of America's November 1942 North African invasion, code-named "Torch" and aimed to relieve pressure on Britain and Russia. On November 8, 1942, U.S. forces landed in Morocco and Algeria. Army censors passed a story by Drew Middleton of the Associated Press about General Eisenhower's defeat at Tunisia's Kasserine Pass, where German forces pushed north.

The top civilian photographers of the war included Margaret Bourke-White, who shot the Italian campaign, Nazi suicides at war's end in Berlin, and the liberation of concentration camps; Robert Capa, who waded ashore on D-Day; Carl

113

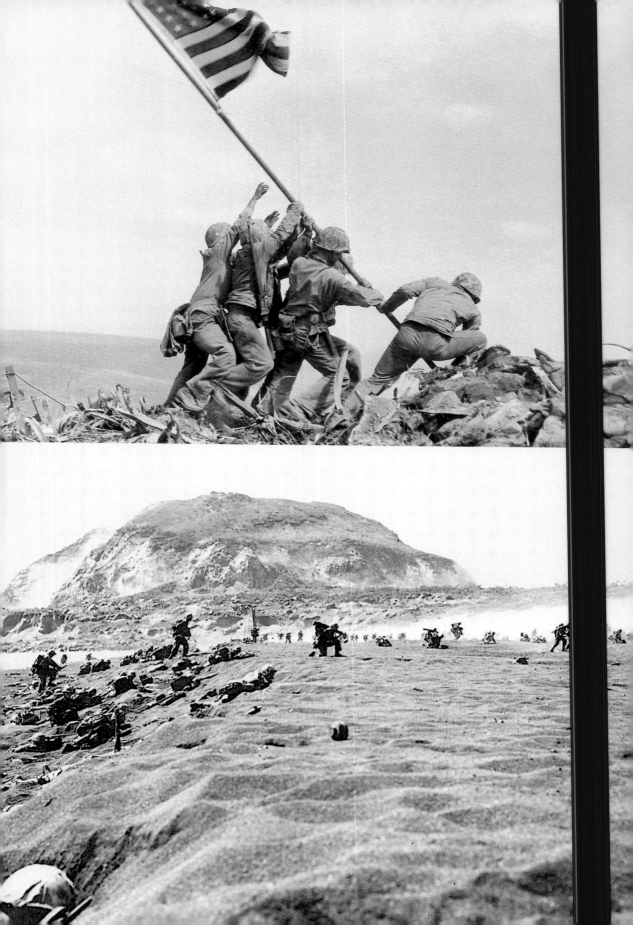

Mydans and W. Eugene Smith, who captured images of combat in the Pacific for *Life*; Lee Miller, a former model who talked *Vogue* into running her pictures, from Army nurses to Nazi death camps; and Joe Rosenthal of the Associated Press, who shot the famous flag-raising on Iwo Jima. Photographers in uniform included Marine cameramen Thayer Soule and David Duncan, who shot pictures from an Army Air Force plane.

The Axis surrendered in Africa in May 1943. The Allies conquered Sicily in August and invaded the Italian mainland in September. Italy quit the war completely, yet Germans fought on Italian terrain quite efficiently. They marched toward Rome, fighting the Allies in the little town of San Pietro. John Huston, best known for directing *The Maltese Falcon,* traveled to Italy to film *The Battle of San Pietro* for the Army Signal Corps. His film mixed real battle scenes with skillful re-creations, yet the movie was pitched as authentic. Some Army officers found it too intense, but Gen. George C. Marshall disagreed. After Huston removed the voices of soldiers who had died the day after filming and deleted some scenes with body bags and dismembered limbs, Marshall released the film to soldiers and the public. Huston's next film, *Let There Be Light,* about psychologically scarred veterans, was not released by the War Department until 1980.

Writer Ernie Pyle and cartoonist Bill Mauldin, who gained fame in Italy, explored the war on human-size terms and helped bury its romance.

Millions read Pyle's syndicated column by the time of his death in April 1945. The shy, delicate, Indiana native took them to the front lines. He focused on individuals, especially infantrymen, whom he saluted as the "mud-rain-frost-and-wind boys." Pyle showed readers the personal side of war. He "felt guilty because he was a civilian who could go back to his typewriter, leaving them in their muddy holes to be miserable and sometimes die," said Mauldin. From one of Pyle's columns, his editor cut five words that give a glimpse of his demons: "You feel small in the presence of dead men, and ashamed of being alive."

Mauldin drew the infantryman's perspective, first for his 45th Division newspaper and then for the Army's *Stars and Stripes.* Soldiers loved his gutsy, no-nonsense cartoons and his dogfaced characters, Willie and Joe. Mauldin said his work served as a safety valve for soldiers' pent-up frustrations—seeing his cartoons, they felt, "Hell, somebody else said it for me." Many officers didn't see the humor, but Gen. Lucian K. Truscott told Mauldin that if he wasn't "pissing off martinets," he wasn't doing his job.

CORRESPONDENTS BEGAN accompanying British bomber crews over the Continent. The UP's Walter Cronkite flew on a raid of a submarine pen in northwest Germany and wrote of "a hell of burning tracer bullets and bursting flak." His dispatch received prominent display, but he thought his prose had been a bit "purple." In contrast, Murrow

115

used understatement. He flew on combat missions, and on one over Berlin he wrote that its two-ton explosives burst "like great sunflowers gone mad."

The long-awaited invasion of France, code-named "Overlord," began on June 6, 1944, two days after the capture of Rome. The Allies accredited 558 reporters, cameramen, and broadcasters to report on the 176,000 troops entering Normandy. Correspondents wrote their own obituaries before they departed to the front.

Some, including Bill Walton of *Time,* parachuted into the French countryside. Some waded ashore, like Ross Munro of Canada's national news service; his eyewitness account was the first to reach the world. Some, like Richard Hottelet of CBS, flew with bomber crews. Hottelet said that if he had stepped out of the plane, he could have walked across the English Channel: 600 warships escorted more than 4,000 transports and landing craft, with some 1,000 ships held in reserve. Overhead, 2,500 Allied heavy bombers dropped 10,000 tons of explosives onto German coastal defenses, while 7,000 fighters and fighter bombers provided an escort and hunted for ground targets. Martha Gellhorn sneaked aboard a hospital ship and hid in a toilet stall as it departed the English coast. At dusk on D-Day, she helped move the wounded on stretchers. Her husband, Ernest Hemingway, was furious that he could not get ashore until later.

Charles Collingwood's interviews with soldiers before the invasion played over and over on CBS. British Air Cmdr. W. Helmore recorded the first eyewitness report for the BBC from over the be es. George Hicks of the Blue Network (later A broadcast live from offshore, his report punctu by explosions and cheers. Four days later, the A provided the BBC with a tape recorder. Ameri reporters got a mobile radio transmitter, call let JESQ, soon dubbed "Jig Easy Sugar Queen."

Working for *Life* magazine, Robert Capa w ashore on the morning of June 6 at Omaha Bea He jumped from a landing barge into waist-de water and waded up the sand amid Germ machine-gun fire. In Britain, a teenage darkro technician processed his 108 negatives with t much heat. The film began to melt and the pictu became distorted. They now rank among the wa most memorable images, their nightmarish quali matching the experience.

In the face of strong German resistance, th Allied advance stalled in the Norman countrysid beyond the beaches, where hedgerows bordered maze of small fields. Over the summer, the Allie pushed toward Germany. Cherbourg fell on June 27 Caen on July 13, after intensive fighting. Operation Cobra allowed Patton's Third Army to roll through the Avranches Gap in mid-August, killing more than 10,000 and capturing more than 50,000 German sol-diers. Paris was liberated on August 24 amid riotous celebrations. Lipstick-smeared correspondents, including CBS's Larry LeSueur, ignored censors and broadcast from Radio Nationale de France. Troops pushed on, but many correspondents stayed in Paris.

By the spring of 1945, an Allied victory seemed

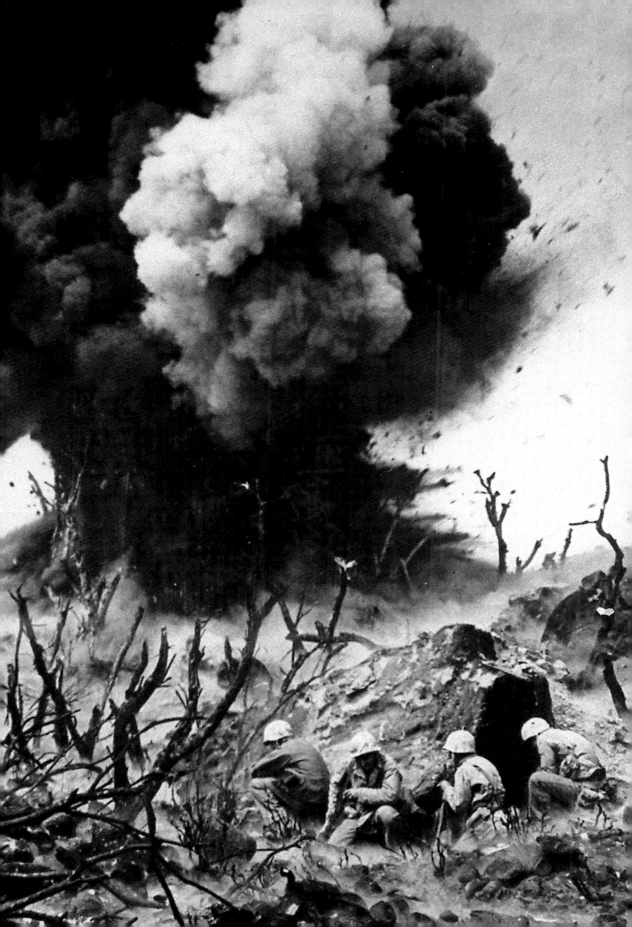

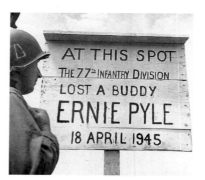

imminent. When Franklin D. Roosevelt, elected in 1944 for his third term, suffered a fatal cerebral hemorrhage on April 12, 1945, his vice president, Harry S. Truman, assumed office. On May 7, 1945, Germany surrendered.

REFUGEES' STORIES of systematic brutality and mass murder had appeared for years, but many had found them too fantastic to believe. The Jewish press screamed out about Hitler's "Final Solution," but editors tended to believe Nazi accounts instead. When the Gestapo admitted killing 258 Jews in Berlin in June 1942, the *Chicago Tribune* ran it as a front-page story. But two weeks later, when Jewish groups accused the Nazis of killing a million Jews, the *Tribune* put it on page six.

The awful truth began to come when the Buchenwald death camp outside Weimar was freed by Patton's Third Army on April 10, 1945. Reporters encountered 20,000 living skeletons, many unable to stand. Marguerite Higgins of the *New York Herald Tribune* asked a boy of eight why he was there. "I am Jewish," he said. "All the older people were burned up." Ann Stringer of the United Press saw lampshades made of human skin. General Patton, outraged, ordered Weimar residents to tour the camp. Some women fainted; others avoided the horror by staring into the sky.

Murrow could barely contain his fury as he toured Buchenwald, but he read his report in a flat, matter-of-fact voice. He walked through a barracks of 1,200 men crowded into a space for 80 horses. In the kitchen, he saw the daily ration: one pie brown bread, margarine the size of three stic gum, and a tiny bit of stew.

He walked outside to the concrete court "There were two rows of bodies stacked up cordwood.... Some had been shot through the but they bled but a little. All except two were n I tried to count them as best I could and arriv the conclusion that all that was mortal of more five hundred men and boys lay there in two piles." He closed by praying that listeners w believe his report and refused to apologize if he upset anyone.

Margaret Bourke-White, Lee Carson of I Bill Walton of *Time,* and Don Whitehead of the followed a stench and found themselves at a w camp on the edge of a carpet of human bor Charred skeletons lined the barbed-wire fen Walton threw up. Bourke-White suppressed revulsion and began taking pictures. Emaciat survivors in prison clothes told what had happen When guards learned that American troops we coming, they killed the 350 inmates. They attract them with a pot of soup, then lit a flammable liqu nearby. Blazing inmates got caught on the wir Those who survived had not been locked inside.

A few correspondents witnessed as Germany Gen. Alfred Jodl signed the surrender papers May 7, 1945. Adolf Hitler had committed suicide his bunker. "The most hated man in the world i dead," crowed the *British News Chronicle.* Allie armies occupied most of Germany. The German

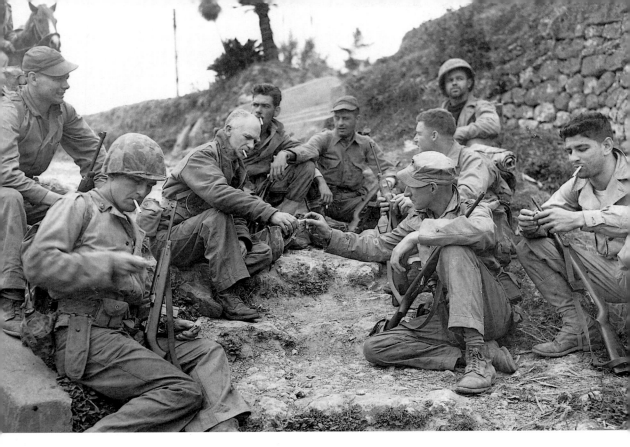

had no will left to fight. They learned of the surrender on May 7. The AP's Edward Kennedy heard it on German-language radio.

But the war against Japan continued until midsummer. In a brutal campaign from January to July 1945, the Allies recaptured the Philippines. Action nearly leveled the ancient walled city of Manila. On February 19, the Fourth Marine Division landed on Iwo Jima. In a month of some of the worst fighting in the Pacific, they captured the island.

The advance toward Japan reached a desperate level when an Army-Marine invasion force landed on Okinawa. Japan launched kamikaze suicide planes in waves. Infantry fighting ended on June 21, 1945, with the conquest of Okinawa. Bombers blasted cities in preparation for an invasion. Not many knew about the atomic bomb.

New York Times reporter William L. Laurence had written about the splitting of the atom when Columbia University announced the landmark event in January 1939. In September 1940, the

Saturday Evening Post published his account of how atomic energy could destroy a ship or a city. The story didn't generate a buzz—or so Laurence thought—but actually the U.S. government was keenly interested, and agents asked librarians for the names of anyone who requested a copy.

Laurence got suspicious when his physicist friends started disappearing. When, in June 1943, he received instructions from the Federal Office of Censorship not to write about atomic experiments or uranium. The memo went to all American newspapers and radio stations, but Laurence was one of the few who understood its significance.

Through anonymous sources, journalist Drew Pearson learned that researchers in Washington, Tennessee, and New Mexico were at work on a bomb. The government had set up an atomic research and development project in August 1942 called the Manhattan Engineering District, or the Manhattan Project. Drew Pearson knew—and kept—the war's biggest secret for more than a year.

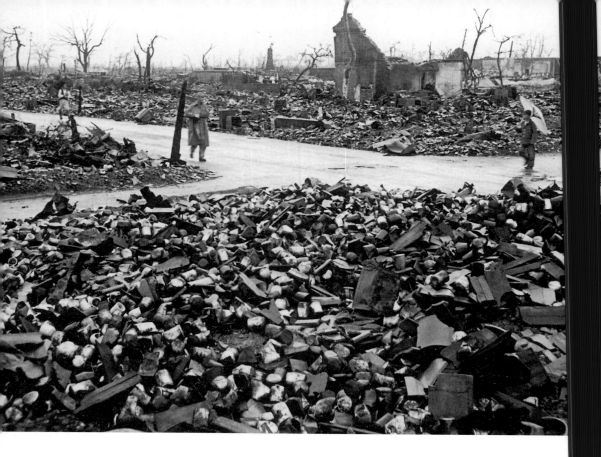

In April 1945, the Manhattan Project's Gen. Leslie Groves chose Laurence to prepare stories about the bomb. Laurence dropped out of sight. He visited atomic development sites and wrote four alternative versions of a not-yet-true story about a New Mexico desert detonation, with reports of its size ranging from a loud, bright pop with little damage to a devastating blast that wiped out much of the state. Groves ordered Laurence to witness the test on July 16 near Alamogordo. At 5:30 a.m., Laurence watched from five miles away. "There rose as if from the bowels of the earth a light not of this world, the light of many suns in one," he recalled. An Army press release said a "remotely located ammunition magazine" had blown up. Newspapers and radio stations yawned.

On August 6, Laurence traveled under sealed orders to the Pacific, arriving too late to accompany the *Enola Gay* as it dropped the world's first atomic bomb on Hiroshima, Japan. Laurence did fly on August 9 as another B-29, the *Great Artiste,*

dropped a bomb on Nagasaki, making him the ⟨only⟩ journalist to witness the deployment of an ato⟨mic⟩ bomb in wartime.

As the bomber approached Nagasaki, its wi⟨ngs⟩ and propellers crackled, and Laurence wonde⟨red⟩ whether atmospheric electricity might set off ⟨the⟩ bomb in its rack. Then, at 12:01 p.m., he put on ⟨a⟩ welder's glasses and watched "a black object" d⟨rop⟩ from the bomber's belly. There was a flash, a bl⟨uish⟩ green light, a shock wave.

"Observers in the tail of our ship saw a giant b⟨all⟩ of fire ... belching forth enormous white smo⟨ke⟩ rings. Next they saw a giant pillar of purple fi⟨re⟩ 10,000 feet high, shooting skyward with enorm⟨ous⟩ speed," Laurence wrote in the *Times*. He f⟨elt⟩ no compassion for the victims, he said, recalli⟨ng⟩ Pearl Harbor and Japanese cruelty to prisoners ⟨at⟩ Bataan. President Truman announced the blast ⟨16⟩ hours later. White House reporters received bac⟨k⟩ ground material prepared by Laurence. Now the⟨y⟩ paid attention.

The first reporter on the scene in Hiroshima was Bin Nakamura of Japan's Domei news agency. Nakamura had been at breakfast two miles from the center of town when a wall of air and heat threw him down and singed his face. He could see the ball of fire. He found the Domei office in town incinerated. He dictated a story by radio that evening. A month later, Wilfred Burchett of the London Daily Express became the first Western journalist in Hiroshima and gave accounts of radiation sickness. "We know that something is killing off the white corpuscles," a doctor told Burchett, "and there is nothing we can do about it." Estimates placed the final death count as high as 200,000 in Hiroshima, 150,000 in Nagasaki—but as Josef Stalin once said, "A single death is a tragedy. A million deaths is a statistic."

Americans did not read the full story until the *New Yorker* magazine sent John Hersey to Hiroshima in 1946. His article was voted the century's best piece of journalism by New York University. Hersey interviewed many victims but focused on six: two doctors, a minister, a seamstress, an office clerk, and a German priest. The story contained powerful details. The flash burned human silhouettes onto walls, just before it blew the bodies to atoms. A doctor walking through a hospital corridor survived, but the patient he had just seen did not.

Hostilities ended on August 15, 1945; the formal surrender occurred on September 2 in Tokyo Bay. Mamoru Shigemitsu, personal representative of Emperor Hirohito, led the Japanese delegation. CBS's Bill Dunn noted that of the eleven Japanese, three wore frock coats and top hats, one wore white linens, and the others wore army uniforms. MacArthur, head of the American delegation, wore a plain uniform without decoration, necktie, or sword. Cameramen Duncan and Mydans snapped images of the surrender ceremony, conducted at a plain table on the deck of the U.S.S. *Missouri*. A fleet of 1,900 Allied planes swept overhead and the sun burst through the clouds as if scripted.

World War II would be remembered as "The Good War," thanks in part to the correspondents who reported on it. "Only the soldier really lives the war—the journalist does not," CBS's Sevareid wrote in 1945. Death did not discriminate, however: 37 American journalists died in the war. Ernie Pyle caught a machine-gun bullet in his head on April 18, 1945, on the Pacific island of Ie Shima. Found in his pocket was a fragment of a column he was writing. It could serve as an epitaph:

Dead men by mass production—in one country after another—month after month and year after year.... Dead men in such monstrous infinity that they become monotonous. These are the things that you at home need not even try to understand.... You didn't see him lying so grotesque and pasty beside the gravel road in France. We saw him, saw him by the multiple thousands. That's the difference.

121

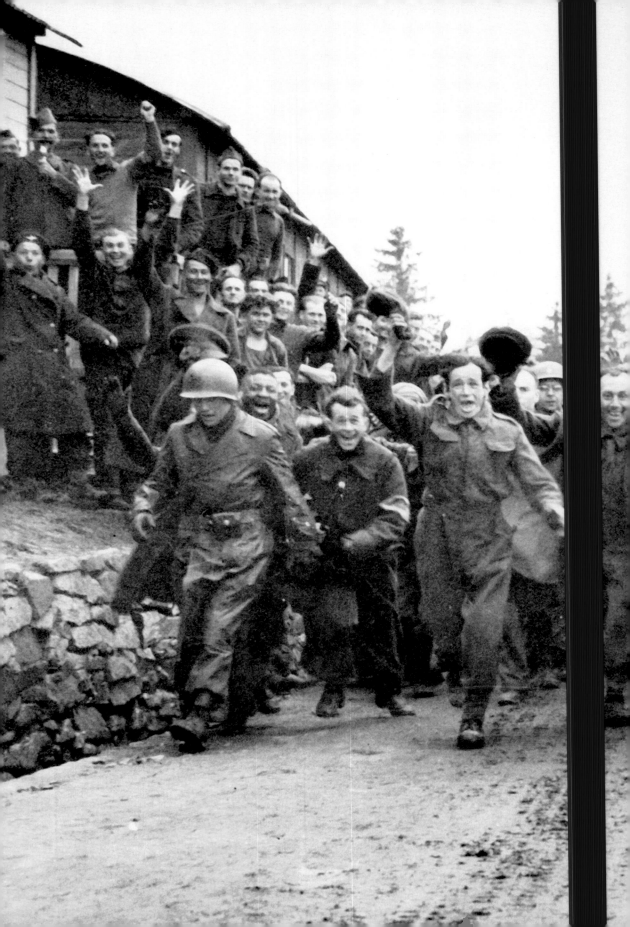

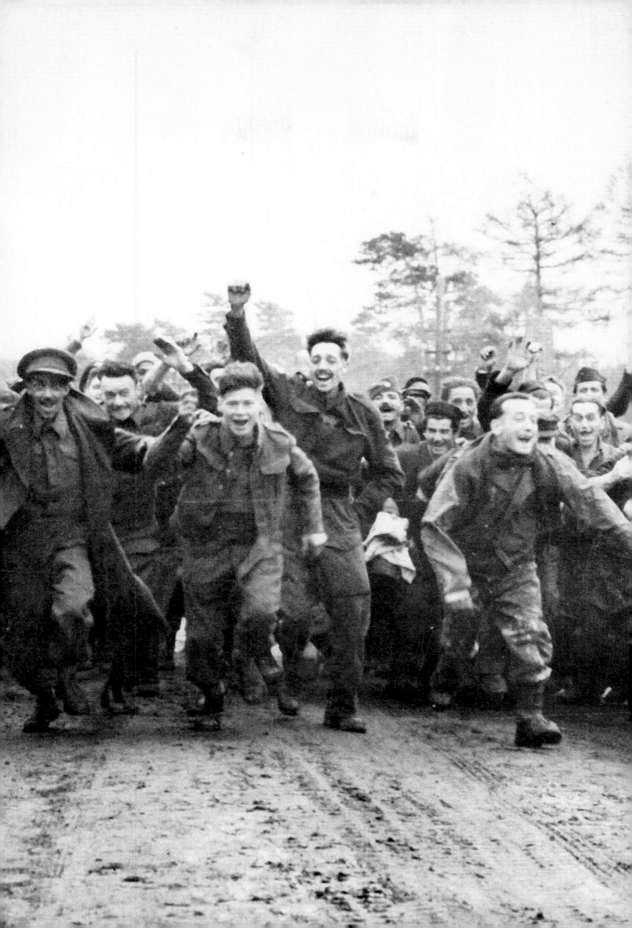

MARGARET BOURKE-WHITE

GO RIGHT UP AND LOOK YOUR FEARS IN THE FACE—and then do something!" her mother told her. Margaret Bourke-White (1904-1971) took the advice. She delighted in defying convention and being first. As a youth, she posed nude in art class and carried snakes to school. In college, after rejecting herpetology, she embraced photography, another unusual career for a woman at the time.

Bourke-White excelled in picturing big things—dams, skyscrapers, war, the Holocaust. She was the first photographer hired by *Fortune*, she snapped the cover of the debut issue of *Life*, and she became the first accredited female correspondent of World War II (forcing the Army to approve a new kind of journalist's uniform—with a skirt). Forsaking that uniform for a bomber suit, above, she became the first woman to fly on a U.S. military combat mission. Recording a nighttime barrage in the Apennines, right, required an exposure of up to 20 minutes. Her pictures helped establish the photo magazine and put cameras and typewriters on equal footing.

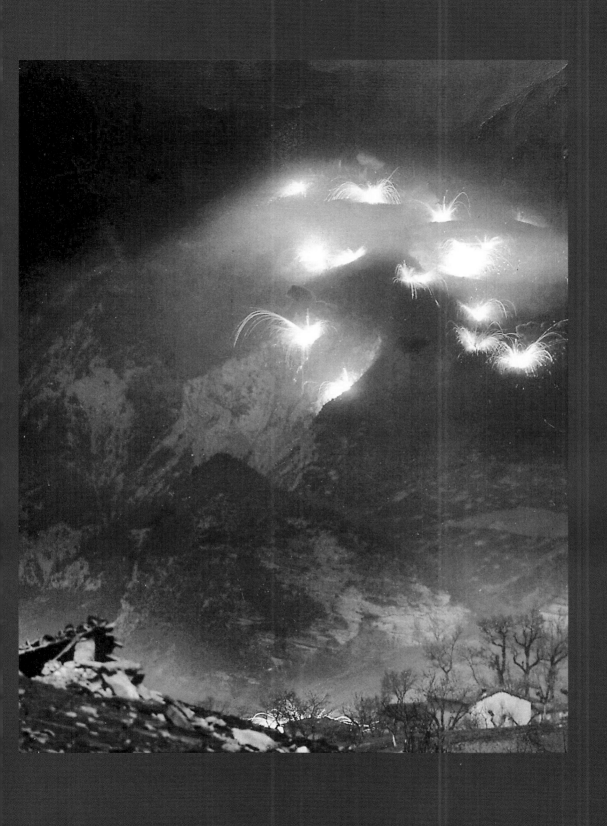

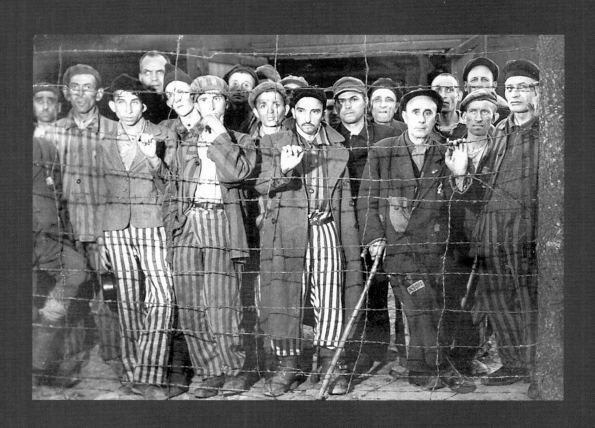

Bourke-White survived being torpedoed near Africa and shelled in Europe, but nothing shook her like the final horrors of the war. The granddaughter of Orthodox Jews with roots in Poland, she placed a "protective veil" over her mind at Buchenwald Concentration Camp, above. A colleague recalled her working "like a demon" after she found the mayor of Leipzig, Germany, and his wife and daughter, who quietly had taken poison in 1945, right.

"WE HAVE DRAWN A LINE, NOT ACROSS THE PENINSULA BUT ACROSS THE
WORLD. WE HAVE CONCLUDED THAT COMMUNISM HAS PASSED BEYOND THE
USE OF SUBVERSION TO CONQUER INDEPENDENT NATIONS, AND WILL NOW
USE ARMED INVASION AND WAR."
Edward R. Murrow, South Korea, July 1950

SECTEU

COLD WAR
TO VIETNAM

CHAPTER FIVE

JACK JAMES OF THE UNITED PRESS wasn't sure where he had left his raincoat. Dawn had brought showers to Seoul, the South Korean capital, on Sunday, June 25, 1950. On the way to his office, he stopped at the American Embassy to look for his coat. As he headed inside, shortly after 7 a.m., an intelligence officer asked him, "What have you heard from the border?" James asked what his question meant. The answer stunned him—and the world. Seven North Korean infantry divisions, supported by three tank regiments, had crossed the 38th parallel, which divided the Communist and democratic halves of Korea. James's UP scoop described a new kind of conflict, in which superpowers clashed through proxies: "The Russian-sponsored North Korean Communists invaded the American-supported Republic of South Korea today," James wrote, "and their radio followed it up by broadcasting a declaration of war." The North Korean broadcast accused South Korea of "invading" the North. Russian-trained soldiers, 100,000 strong, quickly pushed back 65,000 South Korean defenders.

Preceding pages: East German border guard Conrad Schumann leaps to West Germany and freedom in 1961 over freshly laid barbed wire, precursor to the wall that cut Berlin in half. Left, Sandy Colton of the Stars and Stripes *covered the Korean War in his beloved jeep.*

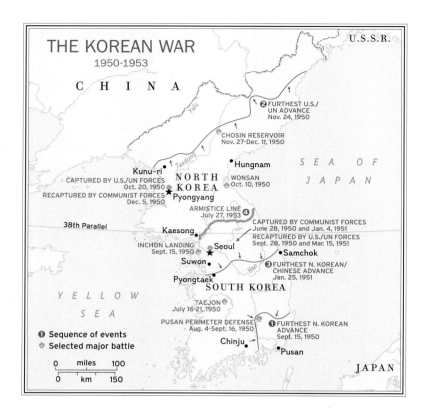

THE KOREAN WAR
1950-1953

CHINA

U.S.S.R.

② FURTHEST U.S./
UN ADVANCE
Nov. 24, 1950

CHOSIN RESERVOIR
Nov. 27-Dec. 11, 1950

Kunu-ri
CAPTURED BY U.S./UN FORCES
Oct. 20, 1950
RECAPTURED BY COMMUNIST FORCES
Dec. 5, 1950

•Hungnam

**NORTH
KOREA**
WONSAN
Oct. 10, 1950

Pyongyang

**SEA OF
JAPAN**

ARMISTICE LINE
July 27, 1953 ④

38th Parallel

Kaesong•

CAPTURED BY COMMUNIST FORCES
June 28, 1950 and Jan. 4, 1951
RECAPTURED BY U.S./UN FORCES
Sept. 28, 1950 and Mar. 15, 1951

INCHON LANDING
Sept. 15, 1950 ★ Seoul

•Samchok

Suwon•

③ FURTHEST N. KOREAN/
CHINESE ADVANCE
Jan. 25, 1951

Pyongtaek•

SOUTH KOREA

**YELLOW

SEA**

TAEJON
July 16-21, 1950

PUSAN PERIMETER DEFENSE
Aug. 4-Sept. 16, 1950

① FURTHEST N. KOREAN
ADVANCE
Sept. 15, 1950

Chinju•

•Pusan

JAPAN

① Sequence of events
⬦ Selected major battle

0 miles 100
0 km 150

*Map, left, shows the progress of
troop movement and battles during
the Korean War. Right, in 1950, the
AP's Max Desfor photographed
these South Korean refugees climb-
ing the icy ruins of a bridge to cross
the Taedong River. They were fleeing
from the threat of North Korean
and Chinese troops, advancing
southward. Desfor called it "the
most heart-rending sight I've seen."
The next year his photograph won
the Pulitzer Prize.*

Only four days earlier, the *New York Herald Tribune* had published reporter Marguerite Higgins's interview with Gen. Douglas MacArthur, commander of the American occupation forces in Japan, who said Asia would be free from war for at least ten years. State Department special representative John Foster Dulles had also just announced that the world's Communist nations were not strong enough to wage war.

The most likely Communist target seemed to be Formosa, where Chiang Kai-shek's nationalist followers, defeated in a civil war, thumbed their noses at the Chinese Communists. American journalists Theodore White and Edgar Snow had warned in the 1940s that Chiang was corrupt and unpopular and that the Communists, led by Mao Zedong, had tremendous appeal. Mao's takeover of mainland China in 1949 sparked a "Red scare." Since the end of World War II, the Soviets had become a superpower. They had created Communist client states along their western border and had opposed plans for a pacified Germany. According to the U.S. National Security

Council, the Soviets, who had tested an atomic bomb in 1949, were bent on world domination. America's military strategy focused on the Soviet Union.

Few foresaw the new South Korean nation as a bulwark against Communism. Japan had invaded the peninsula at the start of the Russo-Japanese War in 1904 and annexed it in 1910. After World War II, the Allies sought an independent Korea. One day after the second atomic bomb dropped on Japan, the State Department asked an obscure lieutenant colonel to pick a line to separate occupation zones. Using a small *National Geographic* map, Lt. Col. Dean Rusk—later Secretary of State—chose the 38th parallel, just north of Seoul. The Soviets entered the northern half while MacArthur sent one regiment south after accepting the Japanese surrender in Tokyo Bay. South Koreans created the Republic of Korea, though President Syngman Rhee exercised autocratic powers. Subsequent efforts to unify the two halves failed. The Russians left by December 1948, Americans by June 1949, but U.S. military advisers remained.

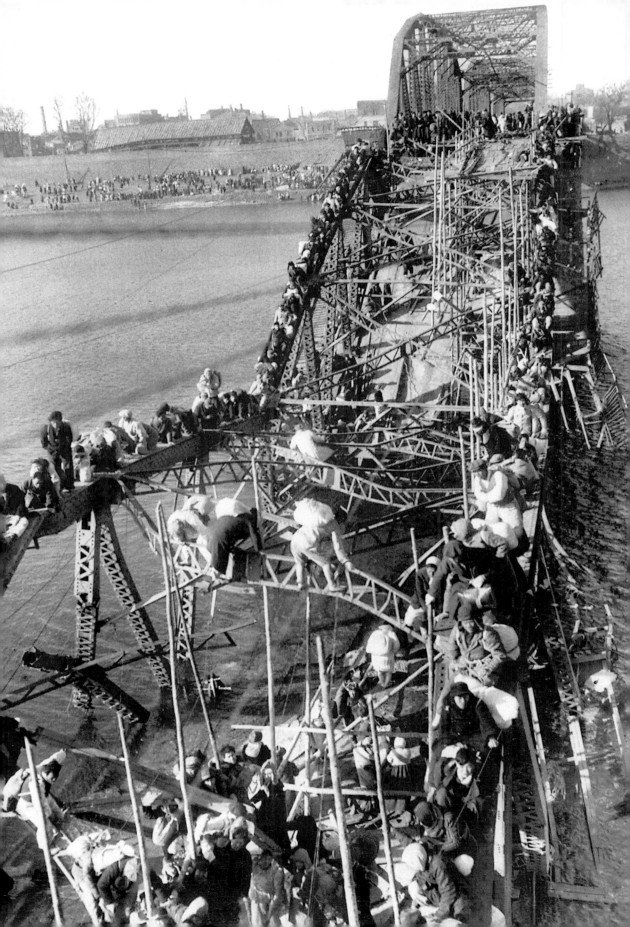

When the North Korean Army smashed through the South Korean defenses and headed toward Seoul, it proved that atomic weapons would not replace conventional war. "Korea ripped away our complacency," Higgins wrote, "our smug feeling that all we had to do for our safety was to build bigger atomic bombs." Nuclear arsenals did not stop "limited" wars by client or puppet states. Nor could the threat of war suppress the yearning for independence among colonial peoples. South Korea suddenly was valuable, a foothold of anti-Communism in the Far East. President Harry S. Truman committed air and naval power to South Korea's defense on June 27, the same day North Korean troops entered Seoul.

American journalists tried to fly into Seoul's Kimpo airfield on June 25 but, confronted with enemy fighter planes, returned to Japan. Higgins arrived two days later on the last plane into Kimpo. With her were Keyes Beech of the *Chicago Daily News,* Frank Gibney of *Time,* and Burton Crane of the *New York Times.* Heading toward Seoul, they could hear machine-gun fire. At the front, South Korean troops could do little to stop the armored assault. Bazookas, grenades, and Molotov cocktails proved futile against the Russian-made tanks. Higgins and her companions joined a convoy of 60 jeeps traveling south, toward the city of Suwon. The Han River bridge, their only escape route, exploded in front of them, blown up by panicked South Koreans to fend off the enemy. Separated from the others, Higgins crossed the river in a boat secured at gunpoint by Americans. Wearing a skirt and blouse, she carried her typewriter 14 miles before finding Beech again.

Life magazine photographer David Douglas Duncan, who had served with the Marines in World War II, accepted an invitation to fly from Tokyo to Itazuke airfield at Fukuoka, Japan, on June 27. He stepped off the plane and saw soldiers setting up 50-caliber antiaircraft guns. Two F-80 fighter jets zipped overhead, performing the "victory roll," indicating they had just shot down enemy planes in a dogfight. Duncan soon became the first photographer to ride

aboard a jet in combat, zooming over Korea at 600 miles per hour and giving him "a feeling of being strapped to a rocket of godawful strength. It was one hell of a sensation."

Higgins and *Time-Life* photographer Carl Mydans were at the front line on July 5, when the first American troops went into battle near Osan, 25 miles south of Seoul. As Higgins watched, enemy machine guns opened fire, claiming the first American, a West Virginia teenager who tried to stop a tank with a bazooka. "These damn bazooks don't do any good against those heavy tanks," a sergeant told Higgins. "They bounce right off." Rarely, said Higgins, had so few been asked to do so much with so little. A lieutenant who had lost 17 men out of 20 angrily asked her, "Are you correspondents telling the people back home the truth? ... Are you telling them that we have nothing to fight with, and it is an utterly useless war?"

She and the press corps did send out uncensored reports. MacArthur asked correspondents to respect voluntary guidelines to keep information from the enemy. News of the rout awakened the United Nations to the real danger: If the North Koreans had advanced south, they could have captured all of Korea. Instead they fanned out to the west. North Korean soldiers, dressed as peasants and farmers, infiltrated American lines and threw grenades at unsuspecting soldiers. Others, dressed as refugees, smuggled guns. After five days of desperate fighting at Taejon in mid-July, the Americans withdrew, but soon Army troops, reinforced by Marines, regained strength and held a perimeter in the southeast of the peninsula near the seaport of Pusan. Despite heavy pressure, the Pusan perimeter held.

Higgins took a lot of chances—and raised a lot of eyebrows. Seldom has a journalist been as loved and hated by the competition. She was aggressive yet petite, a native of Hong Kong, and spoke English, Cantonese, and French. At the University of California and Columbia University's School of Journalism, she earned a reputation for pushiness and untidiness. She could get nearly any story, sometimes by using

her looks. She wrote clumsily and often smudged herself with carbon paper. Courage she had in abundance. As troops fled Seoul, she rode a transport plane onto the Suwon airstrip with a cargo of 155-mm shells that could have exploded. An American colonel greeted Higgins with "You'll have to go back, young lady.... There may be trouble." Higgins replied, "I wouldn't be here if there were no trouble." General Walker tried to banish her from Korea, but MacArthur overruled him.

According to Higgins, MacArthur planned an early seaborne invasion. An amphibious landing behind the North Koreans could bottle them up, he reasoned. Inchon, a west-coast port just south of the 38th parallel, intrigued him as an invasion site. His advisers told him that Inchon's 30-foot tides, mud flats, and narrow channels would make it nearly impossible. MacArthur figured that the North Koreans considered an Inchon invasion impossible, too, so the plan offered the element of surprise.

Six cruisers and four aircraft carriers were among the 320 ships that left Pusan in early September and arced north. American destroyers tricked shore batteries into firing, then, for 48 hours, the invasion ships bombarded the shore. At 5:30 a.m., September 15, a half-hour before high tide, the Fifth Marines charged ashore on Inchon's Red Beach. The Marines secured three key hills within an hour. Higgins went ashore in the fifth wave. "We struck the sea wall hard at a place where it crumbled into a canyon. The bullets were whining persistently, spattering the water around us. We clambered over the high steel sides of the boat," she wrote. The Marines then dropped into three feet of water, and so did Higgins and her typewriter. The invasion worked. UN troops captured Seoul before month's end and cut North Korean supply lines. Over 125,000 North Korean troops were taken prisoner. This time MacArthur had gambled and won.

His troops pursued the enemy northward. Diplomatic strategist George F. Kennan urged stopping at the 38th parallel to avoid antagonizing the Chinese and Soviets, but Truman, MacArthur, and United Nations planners rationalized that by crossing, they could unite the two Koreas. Pyongyang, North Korea's capital, fell on October 20. By then, UN forces included battalions from Turkey, Canada, Australia, Thailand, the Netherlands, and the Philippines. Landing at Wonsan in late October, the U.S. X Corps secured the western coast. The campaign seemed close to its end, and MacArthur told an aide within earshot of an AP reporter that his troops would go home once they reached the border between North Korea and China. But before dawn on November 25, more than a quarter million Chinese attacked. At Kunu-ri, one division alone lost over 4,000 men and most of its artillery. On November 27, 120,000 Chinese troops attacked UN forces on both sides of the Chosin Reservoir. The Marines had walked into a "mousetrap," a private told Higgins.

Temperatures dipped to 15° below zero. Rifles jammed, mortars caked with ice, artillery shells landed short. Canteens froze and burst. Ears blue with frost and faces swollen in the icy wind, some troops walked unshod, unable to get their frostbite-blackened feet into shoes. It took an hour to thaw a can of beans—an hour they could not spare, said Higgins. A Marine colonel told Beech, "Remember, whatever you write, that this was no retreat." Outnumbered at least six to one, the Marines fought to exhausted numbness. Duncan asked one Marine what he wished for. "Give me tomorrow," he replied. By December 5, beleaguered UN forces withdrew to the 38th parallel. By the 15th, UN forces halted the Chinese offensive about 50 miles south of Seoul.

In December 1950, the Eighth Army imposed censorship because of press criticism of MacArthur. In April 1951, after MacArthur ignored orders to stop making foreign policy, Truman relieved him of command. Censorship reverted to a voluntary system after Gen. Matthew Ridgway replaced MacArthur. Soldiers died in skirmishes, but the front stabilized back near the 38th parallel. Truce talks started July 10, 1951, and continued for two years, prisoners of war the sticking point. Wilfred Burchett, an Australian

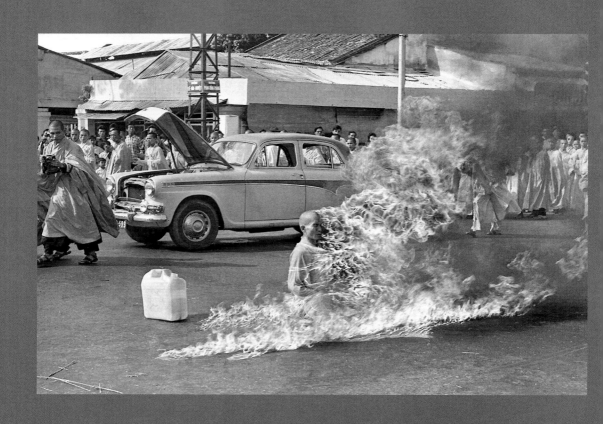

As part of an organized demonstration against religious persecution in South Vietnam, Buddhist monk Thich Quang Duc, left, struck a match to his fuel-soaked robe at 9:22 a.m. on June 11, 1963. Map, right, shows movement of troops and major battles in Vietnam.

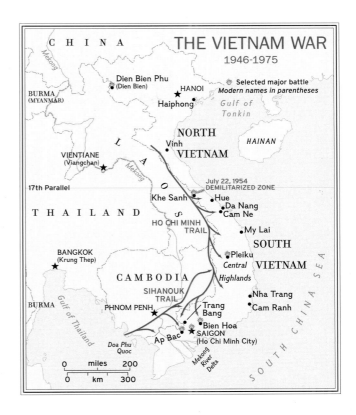

Socialist attending the talks with the North Korean–Chinese delegation, wrote for Paris's *Ce Soir* and informed other reporters from inside.

In late 1952 President-elect Dwight D. Eisenhower paid a six-day visit to Korea. Correspondents kept it secret until he was on his way home. The following spring, a State Department leak revealed that the President would accept a partitioned Korea. A cease-fire took effect July 27, 1953. Secretary of State John Foster Dulles quietly told James Reston of the *New York Times* that the Chinese had accepted a truce because Eisenhower was considering atomic weapons. The peninsula remained pretty much as it had been in the spring of 1950. To some it looked like a tie, but the Communists had been contained, so others saw it as a diplomatic, if not military, victory.

At the time of the Korean War, Americans were beginning to watch television. In November 1951 CBS introduced the program *See It Now,* hosted by Edward R. Murrow. A year later, Murrow convinced CBS to produce *Christmas in Korea.* Five reporters

and camera crews interviewed nurses in a mobile hospital and soldiers at the front, singing, joking, and relaxing. On the war, one commented: "I think it's a bunch of nonsense." The sheer bulk of the machinery required meant that Murrow's film crews could not be spontaneous or get near combat, yet the 1952 broadcast was a milestone. Jack Gould of the *New York Times* called it "a visual poem, one of the finest programs ever seen." Each man in one platoon gave his name and address on camera. During the actual broadcast, Murrow announced that half of those men had been killed or had gone missing.

The war had its share of horror. René Cutforth of the BBC witnessed saturation bombing and the effects of napalm, whose intense heat, he told listeners, he felt singe his eyebrows. Human victims gave off the smell of roast pork, he said. Australian reporter Alan Dower stopped South Korean police from executing a line of women and babies whom they identified as Communists. In 1999 reports of an American mass killing surfaced, when the Associated Press team of

"When my time comes, I want it to be on a patrol with the Marines," photographer Dickey Chapelle once said. On November 4, 1965, she died in action when a Viet Cong booby trap exploded near Chu Lai, South Vietnam. Right, Chaplain John McNamara administers last rites. Facing page, an AP dispatch reports her death.

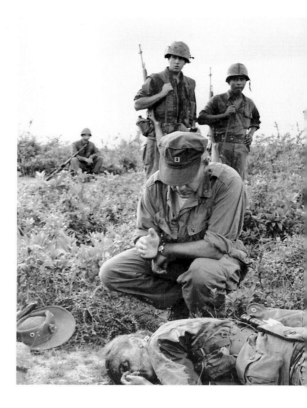

Sang-Hun Choe, Charles J. Hanley, and Martha Mendoza interviewed American veterans who said they had machine-gunned hundreds of peasant refugees beneath a bridge at No Gun Ri in July 1950. Once-classified documents showed American commanders had ordered green troops to shoot civilians as a safeguard against infiltrators. Although the details remain in dispute, 50 years later the story won a Pulitzer Prize.

MANY WARS of the 1950s and 1960s were about gaining independence. The Second World War's defeat of Fascism, along with empire builders' exhaustion, kindled the desire for freedom in colonial states. Algeria, in North Africa, began its fight for freedom from France in 1954. After neighboring Tunisia and Morocco gained independence in 1956, the uprising became more brutal. The rebels relied mostly on small-scale raids against French patrols and garrisons. By the time the war ended in 1962, it had claimed half a million lives. At first, France called the rebellion an "internal difficulty." Algerian publications were censored and French papers that did not follow the government line were seized. Offending journalists were fined and jailed.

Writer and photographer Dickey Chapelle was the first American to report on the Front de Libération Nationale (FLN). Born Georgette Louise Meyer, she renamed herself "Dickey" after her hero, Adm. Richard Byrd. She had a husky voice and a no-nonsense attitude. "I lug my own stuff and I take no favors," she said. Combat did not scare her.

Approached in New York by the Algerian rebels' UN representative, Chapelle sold the story in America before going to Algeria. *Argosy, Pageant,* and four dozen newspapers printed stories of her month there.

To link up with the rebels, Chapelle went to Algerian headquarters in Madrid, Spain. She reached Algeria via Rabat, Morocco, dressed as a veiled Arab and a German tourist and traveling by horse and mule. She hid in a harem to meet heavily armed FLN fighters. She marched into the summer heat of the Sahara and lived on tea, dates, and sugar. She sat out a French air raid that killed 18 shepherds including one infant. The longer she stayed, the more she saw her hosts as freedom fighters. She said the usual answer a rebel gave when asked why he fought was, "So my country will be free"—the same idea, Chapelle said, "our colonists had in 1776." She left Algeria referring to the rebels as "we," not "you" or "they."

Compared with the war for Algerian independence, the effort to free the Congo from 80 years of Belgian rule seemed easy at first. Amid anti-white

riots in 1959 and mounting nationalist pressures, Belgium announced that it would grant independence to the Congo on June 30, 1960. But the 13.6 million Congolese—200 tribes that included Stone Age aborigines and pygmies who hunted with poison darts—were not prepared. As *New York Times* reporter Henry Tanner put it, "When the Belgians left ... there was one Congolese lawyer and perhaps a half a dozen young men with some training as economists, administrators, and technicians. These men had to run a country as large as the United States east of the Mississippi." Still, the new nation reacted joyfully when Belgian King Baudouin proclaimed freedom. Fierce pride asserted itself. When a reporter addressed a restaurant worker as "garçon," BBC reporter Keith Kyle recalled, "The waiter drew himself up to his full height and said, 'Since yesterday we have lived in the Independent Republic of the Congo. From now on, you will be pleased to call me Monsieur le Garçon.'"

Fighting began July 1 between tribes in Leopoldville and Luluabourg. Force Publique, a corps of native soldiers led by Belgian officers, mutinied July 4-5. Black natives began beating and raping whites, and on July 11 the country's richest province, Katanga, declared itself an independent state, headed by Moise Tshombe and protected by Belgium to safeguard international investments. The country descended into chaos. By July 1960 the prime minister, Patrice Lumumba, asked the UN Security Council to send in troops. Within six months, political enemies had murdered Lumumba. Rebels beat correspondents from *Life.* They smashed Larry Burrows's cameras. Belgian helicopters and boats evacuated whites. One photograph in *Life* showed a seven-year-old white girl on her way to a helicopter. "I don't like Africans now," she told the photographer. "They threw rotten tangerines at my party dress."

UN troops slowly restored order. Fighting ended, an agreement reunited Katanga with the Congo, and the structure of government was discussed. In 1965, after UN troops departed, Col. Joseph Mobutu—later calling himself Mobutu Sese Seko—took power in a coup. Nearly 50 years independent, the country remains, in Kyle's assessment, Africa's "basket case."

VIETNAM'S STRUGGLE was perhaps the most painful of any state emerging from colonial domination. A French hegemony dated back more than a century. The French occupied Saigon in 1859, Hanoi 14 years later, and extended authority throughout by 1883. In 1919 Vietnamese leader Ho Chi Minh tried to appeal to the Versailles Conference for independence. Dismissed without ever being heard, he joined the Indochinese

North Vietnamese forces attacked South Vietnamese villages during Tet, the Vietnamese New Year, in 1968. A famous photograph from that offensive shows Saigon's chief of police executing a Viet Cong prisoner without trial, right. "I had no idea he would shoot," AP photographer Eddie Adams later said, "I made a picture at the same time."

Communist Party. Vichy France kept nominal power until Japan took over in March 1945. On the day of Japan's surrender, September 2, 1945, Ho declared Vietnam a free nation, using language from the American Declaration of Independence.

Chinese nationalists accepted Japan's surrender in the north, the British in the south—but they handed control back to the French. France recognized Ho's new nation, but in November 1946 asserted its power by bombing the northern port of Haiphong, killing 6,000 civilians. Later that year in Hanoi, Ho's capital, the Vietnamese attacked the French and began an eight-year guerrilla war that cost France 50,000 dead. The *Christian Science Monitor* termed it "extremely doubtful" that France could "cope with guerrilla fighting" and put down the rebels, known as Viet Minh.

The end of French occupation came in 1954 at Dien Bien Phu. French paratroopers dropped into rebel territory 220 miles west of Hanoi, hoping to entice the enemy into battle. North Vietnamese Gen. Vo Nguyen Giap and four Chinese-trained Viet Minh divisions encircled and besieged the French for 169 days. Artillery, carried south from China, finally forced a French surrender. One French photographer, Daniel Camus, recorded the defeated garrison marching out. The celebrated photojournalist Robert Capa died when he stepped on a mine, the first American correspondent killed in Vietnam.

At a press conference a month before the surrender at Dien Bien Phu, Eisenhower characterized the loss of Indochina to Communism as the first step in a series of "falling dominoes." The U.S., which had footed 80 percent of France's war costs, hoped that North and South could be unified peacefully. The Viet Minh, pressured by the Soviets, agreed to split the country at the 17th parallel into an independent Communist North and a nominally democratic South. In October 1955 a Republic of Vietnam was proclaimed in the South, with Ngo Dinh Diem its first president. The Geneva agreement called for elections in July 1956, but President Diem blocked the vote, knowing that elections would put the Communists in charge. The United States endorsed Diem. The North Vietnamese began supplying arms to rebels in the South. Numbering as many as 10,000, they formed the National Liberation Front or Viet Cong.

U.S. presidents sent military advisers to help the fledgling government: Truman, 35; Eisenhower, 500; Kennedy, set on defeating the Communists, 16,000. In June 1961 Kennedy met Soviet Premier Nikita Khrushchev to discuss the thorny problem of the Soviet and Western occupation zones of Germany. Khrushchev bullied the young, inexperienced president. Soon thereafter Kennedy told the *New York Times*'s James Reston that Vietnam was the place to show the Soviets America's resolve against Communism. CBS's David Schoenbrun questioned the President about the lessons of history. "Well, Mr. Schoenbrun, that was the French," Kennedy answered. "They were fighting for a colony, for an ignoble cause. We're fighting for freedom, to free them from Communists, from China, for their independence."

Meanwhile Diem ruled South Vietnam autocratically. A failed coup against him in 1960 left 400 dead.

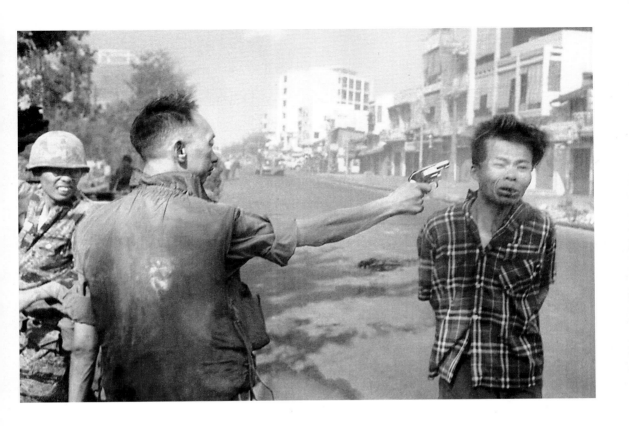

"Diem seems to have paralyzed rather than inspired those around him," Stanley Karnow wrote in *The Reporter* magazine in January 1961. "The characteristics that made Diem a success in 1955 and 1956—obstinacy, single-mindedness, and guile—are his most obvious weaknesses today." Diem, a Catholic, cracked down on his religious opponents in 1963. Buddhists in the city of Hue, near the northern border, gathered on May 8 to protest a ban on flags celebrating Buddha's birthday. Eight protestors, shot down by South Vietnamese police, became martyrs. Malcolm Browne, head of the AP's Saigon bureau, earned the trust of Buddhist protesters, who planned a demonstration for June 11.

Robed Buddhists, monks in yellow and nuns in gray, formed a circle and blocked traffic. One older monk, Thich Quang Duc, assumed the lotus position on the pavement. Two other monks doused him with fuel. Browne watched in shock as Thich dropped a lit match into his robe. Flames exploded. He did not move. His face contorted in agony. Three minutes

later he fell back, a charred corpse. *New York Times* reporter David Halberstam witnessed the monk on fire with shock and confusion. "One part of me wanted to extinguish the fire, another warned that I had no right to interfere, another told me it was too late, another asked whether I was a reporter or a human being," he said. Browne took a photograph later used by Buddhist leaders to promote rebellion. Kennedy said the U.S. would "have to do something about that regime" while Diem's infamous sister-in-law, Madame Nhu, said she welcomed more Buddhist "barbecues." Violence escalated until Diem died in a November 1963 coup, encouraged by the U.S.

In two world wars and Korea, journalists went to the front to get stories. But in Vietnam, there was no front. "Conventional coverage is out of the question," said Peter Braestrup of the *Washington Post.* After the war, North Vietnamese Gen. Vo Nguyen Giap told CBS television correspondent Morley Safer that wars are fought on many fronts, including that of public opinion. Giap had his troops move quickly, strike with

141

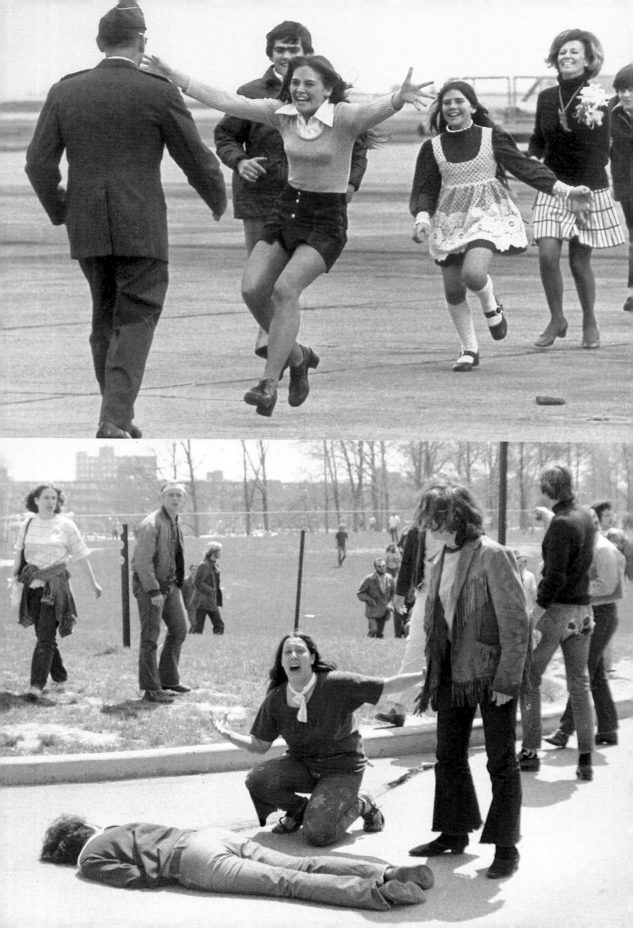

surprise, and attack openly only when odds were in their favor—then disappear. Viet Cong were to be polite to villagers, to pay for anything they took. What the Viet Cong and North Vietnamese lacked in firepower, they made up in their appeal to hearts and minds—and their determination. "I'd give anything to have 200 VC under my command," American Maj. Charles Beckwith told Safer. "They're the finest, most dedicated soldiers I've ever seen."

Without front lines, the military had to find new ways to report progress. Public relations officers cited enemy soldiers killed and bomber sorties, but nothing gauged fighting spirit. Enemy body counts were easily inflated. By 1965, the American Embassy in Saigon gave daily briefings, derided by the press corps as the "Five O'Clock Follies." Halberstam said that briefing officers rarely saw fighting, could not vouch for the truth of reports, but gave out information anyway: "It was a known fact of Saigon life that as the information went up from company to battalion to division and on to Saigon the statistics changed, Viet Cong casualties rising dramatically. All battles were victories. At the daily briefing, the U.S. Army won the war a thousand times."

Some journalists absorbed the briefings uncritically and questioned others' patriotism; others were more skeptical. Life photographer and ex-Marine David Douglas Duncan challenged photographs of a 1968 massacre at the village of My Lai, arguing they were propaganda. Tragically, they proved to be genuine. Journalists who checked facts for themselves got an entirely different view than those in Saigon.

Editors and publishers in the United States had to decide whether to trust their own journalists or their government. In a Solomon-like decision in August 1963, the *Times* printed both the State Department's and Halberstam's radically different accounts of arrests by the South Vietnamese, side by side on the front page. Neil Sheehan of the United Press International got fact-checking lessons from Homer Bigart, who covered the war first for the *Herald Tribune,* then for the *Times.* Early in 1961, Sheehan cabled an American major's report that South Vietnamese troops had killed 200 guerrillas. Bigart told Sheehan, "There better be 200 bodies there because you and I are going down to have a look." They found only 12 bodies. Responding to accusations that the press was against the war, David Halberstam once said the debate was not about victory but rather about "the lies, lies, lies."

A SERIES of unstable governments replaced Diem, neither uniting the country nor halting Viet Cong operations. The American response was to send more men and weapons. By February 1963, major Viet Cong offensives had struck in Tay Ninh Province and the Mekong Delta. South Vietnamese patrol boats harassed Viet Cong and North Vietnamese targets along the coast. After one such raid, on the night of August 4, a North Vietnamese patrol boat clashed with a destroyer, the U.S.S. *Maddox.* Sonar operators thought they heard a torpedo but later told CBS it was hard to tell them from whale flatulence. President Johnson got congressional approval to "take all

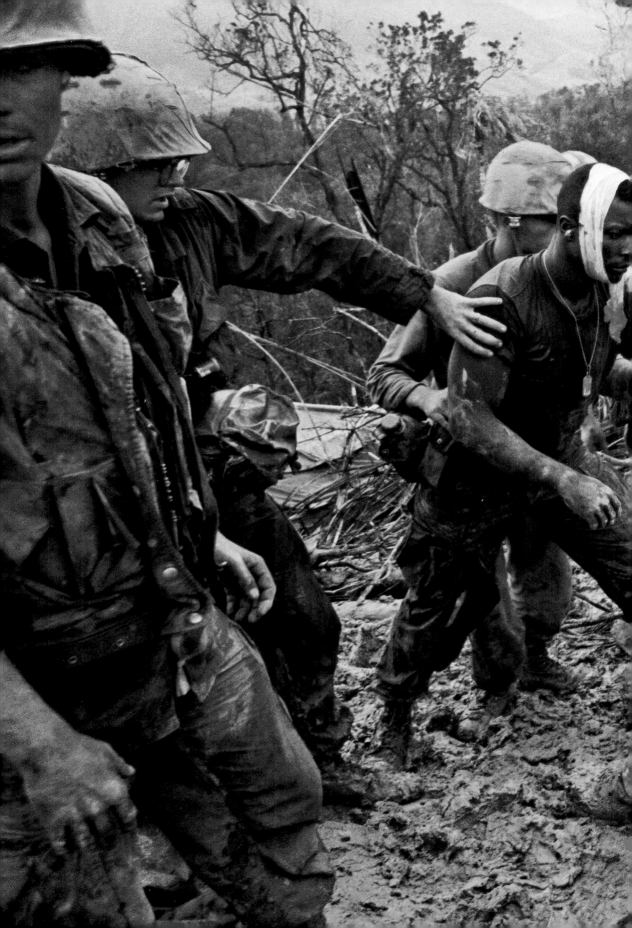

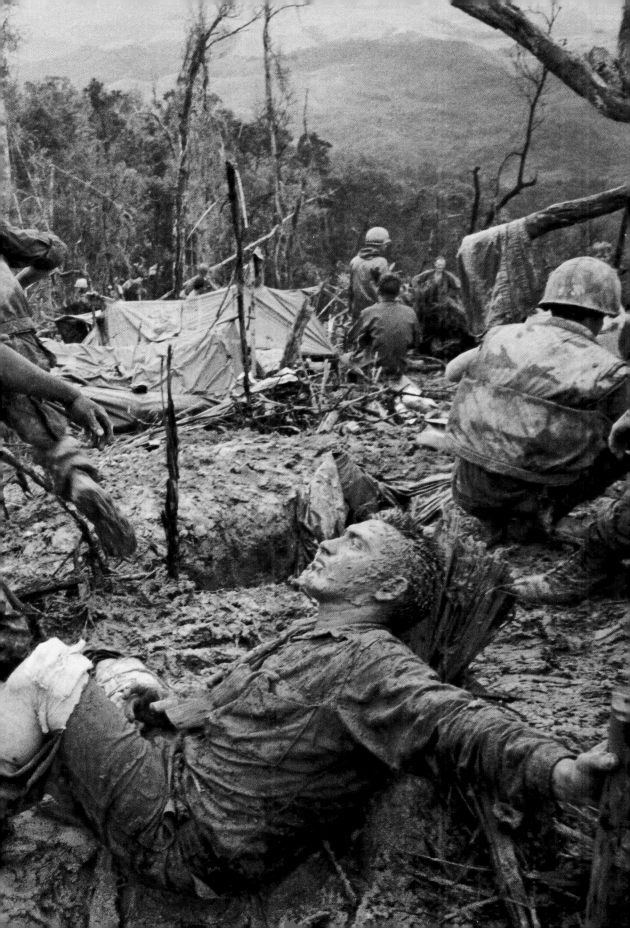

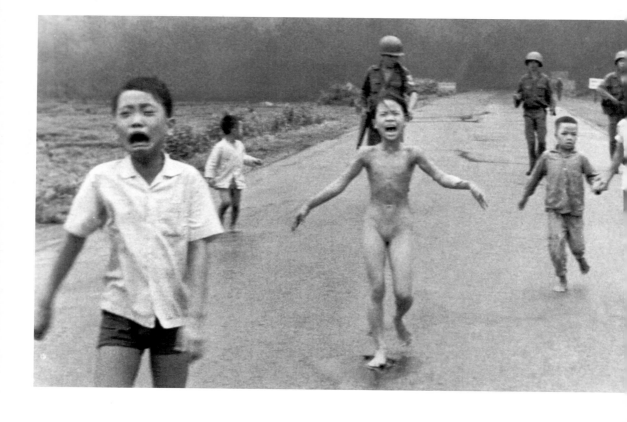

necessary measures" to protect U.S. forces: the Tonkin Gulf Resolution, a blank check to expand the war. Naval air units bombed North Vietnamese coastal targets to bring greater pressure on the enemy. Gradually the U.S. was fighting the war instead of directing South Vietnam in it. In November 1964, the Viet Cong attacked an American support base at Bien Hoa. In February 1965, they attacked an American air base at Pleiku, in South Vietnam's Central Highlands, prompting a long-term bombing mission. Bombers operating out of Thailand pounded North Vietnam, but they did not break the North Vietnamese or Viet Cong will to fight. Instead, morale rose, just as during the Blitz of London in World War II.

In March 1965 3,500 U.S. Marines waded ashore near Da Nang. American engagements took on the pattern of small units, operating from strong points in search-and-destroy missions, with air support from helicopter-borne troops, helicopter gunships, and Air Force fighters. Each time commanders identified and engaged enemy troops, though, they seemed to fade

away. Throughout 1966-67, military operations increased. U.S. combat forces grew to 389,000 by late 1966 and peaked at 550,000 in 1969. The press corps ballooned as well, with about a thousand journalists ultimately in South Vietnam, 700 with accreditation. Some stayed at the Caravelle and other Saigon hotels and reported from government handouts and press conferences. Others freely caught rides in helicopters and jeeps. Guerrillas could appear anywhere, anytime, and about 50 journalists were killed in Vietnam, Laos, and Cambodia: Robert Capa and Dickey Chapelle; Larry Burrows, whose helicopter crashed in Laos; Marguerite Higgins, who died of an infection contracted in Vietnam. Five foreign correspondents were slain by machine-gun fire in May 1968 when their jeep surprised Viet Cong in a Saigon suburb. The next day UPI photographer Charles Eggleston armed himself and left on a suicide mission to avenge their deaths. No Westerner ever saw him again.

Journalists were not required to submit stories for official inspection. Cables that displeased government

Nine-year-old Kim Phuc runs screaming, left, after tearing off her burning clothes when South Vietnamese planes mistakenly napalmed her village on June 8, 1972. Photographer Hung Cong "Nick" Ut made sure the girl received medical care. Right, Ut visits Kim and her niece later. The 1972 photograph earned a Pulitzer Prize.

officials might be delayed or lost, Browne recalled, but the war was thoroughly reported. Barry Zorthian, official U.S. spokesman in South Vietnam for much of the war, said that censored or not, journalists and their stories posed no threat to the Army—but they did affect public opinion back home, especially through television. Film from Vietnam, shipped to Tokyo and relayed to the U.S. by satellite, appeared on the CBS, NBC, and ABC evening news shows. War reports and body counts arrived as Americans ate dinner. An article in the Army's *Military Review* suggested that the visceral power of these programs was the key factor in shifting American public opinion against the war. Zorthian, the government spokesman, disputed that point. The Army's official history of the war argued that rising casualties had more influence: A tenfold increase in the numbers of dead decreased public war support by 15 percent.

Television seldom showed carnage, particularly when the victims were American, but it did highlight the difference between government statements and hard facts. When CBS's Safer and camera crew filmed troops using lighters to burn Cam Ne in 1965, the visual impact overwhelmed any print story. The North Vietnamese used the film as propaganda. President Johnson chewed out CBS President Frank Stanton for having "shat on the American flag."

A full-scale Viet Cong and North Vietnamese attack occurred in January and February 1968. The Tet Offensive—named for Tet, the Vietnamese New Year—was the war's first large-scale open fighting. Guerrillas suffered tens of thousands of casualties,

making Tet a military victory yet a political and psychological defeat for America and South Vietnam. TV viewers witnessed fighting in the streets and guerrillas inside the U.S. Embassy compound. They read the most famous quote of the war, spoken by an unidentified Marine and quoted by Peter Arnett, a young New Zealander reporting for the AP: "It becomes necessary to destroy the town in order to save it." The comment seemed symbolic.

"What the hell is going on? I thought we were winning the war," CBS anchorman Walter Cronkite asked when he read the first Tet accounts. Cronkite decided to visit Saigon himself. He watched gunships attack, toured the smoking ruins of the Chinese neighborhood, saw house-to-house fighting in Hue, and shared a copter with the remains of 12 Marines in body bags. He found incredible Gen. William Westmoreland's insistence that 206,000 more American troops would win the war.

In his memoir, Cronkite said he weighed the evidence and concluded that the war could no longer be justified. At the end of a special report on Tet, for one of the few times in his career, Cronkite made a personal statement: "To say that we are mired in stalemate seems the only realistic, yet unsatisfactory, conclusion.... It is increasingly clear to this reporter that the only rational way out, then, will be to negotiate, not as victors, but as an honorable people who lived up to their pledge to defend democracy, and did the best they could." Watching that broadcast, President Johnson said, "If I've lost Cronkite, I've lost middle America." Even conservative journalist

147

William F. Buckley of the *National Review* said that the request for more troops should be denied.

Johnson's successor, Richard Nixon, began a program of "Vietnamization," replacing American soldiers with South Vietnamese. His problem was how to withdraw without appearing defeated. He took a calculated step in March 1969. Unpublicized U.S. raids rattled enemy bases in Cambodia, where the Viet Cong and North Vietnamese assumed they were safe. In April 1970, while American troops withdrew from Vietnam, U.S. and South Vietnamese troops invaded Cambodia. Publicity about the campaign, coupled with investigative reporter Seymour Hersh's revelations about the My Lai massacre, touched off violent campus protests in the U.S., weakened the Cambodian government, and strengthened the appeal of Cambodia's Communist rebels, the Khmer Rouge. South Vietnamese troops, backed by American air support, invaded Laos in 1971. Instead of containing the war, the U.S. seemed to be widening it.

In 1972 Nixon pushed South Vietnam to negotiate a settlement. His administration announced a major peace breakthrough and, a week later, Nixon won reelection. He decided to bomb Hanoi and Haiphong at Christmas 1972, to punish the North, give the weakened South Vietnamese government breathing room, and push peace talks to a conclusion. An agreement was signed in Paris in January 1973, allowing the United States to claim "peace with honor." The U.S. exited South Vietnam that spring and left the country to defend itself. North Vietnamese and Viet Cong troops overran the South in a final

offensive in April 1975. Most American officials and journalists evacuated, but New Zealander Peter Arnett stayed to the bitter end, watching American soldiers boarding helicopters on the roof of the U.S. Embassy. "They were the same clean-cut–looking young men of a decade ago," he wrote. "But the Vietnamese were different." They had learned the American way of war.

The end came in Cambodia that same month. The Khmer Rouge, led by Pol Pot, closed in on the capital in spring 1975. As Americans evacuated their embassy on April 12, Sydney Schanberg of the *New York Times* stayed behind, watching the Khmer Rouge arrive. "Most of the soldiers are teenagers," Schanberg wrote. "They are universally grim, robotlike, brutal."

His interpreter, Dith Pran, spent four years in forced labor during their reign of terror, portrayed in the film *The Killing Fields.* He escaped in October 1979 and reunited with Schanberg. He estimated that ten percent of Cambodians died of hunger in 1975. The Khmer Rouge killed perhaps two million by starvation, torture, overwork, and execution. Pol Pot tumbled when troops from reunified Vietnam invaded in 1979 and installed a friendly government.

The Cambodian peasant revolution occurred in a near-vacuum of Western attention. Future circumstances would be different: correspondents welcomed but tightly controlled. From the Falklands to the Persian Gulf to Afghanistan, governments at war sought the benefits of press coverage without the drawbacks. Many came full circle, back to the restrictions of the Russo-Japanese War that had frustrated Jack London a century earlier.

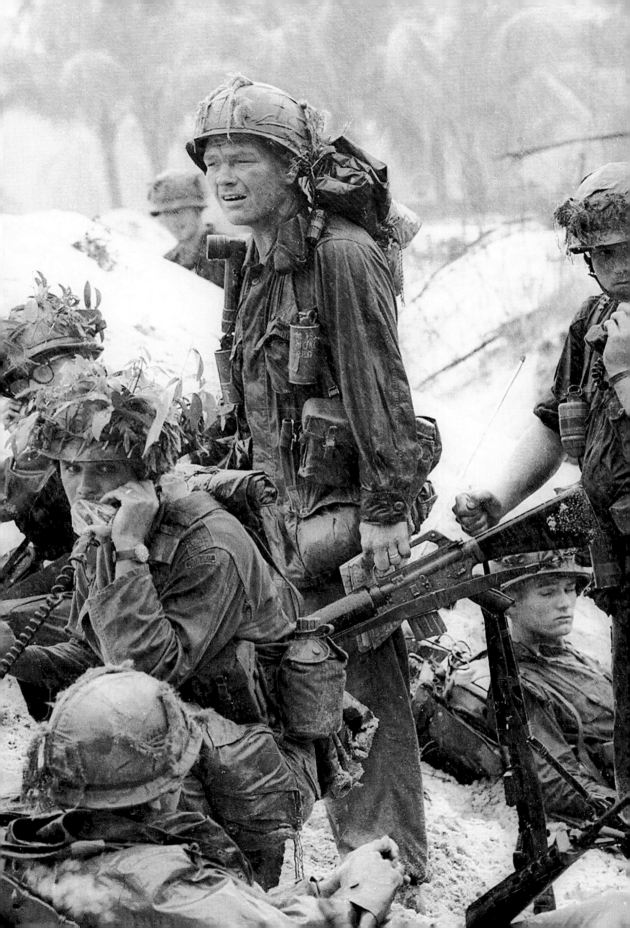

LARRY BURROWS

HE WANTED TO SHOW "THE SUFFERING, THE SADNESS that war brings."
A man of sensitive, gawky charm, Larry Burrows (1926-1971), above, made friends easily,
grieved for the innocent, and captured raw emotion, artistically framed and lighted. His wife argued
he wasn't a war photographer at all, just a photographer—a gifted, dedicated photographer best
known for nine years of images from Vietnam.

In his early assignments for *Life*, Burrows photographed art works and learned composition
and color. He later perfected the photo essay, a series of pictures that tells a story. His ride on
the helicopter *Yankee Papa 13* chronicled a mission of Marine Lance Corporal James C. Farley,
kneeling beside a dying copilot, right. Burrows received air crewman's wings after the mission with
the explanation, "You've earned it." Larry Burrows died on February 10, 1971, when the helicopter
carrying him crashed in Laos.

LIFE

By LARRY BURROWS in VIETNAM

WITH A BRAVE CREW
IN A DEADLY FIGHT

Vietcong zero in on
vulnerable U.S. copters

In a U.S. copter
in thick of fight—
a shouting
crew chief,
a dying pilot

APRIL 16 · 1965 · 35¢

Photographer Larry Burrows boarded helicopter *Yankee Papa 13*
on March 31, 1965. *YP13* was one of 17 aircraft on a mission to
ferry South Vietnamese troops to a site 20 miles away. Viet Cong
guerrillas were hiding in the tree line, "just waiting for us to come
into the landing zone," Burrows wrote. Crew chief James Farley
answered their murderous fire with a .60-caliber machine gun,
above. The helicopters continued on the mission, drawing more
hostile fire as they progressed.

With one of the mission's helicopters shot down, *YP13* braved
enemy gunfire to rescue survivors. After taking off in a hail of
Viet Cong bullets, Farley and Pfc. Wayne Hoilien bandaged the
shoulder of *YP3's* gunner. They worked atop the body of the
downed helicopter's copilot, Lt. James Magel, who had just died
of his wounds. Minutes later, right, in an empty supply shack,
Farley broke down.

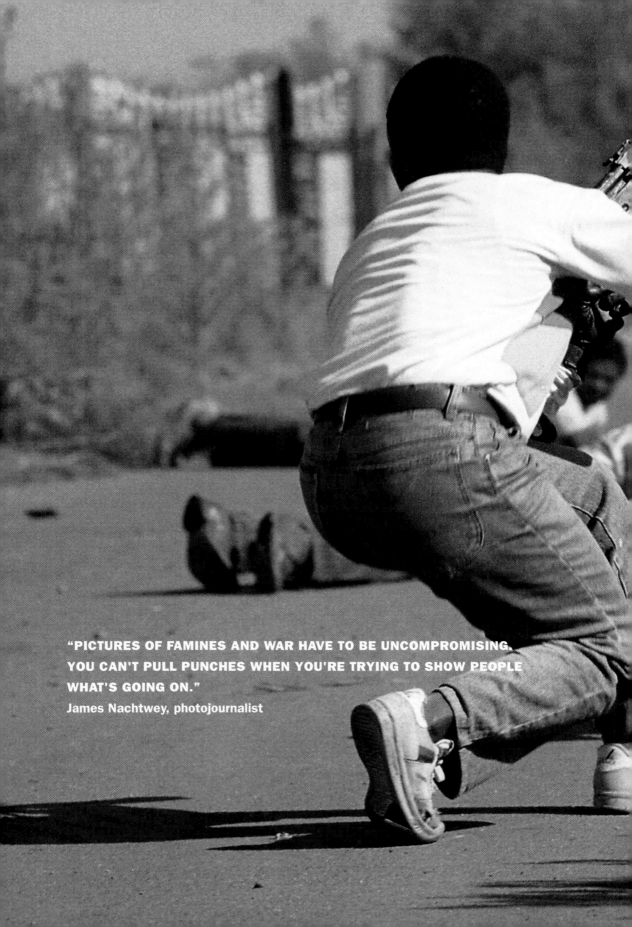

"PICTURES OF FAMINES AND WAR HAVE TO BE UNCOMPROMISING.
YOU CAN'T PULL PUNCHES WHEN YOU'RE TRYING TO SHOW PEOPLE
WHAT'S GOING ON."
James Nachtwey, photojournalist

WAR IN
TIME OF PEACE

158

CHAPTER SIX

A ROW OF TELEPHONE POLES stood starkly in the West African sand, beside them a group of Liberian government officials in their underwear. Most were fat old men who had worked with President William Tolbert—already dead, disemboweled in his bed by an army officer. Now it was their turn. A coup by native tribes, led by Sgt. Samuel K. Doe, had violently halted 133 years of rule by descendants of American slaves. A refuge for freed blacks before the American Civil War, Liberia had modeled itself on Western democracies. Friction between American and indigenous Liberians had simmered for decades. It finally boiled over on the night of April 12, 1980, when Doe and his followers boldly and bloodily took power.

On the beach with the 13 men was *Fort Worth Star-Telegram* photographer Larry C. Price. Because students from Fort Worth did missionary work in Liberia, Price had rushed there for Doe's first press conference. Learning of the public executions, he began taking the pictures that would win him a Pulitzer Prize. A man tied to a pole, the victims facing their executioners—then slumped bodies, the soldiers raising their arms in exultation. "Things got wildly out of control," Price said

Preceding pages: Photographer David Turnley captured journalistic colleagues in action during civil war in South Africa, 1994. Left, kidnappers threaten Wall Street Journal *reporter Daniel Pearl. Abducted in Pakistan on January 23, 2002, Pearl was killed days later. In July, a Pakistani court sentenced Ahmed Omar Saeed Sheikh to death for the ruthless murder.*

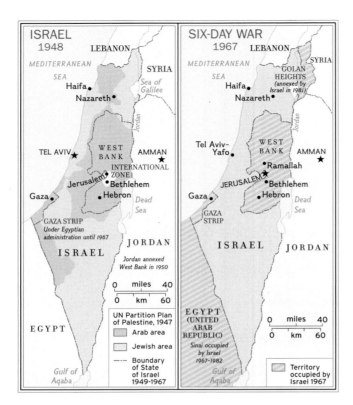

In 1946, British destroyers corralled the refugee ship Hatikvah *into harbor at Haifa, Palestine. These two Polish children, right, a sister and brother, were among the 3,000 Jews traveling in a boat designed for 500. Ultimately they found their parents. Maps, left, show how territorial boundaries between Jewish and Arab lands in the Middle East have shifted over the past decades.*

Television brought the action to Liberians. In the following years, they learned that what goes around, comes around. Doe survived one coup attempt but not a second, by American-educated Charles Taylor. In 1990 Doe was captured and tortured, and again video recorded it: the knife cutting off his ears, blood staining his underpants, his bruised and bloodied face.

While Sierra Leone native Foday Sankoh was in political exile in Liberia, he met Charles Taylor. Sankoh formed the Revolutionary United Front and led an insurrection in 1991, starting years of civil war. They seemed to have little world impact, but according to *Washington Post* reporter Douglas Farah, in 1998 two terrorists arrived in Liberia to buy cut-rate diamonds from Sierra Leone mines. Reselling the diamonds, they raised millions of dollars for global operations. Their alias? Al Qaeda—the same group, led by Osama bin Laden, accused of hijacking four American passenger jets on September 11, 2001, and flying them into the World Trade Center in New York and the Pentagon in Washington, D.C.

As the world has shrunk and become ever more interconnected, modern war has grown more sinister. The Soviet bloc disintegrated from 1989 to 1991, and some dared to hope that the world might move beyond war. Utopia has failed to arrive. Shadowy terrorist groups attack civilians and never march in the open as did the armies of old. Terrorism and guerrilla tactics, cheap ways to wage war, appeal to some disenfranchised—and to some governments. With no clear lines that separate areas of danger and safety, modern war is tough on soldiers and correspondents.

In 1994, correspondents had no immunity from bullets in covering the birth of democracy in South Africa after apartheid. Serious rioting began in 1976 in sprawling Soweto, one of the townships designated for blacks by the white-rule government. Donald Woods, white editor of South Africa's *East London Daily Dispatch,* publicized the jailhouse murder of black leader Steve Biko in 1977. The government imposed strong press controls. A state of emergency was imposed in 1985, and correspondents could be

fined or jailed for embarrassing the government. Any report of racial "unrest," as the government called it, was forbidden, as was news about banned groups or individuals, such as the imprisoned leader of the African National Congress (ANC), Nelson Mandela. Even to own a picture of Mandela was to risk arrest.

South Africa freed Mandela in February 1990. Between his release and his 1994 election as the nation's first black president, though, nearly 14,000 South Africans died in political violence. As press laws relaxed, four white news photographers—Joao Silva, Greg Marinovich, Kevin Carter, and Ken Oosterbroek—exhilaratedly covered the scene. In 1992, a South African magazine dubbed them the "Bang-Bang Paparazzi" for their attraction to urban gunfire. They preferred the "Bang-Bang Club."

"No pictures, no!" shouted a mob of ANC supporters as Marinovich shot frame after frame of their attack on a Zulu man accused of being a spy for the rival party. "I'll stop taking pictures when you stop killing him," Marinovich yelled. He watched as

torturers doused the man in gasoline, set him afire, and buried a machete in his flaming head. Fleeing to his car, the photographer was himself almost stabbed. His photo won the Pulitzer Prize.

Fighting broke out in the Thokoza township over the coming elections. One bullet struck Oosterbroek; another wounded Marinovich. Mandela said he hoped Oosterbroek was the war's last victim. Once elected, Mandela proceeded through the 1990s to disband black townships and offer new opportunities for all.

Carter, the most famous of the Bang-Bang Club, was not there to see the new South Africa. In March 1993, he and Silva had flown into southern Sudan, where Christians and indigenous tribes were fighting to break away from the Islamic government in the North. Famine and intertribal violence had wracked the South, and the Khartoum government made it hard for journalists. Silva and Carter flew into the village of Ayod on a cargo plane full of food. Carter found a bone-thin girl, collapsed on the ground near a food distribution point. A vulture landed behind her and watched as if waiting for her to die. Carter snapped pictures, then chased the vulture away. When the picture appeared in the *New York Times,* readers asked what had happened to the girl. Carter did not know. He had wanted to reach out to her but had been warned that contact could transmit disease.

The photograph won the *Times* its first photography Pulitzer. Newspapers and magazines worldwide reprinted it, prompting a surge of support for Sudan. Still, questions about the girl ate at Carter's conscience. Depressed by the fallout from the picture, by

his deteriorating personal relationships, and by photo assignments he had botched when in a tranquilizer haze, Carter ran a hose from the tailpipe into the cab of his pickup and left a suicide note to Silva: "I am haunted by the vivid memories of killings & corpses & anger & pain ... of starving or wounded children ... of killer executioners." Bearing witness to the tragedy of others, he brought about his own.

Next, stunningly beautiful Rwanda erupted. The nation's majority Hutus raised crops; the Tutsis herded cattle. Hutus took over the government when Rwanda shook off Belgian rule in 1962. The exiled Tutsis formed the Rwandan Patriotic Front (RPF) in 1987 and attacked in 1990. Fighting deadlocked in 1993, spurring Rwandan President Juvenal Habyarimana, a Hutu, to arrange to share power with the Tutsi rebels.

Habyarimana died on April 6, 1994, before the agreement was implemented: His plane was shot down, also killing the president of Burundi, a nation sheltering Tutsi refugees. Rwanda's UN ambassador called it assassination. Within an hour of the crash, Hutu military extremists seized control of Kigali, Rwanda's capital, slaughtering any who might oppose them, whether Tutsis or moderate Hutus. About 800,000 of the nation's 7,500,000 died. For the first time, the UN invoked the word "genocide."

The *Sunday Times* of London said the Rwandan Army broadcast radio and television messages inciting Hutus to avenge the death of their president. "Egged on, the Hutu peasants became uncontrollable," wrote the paper's Colin Smith. At first it was difficult for correspondents to enter. Flights into and out of Kigali were irregular, satellite uplinks initially unavailable. A Cable News Network reporter left at gunpoint. The Tutsi rebels took journalists to mass killing sites, showing piles of bodies months after the slaughter began. Smith visited a Catholic church at Nyarubuye, near the Tanzanian border, and saw hundreds of decomposing bodies of people who had sought sanctuary. A 16-year-old girl told Smith she was ordered, "Stand still while I slaughter you." She survived by hiding under her parents' corpses.

In June, French troops set up a safety zone in southwestern Rwanda. The RPF expanded its hold and forced hundreds of thousands across the borders. More than two million Hutus fled. In Zaire, cholera spread among the refugees. Victims were hastily buried in mass graves to stop the spread. Since then, Rwandans have marked the anniversary with reburials.

In Europe, allegations of genocide were raised in the Balkans. War had ignited among the nations that once comprised Yugoslavia—six republics and two autonomous regions where cultures and religions mixed as if in a blender. Orthodox Serbia, Catholic Croatia, and predominantly Muslim Bosnia existed side by side, each with enclaves of the other groups. Yugoslavia boasted Roman ruins and storybook villages; cathedrals, monasteries, and mosques. It was home to Sarajevo, host for the Winter Olympics in 1984, and to some of the poorest regions of Europe. Until 1991, the patchwork nation maintained unity through delicate political balance—and Communism.

The balance of world power shifted when, in November 1989, border restrictions between East and

163

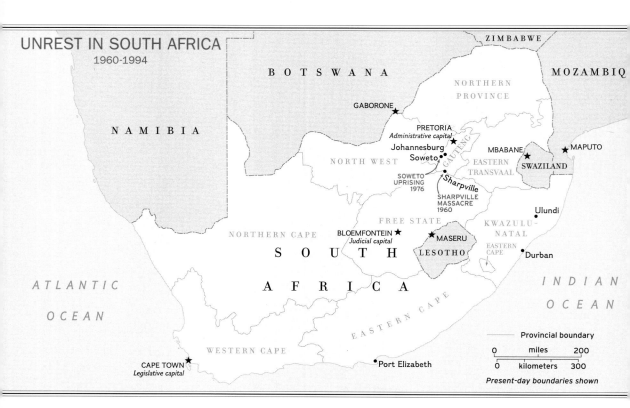

ZIMBABWE

BOTSWANA

MOZAMBIQ

NORTHERN
PROVINCE

GABORONE

NAMIBIA

PRETORIA
Administrative capital

Johannesburg

MBABANE

MAPUTO

NORTH WEST

Soweto

GAUTENG

EASTERN
TRANSVAAL

SWAZILAND

SOWETO
UPRISING
1976

Sharpville

SHARPVILLE
MASSACRE
1960

Ulundi

FREE STATE

KWAZULU-
NATAL

NORTHERN CAPE

BLOEMFONTEIN
Judicial capital

MASERU

LESOTHO

EASTERN
CAPE

Durban

SOUTH

AFRICA

ATLANTIC

OCEAN

INDIAN

OCEAN

EASTERN CAPE

WESTERN CAPE

Port Elizabeth

CAPE TOWN
Legislative capital

Provincial boundary

0 miles 200

0 kilometers 300

Present-day boundaries shown

West Berlin relaxed. Down came the Berlin Wall, and with it the concept of an Iron Curtain between democratic and Communist realms. Antagonisms still erupted. Wealthy Croatia and Slovenia sought political and economic reform, while Serbia, more austere and authoritarian, rejected liberalization. Croatia and Slovenia declared independence on July 25, 1991, after Serbian leader Slobodan Milosevic refused to vacate the Yugoslav federation's presidency. The Serbs attacked the breakaway republics and fought to a standstill.

Propaganda became common. In August 1991, both sides aired clips of a wagon full of bodies, the Serbs saying they were victims of Croatian butchery and the Croats saying they were "heroes who fell in the struggle for Croatian independence." Bang-Bang Club photographer Marinovich, visiting late in 1991, heard from a grinning Croatian that soldiers could trade ears from Serbian bodies for four-day passes.

A larger crisis began in March 1992 when Bosnia declared its independence. In a national vote, Croats and Slavic Muslims chose self-determination, while

Bosnia's ethnic Serbs refused to accept the results. Pro-independence rallies ended in violence; violence grew into war. Milosevic's army invaded, then, under international pressure, withdrew, but most soldiers joined local Bosnian Serbs and by summer 1992 occupied about 70 percent of Bosnian land, surrounding Muslim enclaves. Then they began a campaign of "ethnic cleansing" against Croats and Muslims.

A Muslim in Banja Luka, Bosnia's main Serbian city, told *Newsday* correspondent Roy Gutman in July 1992, "They are shipping Muslim people through Banja Luka in cattle cars.... It's like Jews being sent to Auschwitz." *Newsday's* explosive description of "death camps" at Omarska and Manjaca awakened the world to the worst mass killings in Europe since World War II. "The Serb conquerors of northern Bosnia have established two concentration camps in which more than a thousand civilians have been executed or starved and thousands more are being held until they die," Gutman wrote after interviewing two released prisoners. Allegations gained strength when

A magazine in South Africa, right, inspired the name "Bang-Bang Club" for four white photojournalists who sought out conflict in the early 1990s as the struggle to end apartheid came to a head, map, left. Following pages: In April 1993, South Africans scatter as police fire bullets and tear gas outside the funeral of Chris Hani, African National Congress leader.

a British ITN network TV crew photographed Omarska and another camp, Trnopolje. Images of emaciated prisoners echoed Margaret Bourke-White's photographs of Nazi concentration camps.

Christiane Amanpour of CNN reported from the thick of the fighting in the Balkans. Her passion for presenting the impact on ordinary civilians, with allegations of a "World War II–styled genocide," caused some to question her objectivity. She irked President Clinton by disguising a statement as a question: "My question is, as leader of the free world, as leader of the only superpower, why has it taken you, the United States, so long to articulate a policy on Bosnia?" she asked during a CNN forum, citing "the constant flip-flops of your administration on the issue of Bosnia." Clinton replied that he was doing the best he could, but it was not in the national interest to send ground troops to Bosnia. Amanpour dismissed complaints of bias. She was supported by a March 1995 front-page story in the *New York Times,* reporting CIA information that the Serbs had committed 90 percent

of known acts of ethnic cleansing and characterizing the Bosnian conflict not as a civil war but as "a case of Serbian aggression."

Economic sanctions, NATO air raids, and setbacks in battle led the Serbs to accept peace in Bosnia in 1995. Then they turned to Kosovo, a semiautonomous region of their own country, historically and culturally meaningful to them but also settled by Albanian immigrants. In response to reports of attacks on ethnic Albanians, NATO planes bombed Serbia for three months in 1999. Western governments accused President Milosevic of ordering the mass killing of non-Serbs. In June 2001, after losing reelection, Milosevic was extradited to The Hague, Netherlands, to stand trial before the International Criminal Tribunal for crimes against humanity. As his own defense attorney, Milosevic unrepentantly challenged the prosecution as his trial stretched into 2004.

AFTER VIETNAM, the United States remained cautious about committing large numbers of troops overseas.

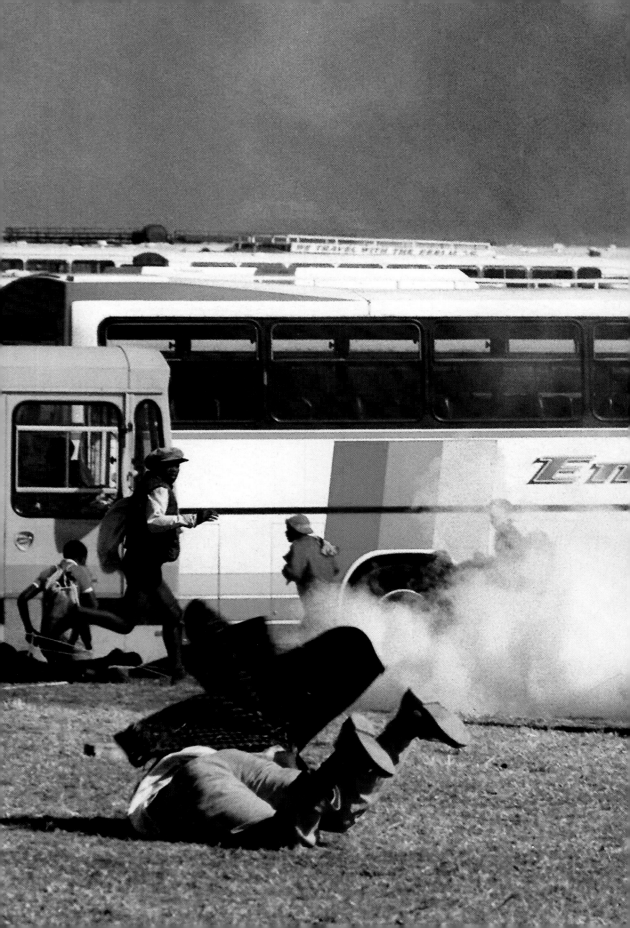

Acrimony and distrust colored relations between military and media. Once again government reports failed to match what correspondents saw, this time during revolutions in Nicaragua and El Salvador, where the U.S. government supported right-wing factions—the government in El Salvador and the Contras, or anti-Marxist rebels, in Nicaragua.

El Salvador had endured decades of labor uprisings, fomented by the wide gap between a few rich and many poor. In 1932 Agustin Farabundo Martí led a labor protest against coffee plantations, and the army responded by killing thousands of Indian laborers and executing Martí. For decades, the military dominated the country. They cracked down on leftist organizations and established government death squads, *escuadrones de muerte,* in the 1970s. In March 1980, guerrillas tried to topple the government. In 1980 Archbishop Oscar Romero, who championed social reform, was killed during Mass. The murder was later linked to the ruling junta. Journalists struggled to reconcile the statements of the junta with the atrocities.

In 1981 Raymond Bonner of the *New York Times* lived and hiked with the guerrillas, who told him that theirs was a homegrown revolution, "spawned by decades of political and social injustice." Guerrilla leaders compared it to Vietnam. America advised the government and trained officers, while guerrillas used Korean War–era M-1 carbines or ancient Czech bolt-action rifles, set up schools and clinics, and won peasant loyalty. Bonner and *Washington Post* reporter Alma Guillermoprieto reported in January 1982 that an American-trained Salvadoran army unit had killed hundreds of civilians at the village of Mozote. They found charred skulls and bones and talked with survivors The U.S. State Department vigorously denied the story, and a Salvadoran junta spokesman called it a fabrication by "subversives."

The *Times* recalled Bonner. Ten years later he was exonerated. In 1992 the *Times* published a photo of a mass grave at Mozote where forensic examiners had found 38 skeletons, most children with their throats cut. In all, the dead numbered at least 794. "The peasants did not exaggerate," a *Times* editorial stated. Soon documents released from the State and Defense Departments and the CIA revealed that the Reagan and Bush administrations knew of the massacres.

American intervention in Nicaragua has a longer history. Revolutionaries there invited William Walker, a Tennessee adventurer, to lead his private army into Managua, the capital. He proclaimed himself president in 1856. Central American governments and American entrepreneur Cornelius Vanderbilt allied to force Walker's surrender a year later. U.S. forces entered Nicaragua in 1912 and 1927, fought off by guerrillas led by Augusto Cesar Sandino. Sandino was executed in 1934, a move engineered by National Guard commander Anastasio Somoza. Two of Somoza's sons, Luis and Anastasio, held the presidency and powered the military with U.S. support. Revolutionaries adopted Sandino's name and formed the Sandinista National Liberation Front to fight the right-wing dictatorship in the 1970s.

In 1978 Sandinista leader Pedro Joaquin Chamorro, editor of *La Prensa*, was assassinated. Rioting brought

168

repression by the National Guard, which began killing more civilian opponents of the government. On June 20, 1979, a National Guardsman murdered ABC correspondent Bill Stewart. Films of the killing ran on the air. A Georgia congressman accused journalists of distorting the news. An ABC colleague of Stewart's angrily asked, "Where the hell have you been, sir?" Sandinista offensives continued into 1980, and the rebels captured Managua in July. Somoza left the country and was assassinated in Paraguay the next year. Rejecting an American offer to mediate, the Sandinistas cancelled elections, established relationships with the Soviet Union and Cuba, and forced brutal relocations of Mesquite Indians.

During the 1980s, the United States quietly began arming the Contras against the Sandinistas. *New York Times* reporter Stephen Kinzer in 1983 documented an American-supplied Contra base across the border in Honduras, stacked with American crates labeled "fragmentation grenades and mortar shells." American and Honduran officials insisted otherwise.

Evidence began piling up of a clandestine American operation to arm the Contras despite a congressional ban. Journalists learned that the pipeline began in the Middle East. On Halloween 1986, the Lebanese magazine *Al Shiraa* reported that the U.S. had been selling weapons to Iran in hopes of freeing Western hostages held by Lebanese Muslim extremists, with the profits going to the Contras in Nicaragua. The scandal became known as the Iran-Contra Affair.

President Ronald Reagan called the Contras "the moral equivalent of our founding fathers." Some news stories undercut that patriotic image. In 1987 reporter Rod Nordland and photographer Bill Gentile from *Newsweek* went on a monthlong Contra patrol in the northwestern Nicaraguan rain forests. Gentile filmed a Contra helicopter disguised with Red Cross markings moving military supplies. The Contras frightened peasants into walking ahead of their patrols "like human mine detectors." Later the two correspondents joined the Sandinistas, whom they found bolder and more highly motivated.

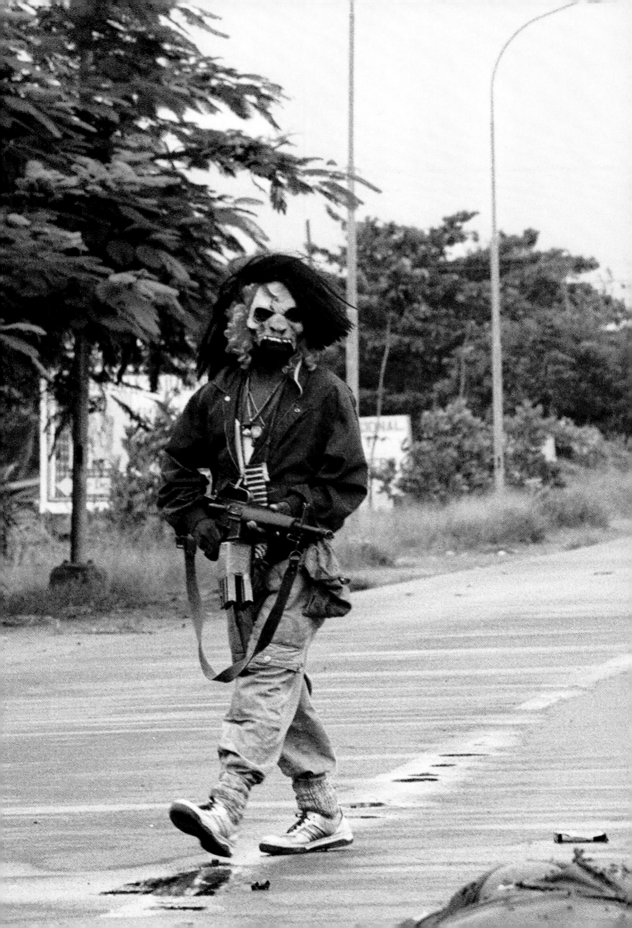

In return for fair elections, the Sandinistas approved a plan to repatriate disarmed Contra rebels. Violeta Chamorro, the widow of the slain *La Prensa* editor, ran for president in 1990 and won easily.

IN 1982 two events a world apart—in the Middle East and the South Atlantic—marked the deterioration of correspondents' freedom to report from war zones.

Through the 20th century, European Jews had sought refuge in Palestine, provoking conflict between Jews and Muslims. A 1947 UN resolution marked separate territories, but Israeli victories in 1948 and 1967 sent thousands of Palestinian refugees into camps in neighboring Islamic countries. Most feared they might never have their own independent nation.

In early 1982, units of the Palestine Liberation Organization (PLO) lobbed artillery shells into northern Israel, pressuring for a Palestinian homeland. Israeli Prime Minister Menachem Begin ordered a "Peace for Galilee" invasion to establish a security zone in southern Lebanon. Moving north, troops encountered Syrian opposition. By June 11, after two days of severe fighting, the combatants agreed to a ceasefire—which did not last. Israeli forces trapped PLO holdouts and crushed a refugee camp. PLO fighters evacuated Beirut on September 3 under an agreement brokered by the U.S. and Saudi Arabia.

On September 16, Israel allowed its Lebanese allies, the Christian Phalangists—seeking revenge for the recent assassination of Christian President Bashir Gemayel—to enter Palestinian camps near Beirut. For three days, Israeli tanks blocked foreign observers from the Phalangist death squads' violence. The full story emerged only after the Israelis and their allies pulled back. The Lebanese daily paper *As-Safir* published a photograph of the lifeless hand of a woman, clutching her Lebanese Muslim ID card. She apparently had been showing a Phalangist gunman that she was not Palestinian when he fired on her. News of the killings of hundreds of unarmed men, women, and children jarred Israeli citizens. Both they and the Palestinians were learning the power of the press.

In December 1987, Palestinians in Israel began their *Intifada*—"shaking off something unpleasant" in Arabic. They relied on the media to gain world sympathy. Photos showed Palestinian youths throwing rocks at heavily armed soldiers. Arab gangs staged violence. In February 1988, former U.S. Secretary of State Henry Kissinger, a strong supporter of Israel, said that the first step to end the Intifada was "to throw out television."

Israel largely followed that course of action during the second Intifada, which began in 2000. In the 1990s, Israel had granted some Palestinian self-determination in the Gaza Strip and the West Bank of the Jordan River. Palestinian terrorist attacks continued. The Palestinians pressed for permanent borders, settlements, full autonomy, and the right for refugees to return. In spring 2002 Israeli soldiers cracked down on militant groups and prevented correspondents from filming. Journalists faced rubber bullets, tear gas, and barbed wire when PLO leader Yasser Arafat's headquarters in Ramallah were cornered by the Israeli Army. Soldiers arrested an NBC crew and fired stun

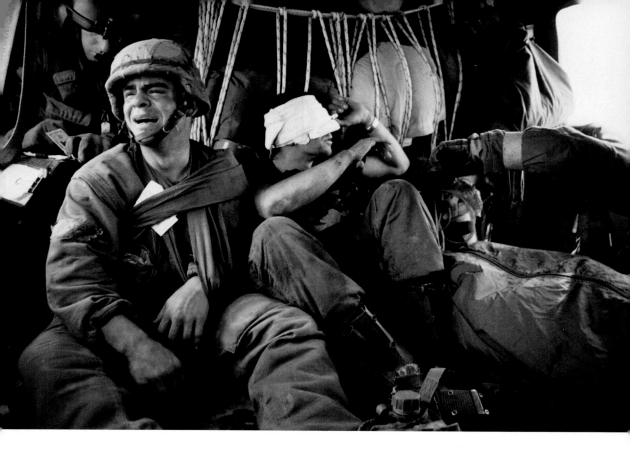

grenades and rubber bullets at two dozen journalists covering an American envoy's arrival. Israel had learned how pictures can shape opinion.

The other 1982 action took place in the Falkland Islands, 300 miles east of Argentina. The British had occupied these islands for 150 years, but the Argentines claimed those they called Las Malvinas. After a dispute between British scientists and Argentine salvage workers on South Georgia, an island to the east, Argentina invaded the Falklands. On April 2 Argentines overwhelmed the small Royal Marine garrison and soon occupied the Falklands. They allowed Simon Winchester of London's *Sunday Times* to stay for three days. "There was no raping or pillaging, and to have relatively civil behavior reported abroad was, the invader-commanders felt, good for their image," surmised Winchester. He smuggled out one uncensored dispatch in the shoe of the departing British governor's son. Finally ordered to leave, he traveled to Buenos Aires and photographed a naval base, then was jailed for 77 days.

In response to the invasion, British Prime Minister Margaret Thatcher declared a 200-mile war zone around the islands and sent two aircraft carriers and more than a hundred warships and transports. From Britain, 28 correspondents sailed with the force, accompanied by seven censors. Stories from the Falklands could be delayed up to 36 hours, live television was forbidden, and photographic images had to travel by ship. Censors changed the "failure" of bomber raids to "success."

On May 21 British forces landed on the northern island. The Argentines surrendered on June 14, and more than 11,400 were taken prisoner. The same day Stanley, the capital, was recaptured by British ground troops. Prime Minister Thatcher questioned the British press's patriotism, but others marveled at how well press controls maintained support for the war. A Ministry of Defense official said, "Next time, we'll cut down on the number of journalists."

The United States applied lessons from the Falklands during the invasion of Grenada in 1983. No

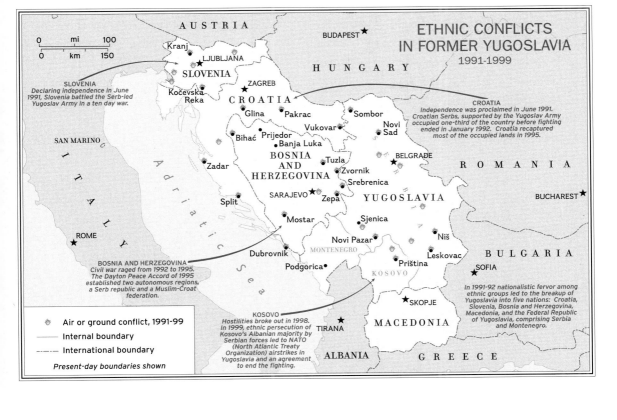

American civilian journalists were on hand to witness their country's occupation of the tiny Caribbean island in October 1983, when a military coup overthrew the government of Prime Minister Maurice Bishop's Peoples Revolutionary Government. U.S. officials announced that 1,100 Cubans on the island were preparing to seize control. American medical students were in danger of being taken hostage.

White House and Pentagon correspondents learned of the invasion an hour after it began. Journalists were refused access for four days, officially to protect both correspondents and the operation. The *Washington Post's* Edward Cody tried to sneak onto the island. Others hired a boat, but at first no one reached Grenada. When journalists were finally allowed in, their reports cast doubt on the official version of the invasion. Fewer Cubans were on the island than had been thought, and

During the Gulf War, 1991, Sgt. Ken Kozakiewicz, above left, grieves after surviving a "friendly fire" incident that wounded and killed fellow soldiers. Map, right, shows the states formed of the former Yugoslavia and the conflicts that ensued in them.

a Navy plane had accidentally bombed a mental hospital, killing at least 17.

Complaints prompted a Defense Department study of media-military relations, which led to the creation of a press pool for coverage of any conflict. Media-appointed representatives would provide stories and images for all the press. Pool coverage began July 19, 1987, when ten journalists flew to the Persian Gulf to report on the reflagging of Kuwaiti oil tankers to protect them during the Iran-Iraq War.

A press pool covered the 1989 invasion of Panama as well. In May 1989, Gen. Manuel Noriega deposed President Guillermo Galimany. Noriega, known to be anti-American and implicated in international drug trafficking, was proclaimed head of state by a rigged assembly vote. U.S. officials feared losing the Panama Canal. On December 16, Panama's National Guard murdered a U.S. Marine officer. American troops overwhelmed the Guard and on January 3, 1990, captured Noriega, who was later sentenced to 40 years in U.S. prison. Americans saw few but the Penta-

175

gon's pictures. The pool of 12 journalists arrived four hours into the fighting and were detained at a base five hours more, so they missed the heaviest action.

WAR CORRESPONDENTS and Western resolve were put to the test when Iraq invaded Kuwait in 1990. Iraqi President Saddam Hussein accused the oil-rich country to the south of violating international agreements and reducing Iraq's income. Using old arguments that Kuwait was once part of Iraq, he vowed to make it his nation's 19th province. Michael Kelly, a reporter for the *Boston Globe* and other publications, described Hussein's negotiations with Kuwait as "an old-fashioned shakedown" in which Iraq demanded of Kuwait "a great deal of money to remain uninvaded." The prince declined, and "the Iraqi Army entered Kuwait a few hours later."

Since the invasion also threatened Saudi Arabia, the world's largest oil producer, President George Bush decided American interests were at stake. He had to persuade Americans that it was worth war to liberate Kuwait, a totalitarian dictatorship where women were forbidden from politics and foreign-born residents were essentially second-class citizens. Kuwaitis in America hired a public relations firm and focused on Iraqi atrocities to stir up hatred toward Hussein.

Kelly, one of the first journalists into Kuwait City after its liberation, interviewed hospital officials who had catalogued the dead and mutilated bodies of Kuwaitis who had refused to recognize the new government. Execution squads broke bones, plucked out eyeballs, and smashed heads, a doctor told Kelly.

Iraq invaded Kuwait on August 2. Within days, Navy Capt. Ron Wildermuth drafted a secret blueprint for military control of Persian Gulf news. According to the *New York Times,* the ten-page memo, called Annex Foxtrot, embodied the desire of senior officials including Bush "to manage the information flow in such a way that supported the operation's political goals and avoided the perceived mistakes of Vietnam." Journalists would be "escorted at all

times. Repeat, at all times." Journalists chose one coordinator per medium, then each coordinator chose journalists for the pool. Correspondents had to follow rules including censorship—"security review," the Joint Information Bureau called it. Pool supervisors accepted 150 journalists at a time, but only half that number actually went into the field with the troops.

Throughout late 1990 and early 1991, negotiators tried to convince Hussein to withdraw. Meanwhile, the buildup of troops, ships, tanks, and planes continued, called Operation Desert Shield, an American-led coalition including British, French, Saudi, and Egyptian troops.

After the withdrawal deadline of January 15, Desert Shield became Desert Storm. The first news of shooting came from a few Western journalists in the Iraqi capital of Baghdad. Antiaircraft guns began firing at 6:32 p.m. EST—2:32 a.m. in Baghdad. From the Al Rashid Hotel ABC's Gary Shepard noticed flashes on the horizon. He told network anchor Peter Jennings by phone that it looked "like fireworks on the Fourth of July, multiplied by one hundred." Soon coalition bombs destroyed the city's telecommunications center, and Shepard was silenced.

The air campaign was part of an assault intended to paralyze military command and destroy civil infrastructure. On the ninth floor of the Al Rashid, the CNN team of Bernard Shaw, John Holliman, and Peter Arnett used a satellite relay to telephone CNN's Atlanta headquarters. The only live reports from Baghdad, carried by other networks, they certified that the 24-hour news network had arrived on the world stage. Secretary of Defense Dick Cheney and Joint Chiefs Chairman Colin Powell were watching. Powell even used CNN as a source of information. "Go for it, guys," executive producer Bob Furnad told his team in Baghdad. "The whole world is watching."

Or rather, listening. Initially unable to broadcast live pictures, the three CNN correspondents described the war in words. It was like Edward R. Murrow watching the Blitz from a London rooftop. "The skies

over Baghdad have been illuminated," said Shaw. "We're seeing bright flashes going off all over the sky. Peter?" Arnett, huddled with the others on the floor, then described "lightning-like effects" of explosions and flak. Holliman interjected, "Holy cow! That was a large airburst we just saw." Explosions thundered in the background.

Meanwhile CNN cameraman Mark Biello filmed the attack for later transmission. The CNN report preceded the Pentagon's by 27 minutes. For 17 hours, CNN reported without censorship. Then an Iraqi press liaison officer, or "minder," arrived and dragged a finger across his throat. Time to cut the live commentary in the name of security.

Most American journalists, including Shaw and Holliman, left Baghdad shortly after the bombing began. Peter Arnett stayed through February, later joined by Christiane Amanpour. They sent out live censored television reports using a portable satellite system trucked in from Jordan. The Iraqis apparently thought that CNN reports might gain them sympathy. Arnett visited bombing sites and, after a strip search, taped an interview with Hussein.

Peter Arnett had a temperament for intrigue. Born in 1934 in southern New Zealand, he worked for wire services in Southeast Asia during the 1950s and '60s. For his first major scoop, a coup in Laos, he swam the Mekong River, carrying his typed story, his passport, and $200 in his mouth. He won a Pulitzer Prize in 1966. From Iraq, he reported the destruction of buildings he identified as a baby milk plant and a public air raid shelter. U.S. officials claimed the plant was a biological weapons factory, the shelter a command-and-control bunker. Arnett grabbed plastic bags of milk powder at the factory and dramatically displayed them during lectures after the war.

Censorship, the pool system, and military escorts limited coverage in Saudi Arabia and Kuwait.

Following pages: In Sarajevo, 1994, a woman sprints through "Sniper's Alley," a main street made dangerous for anyone during the Bosnian War.

Censors balked at a *Detroit Free Press* reporter's use of the word "giddy" to describe American pilots returning from raids—they insisted on "proud."

Military escorts didn't control interviews, yet their presence created what media and legal scholars call a "chilling effect." As NBC's Gary Matsumoto described it, during an interview a public affairs officer would stand nearby, hold a tape recorder, and stare—"patent intimidation," Matsumoto said. Many soldiers, after their interviews, asked the officer, "Can I keep my job?" Journalists who tried to escape the system were called "unilaterals." Some were physically detained by the coalition forces. A *Time* reporter was held under guard, blindfolded. CBS correspondent Bob Simon and three TV crew members were arrested at the border, beaten, and tortured by Iraqis.

For 38 days, Allied planes bombed desert defenses and military installations, but Iraq refused to leave Kuwait. On February 24, 1991, the ground war began. Coalition forces aimed to trick Iraq into believing that they would focus on Kuwait's beaches and border with Saudi Arabia. Meanwhile coalition commander Gen. H. Norman Schwarzkopf drove 260,000 French, British, and American troops through Saudi Arabia deep into Iraq. Another 40,000 American Marines charged onto shore, but many Iraqis had already deserted their bunkers. Warplanes killed others as they fled, a "turkey shoot" along the highways.

Michael Kelly of the *Globe* evaded military oversight after only two hours, drove across the desert, and found Iraqi morale abysmally low. The government and the media had described Iraqi soldiers as battle-hardened, crack fighting units. Captured Iraqis told Kelly, however, they had been coerced into fighting. "From the beginning of the war, I didn't agree with the ideas of the president at all," one officer said. "If we tried to desert they would hang our families." He called Saddam a criminal. "He is killing us," he said.

Edward Barnes of *Life* and Bob McKeown of CBS beat the pool and filed from inside Kuwait City. Iraqi troops set fire to hundreds of Kuwaiti oil wells, and geysers of flame and clouds of choking black smoke

erupted, adding a hellish quality. Downtown Barnes watched deserted streets fill with residents who slowly realized they were free—"laughing, crying, waving flags, hugging one another, shooting into the air and honking their horns in jubilation." Overshadowing the celebration was President Bush's decision to halt the ground war before ousting Hussein. A decade later his son, President George W. Bush, would declare Hussein's Iraq part of an international "axis of evil" still threatening world peace.

At the end of the Persian Gulf War, Molly Moore of the *Washington Post* had little doubt that in the next war, "the high-ranking spin doctors would impose blackouts, restrict coverage, and create an image of painless, antiseptic battles, the same false impression they created for Operation Desert Storm." Gen. Chuck Horner, allied leader of the Gulf War air attack, felt the impact of live TV. "The CNN Effect means that God's looking over your shoulder all the time, and I think it is a blessing," Homer said. "It is not pleasant, and you take hits, but in the end it brings out the best in mankind when he is doing his worst, waging war."

Evidence of the power of uncensored images gained credence in 1993. American troops had led an international humanitarian effort in famine-ravaged Somalia, where clan warlords were using hunger as a weapon to enforce control. On October 3, militiamen ambushed a special forces unit sent to arrest their leader, the chief warlord. They shot down two American helicopters and killed 18 Army Rangers, later dramatized in the film *Black Hawk Down.* Somali video showed captured airman Michael Durant. Paul

Watson of the *Toronto Star* shot pictures of a mob dragging a dead American soldier through Mogadishu. American and UN forces soon withdrew.

Words and pictures are a double-edged sword in wartime. They can motivate or undermine morale. Nowhere have the controversies about images of war been more obvious than after the September 11, 2001, terrorist attacks on New York's World Trade Center and Washington, D.C.'s Pentagon. Repeated broadcasts of the collapse of the twin towers spread fear, in the short term benefiting Saudi Arabian terrorist Osama bin Laden and his Islamic fundamentalist organization, al Qaeda, identified by the White House as the perpetrators. Videotapes made by bin Laden after September 11 may have comforted his followers, but they also provided evidence of his part in the attacks. Tom Franklin's photograph of three New York firefighters raising a flag atop the rubble inspired millions.

The situation in Afghanistan, home to al Qaeda and the repressive Taliban regime, demonstrated the folly of short-term planning in global politics. Americans helped the mujahedeen, Islamic fundamentalist guerrillas, fight the Soviet invasion of Afghanistan. The Russians left in 1989, and Afghanistan fell into chaos. The U.S. closed its embassy in Kabul.

"All you cared about was destroying communism," a top Pakistani newspaper editor told Peter Arnett, assuming he was American. "You welcomed extremists to the struggle and trained them to kill. But many of those people don't like you either ... you're the next target."

America launched air raids against the Taliban and al Qaeda on October 7, 2001. Bush declared in his 2002 State of the Union address that America was fighting a new kind of war: "These enemies view the entire world as a battlefield, and we must pursue them wherever they are." Press attempts to cover this new kind of war were curtailed. The *Columbia Journalism Review* reported less access to American military forces than ever. Press pools did not form until November 25, and pool reporters were confined to a warehouse, which hindered their contact not only with troops but also with medics, rescuers, and others.

Journalists outside America provided a broader view. *Al Jazeera,* a 24-hour news network based in Qatar, covered the 2001 U.S. attacks from inside Afghanistan. Its newscasters snagged exclusive videos of bin Laden, including an October 2001 talk in which he admitted to being a terrorist. Attacks like those on September 11, he said when pressed, were "permissible in Islamic law and logic." U.S. officials complained to Qatar's emir that the broadcasts were anti-American. *Al Jazeera* headquarters in Afghanistan were bombed in a November 13 air raid by the U.S. on Kabul. The Department of Defense apologized: They believed the building housed al Qaeda.

Western journalists who struck out alone took their lives in their own hands. Jim Wooten of ABC may have

missed being killed by three minutes, thanks to his South African cameraman. An ABC crew was driving to Kabul in a caravan of journalists when photographer Tim Manning asked to stop for pictures of Afghan girls struggling with stubborn camels. On the road again, a driver gestured at them, frantically yelling and pulling his finger across his neck. Bandits had ambushed the car ahead of them. Afghan witnesses said Taliban supporters dragged the four journalists out, ordered them to walk toward hills nearby, and shot them.

Daniel Pearl of the *Wall Street Journal* became the tenth correspondent to die during the war on terror. A careful reporter, Pearl had refused an assignment in Afghanistan because he thought it was too dangerous. Instead he went to Pakistan to learn why a Muslim radical named Richard Reid had boarded a U.S.-bound transatlantic flight, his shoes loaded with explosives. Pearl was kidnaped, tortured, and killed by extremists, who sent American officials a video of his execution.

Warfare, especially by and against terrorists, has made everyone a potential target. Correspondents know this. Through the end of 2001, more journalists than American soldiers died in Afghanistan because of the war.

According to *USA Today,* in January 2002, journalists arriving at a military air field in Kandahar, Afghanistan, heard an Army captain inform them, "You're not the targets here. We are."

Upon reflection, the officer apologized. "That's not true," he said. "You are."

183

ACKNOWLEDGMENTS

For Betty Sweeney

The author also wishes to thank the editors and researchers at National Geographic, particularly Barbara Brownell Grogan, Susan Blair, and Harris Andrews. Thanks also to friend and photographer Mike Bullock for his insightful comments on the manuscript, and to John Silbersack at Trident Media Group.

And, as always, thanks to Carolyn and David.

National Geographic would like to thank The Freedom Forum for its guidance and support in this project.

AUTHOR

MICHAEL S. SWEENEY is a journalism professor at Utah State University and an expert on war censorship. His recent book *Secrets of Victory* was a 2001 "Choice" Outstanding Academic title and was named 2001 Book of the Year by the American Journalism Historians Association. He is co-author of the Smithsonian Institution's *On the Move: Transportation and the American Story,* published by National Geographic in 2003, and co-author with Robert D. Ballard of National Geographic's *Return to Titanic,* published in 2004. He is currently writing a book about Ernie Pyle.

ILLUSTRATIONS CREDITS

ADDITIONAL READING

Arnett, Peter, *Live From the Battlefield, From Vietnam to Baghdad* (New York: Simon & Schuster, 1994).

Bourke-White, Margaret, *They Called It Purple Heart Valley* (New York: Simon & Schuster, 1944).

Browne, Malcolm W., *Muddy Boots and Red Socks: A Reporter's Life* (New York: Times Books, 1993).

Cloud, Stanley, and Lynne Olson, *The Murrow Boys: Pioneers on the Front: Lines of Broadcast Journalism* (Boston: Houghton Mifflin, 1996).

Crozier, Emmet, *American Reporters on the Western Front 1914-1918* (New York: Oxford University Press, 1959).

Dunn, William J., *Pacific Microphone* (College Station: Texas A&M University Press, 1988).

Friedman, Thomas L., *From Beirut to Jerusalem* (New York: Farrar, Straus, Giroux, 1989).

Gutman, Roy, *A Witness to Genocide: The 1993 Pulitzer Prize-Winning Dispatches on the "Ethnic Cleansing" of Bosnia* (New York: Macmillan, 1993).

Hankinson, Alan, *Man of Wars: William Howard Russell of the* Times (London: Heinemann, 1982).

Harris, Brayton, *Blue & Gray in Black & White: Newspapers in the Civil War* (Washington, DC: Brassey's, 1999).

Hersey, John, *Hiroshima* (New York: Alfred A. Knopf, 1946).

Higgins, Marguerite, *War in Korea: The Report of a Woman Combat Correspondent* (Garden City, NY: Doubleday, 1951).

Hohenberg, John, *Foreign Correspondence: The Great Reporters and Their Times* (New York: Columbia University Press, 1964).

Kelly, Michael, *Martyrs' Day: Chronicle of a Small War* (New York: Random House, 1993).

Knight, Oliver, *Following the Indian Wars* (Norman: University of Oklahoma Press, 1960).

Knightley, Phillip, *The First Casualty: The War Correspondent as Hero and Myth-Maker* (Baltimore: Johns Hopkins University Press, 2001).

Lande, Nathaniel, *Dispatches From the Front: News Accounts of American Wars, 1776-1991* (New York: Henry Holt, 1995).

Lewinski, Jorge, *The Camera at War* (London: W.H. Allen, 1978).

Lubow, Arthur, *The Reporter Who Would Be King: A Biography of Richard Harding Davis* (New York: Charles Scribner's Sons, 1992).

Marinovich, Greg, and Joao Silva, *The Bang-Bang Club* (New York: Basic Books, 2000).

Mauldin, Bill, *Up Front* (Cleveland: World Publishing Company, 1945).

Milton, Joyce, *The Yellow Kids: Foreign Correspondents in the Heyday of Yellow Journalism* (New York: Harper & Row, 1989).

Moeller, Susan, *Shooting War: Photography and the American Experience of Combat* (New York: Basic Books, 1989).

Moore, Molly, *A Woman at War: Storming Kuwait With the U.S. Marines* (New York: Charles Scribner's Sons, 1993).

Ostroff, Roberta, *Fire in the Wind: The Life of Dickey Chapelle* (New York: Ballentine Books, 1992).

Persico, Joseph, *Edward R. Murrow: An American Original* (New York: McGraw Hill, 1988).

Pyle, Ernie, *Brave Men* (New York: Henry Holt, 1944).

Roeder, George H. Jr., *The Censored War: American Visual Experience During World War Two* (New Haven, Conn.: Yale University Press, 1993).

Safer, Morley, *Flashbacks: On Returning to Vietnam* (New York: Random House, 1990).

Salisbury, Harrison E., *Behind the Lines: Hanoi, December 23, 1966—January 7, 1967* (New York: Harper & Row, 1967).

Smith, Howard K., *Last Train From Berlin* (New York: Alfred A. Knopf, 1942).

Sorel, Nancy Caldwell, *The Women Who Wrote the War* (New York: Arcade, 1999).

Tobin, James, *Ernie Pyle's War: America's Eyewitness to World War II* (New York: Free Press, 1997).

Whelan, Richard, *Robert Capa: A Biography* (Lincoln: University of Nebraska Press, 1994).

Wyatt, Clarence R., *Paper Soldiers: The American Press and the Vietnam War* (New York: W. W. Norton, 1993).

FROM THE FRONT:
The Story of War

by Michael S. Sweeney

PUBLISHED BY THE NATIONAL GEOGRAPHIC SOCIETY

John M. Fahey, Jr., *President and Chief Executive Officer*

Gilbert M. Grosvenor, *Chairman of the Board*

Nina D. Hoffman, *Executive Vice President*

PREPARED BY THE BOOK DIVISION

Kevin Mulroy, V*ice President and Editor-in-Chief*

Charles Kogod, *Illustrations Director*

Marianne R. Koszorus, *Design Director*

Barbara Brownell Grogan, *Executive Editor*

STAFF FOR THIS BOOK

Susan Tyler Hitchcock, *Editor*

Harris Andrews, *Research Editor*

Susan Blair, *Illustrations Editor*

Gerry Greaney, *Art Director*

Carl Mehler, *Director of Maps*

Matt Chwastyk, Thomas L. Gray, Joseph F. Ochlak, Nicholas P. Rosenbach, Gregory Ugiansky, and Equator Graphics, *Map Research and Production*

Cissy Anklam, *Illustrations Consultant*

Dan O'Toole, *Research Assistant*

Gary Colbert, *Production Director*

Richard S. Wain, *Production Project Manager*

Meredith Wilcox, *Illustrations Assistant*

ADDITIONAL STAFF FOR THIS EDITION

Cinda Rose, *Art Director*

Suzanne Poole, *Contributing Editor*

MANUFACTURING AND QUALITY CONTROL

Christopher A. Liedel, *Chief Financial Officer*

Phillip L. Schlosser, *Managing Director*

John T. Dunn, *Technical Director*

Vincent P. Ryan, *Manager*

Clifton M. Brown, *Manager*

One of the world's largest nonprofit scientific and educational organizations, the National Geographic Society was founded in 1888 "for the increase and diffusion of geographic knowledge." Fulfilling this mission, the Society educates and inspires millions every day through its magazines, books, television programs, videos, maps and atlases, research grants, the National Geographic Bee, teacher workshops, and innovative classroom materials. The Society is supported through membership dues, charitable gifts, and income from the sale of its educational products. This support is vital to National Geographic's mission to increase global understanding and promote conservation of our planet through exploration, research, and education.

For more information, please call 1-800-NGS LINE (647-5463) or write to the following address:

NATIONAL GEOGRAPHIC SOCIETY
1145 17th Street N.W.
Washington, D.C. 20036-4688 U.S.A.
Visit the Society's Web site at www.nationalgeographic.com.

Library of Congress Cataloging-in-Publication Data
 Sweeney, Michael S.
From the front : the story of war featuring correspondents' chronicles / by Michael S. Sweeney.
 p.cm.
Includes bibliographical references and index.
1. War correspondents. 2. War—Press coverage. I.Title.
PN4823.S97 2002
070.4′333—dc21
ISBN: 0-7922-8194-2 (regular)
 0-7922-8195-0 (deluxe)